Picasso working on paper

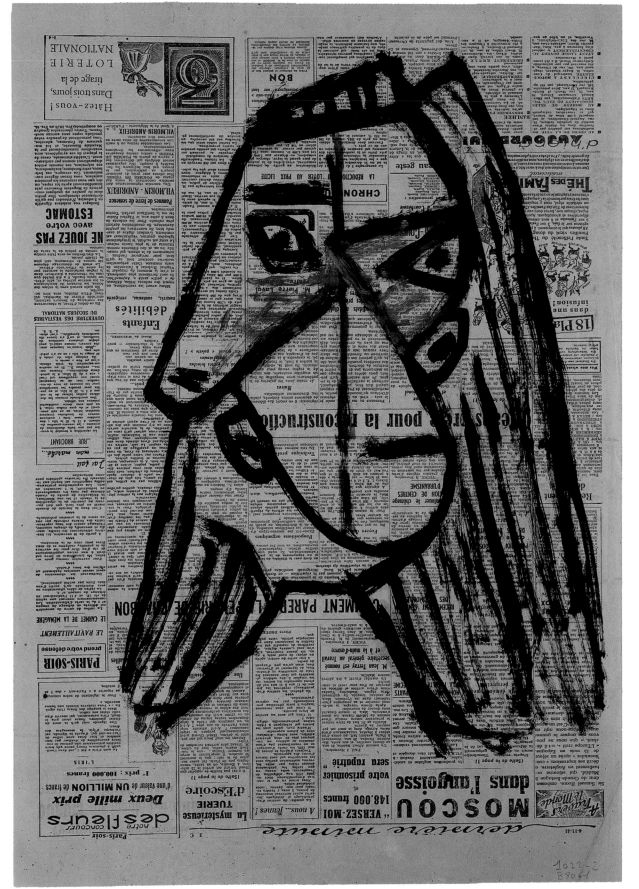

Picasso
working on paper
Anne Baldassari

Translated from the French by George Collins

MERRELL

Published on the occasion of the exhibition
Picasso Working on Paper at the Irish Museum
of Modern Art
29 March – 28 May 2000
Organized in collaboration with the Musée
Picasso, Paris
Curator: Anne Baldassari, Conservator at the
Musée Picasso, Paris

First published in 2000 by
Merrell Publishers Limited
42 Southwark Street
London SE1 1UN
www.merrellpublishers.com
in association with Irish Museum of Modern
Art, Dublin
www.modernart.ie

Distributed in the USA and Canada by Rizzoli
International Publications, Inc.
through St Martin's Press, 175 Fifth Avenue,
New York, New York 10010

British Library Cataloguing-in-Publication Data
Baldassari, Anne
Picasso working on paper
1.Picasso, Pablo, 1881–1973 2.Newspapers
in art 3.Drawing, Spanish 4.Collage, Spanish
I.Title II.Irish Museum of Modern Art
741.9´46

ISBN 1 85894 107 5 (hardback)
ISBN 1 85894 109 1 (paperback)

Produced by Merrell Publishers Limited
Translated from the French by George Collins
Edited by Iain Ross
Designed by Tim Harvey
Compiled by Brenda McParland, Karen
Sweeney and Seán Kissane, Irish Museum of
Modern Art

Front jacket (top): *Cut-Out (The Plate)*, Pablo
Picasso, 1948 (see fig. 166)
Front jacket (bottom): *Cut-Out (The Fish)*, Pablo
Picasso, 1948 (see fig. 167)
Back jacket: *Cut-Out (The Cage)*, Pablo
Picasso, 1948 (see fig. 168)
Frontispiece: *Head of a Woman*, Pablo Picasso,
1941 (see fig. 138)

Photo Credits
All photographs © Réunion des musées
nationaux (photographs by M. Bellot, J.G.
Berizzi, P. Bernard, G. Blot, B. Hatala and H.
Lewandowski) except for the following
(numbers refer to figure numbers):
Figs. 2, 3, 6, 7, 14, 15, 16, 17, 18, 19, 20,
 32, 35, 37, 38, 39, 43, 44, 45, 46, 65, 66,
 67, 69, 70, 71, 72, 73, 74, 75, 77, 78, 81,
 83, 84, 95, 101, 102, 103, 104, 105, 106,
 107, 108, 109, 110, 111, 112, 113, 114,
 115, 116, 124, 125, 126, 127, 128, 129,
 137, 141, 146, 147, 149, 155, 156, 157,
 158, 159, 160, 170, 171, 172, 173, 174,
 175, 176, 179, 180 © Béatrice Hatala
Figs. 8, 9 © Arxiu Fotografic de Museus,
 Ajuntament de Barcelona
Fig. 18 © Pushkin Museum of Art, Moscow
Figs. 21, 22, 23, 24, 25 © Arxiu Històric de la
 Ciutat de Barcelona
Figs. 26–28, 30, 40, 47, 151–54 © Image Art
 Antibes (France)
Figs. 31, 41, 42, 94, 99, 139, 143
Eric Baudouin © Images Modernes
Fig. 33 © Philadelphia Museum of Art, PA,
 United States
Fig. 48 Private collection © All rights reserved
Figs. 50, 76, 122, 123, 156, 166–68, 177,
 178 © Orlando photo
Figs. 51, 140, 142 © Galerie Jan Krugier,
 Ditesheim & Cie, Geneva
Fig. 60 © Philip Bernard, Musée d'Art Moderne
 Lille-Métropole-Villeneuve d'Ascq
Fig. 61 © Sprengel Museum Hannover
Fig. 64 © Fondation Beyeler, Riehen/Basel
Fig. 82 reproduced courtesy of the National
 Gallery of Ireland
Figs. 119, 162 © L'Humanité
Figs. 120, 121 © ADAGP, Paris, and DACS,
 London 2000
Fig. 131 © Bibliothèque de Documentation
 Internationale Contemporaine
Figs. 132–35 © Estate Brassaï © RMN
Fig. 144 Private collection © Jacqueline Hyde
Figs. 145, 148, 150 © Rodolphe Haller
Fig. 155 © Yale University Art Gallery, New
 Haven, CT, United States
Fig. 161 © The Museum of Modern Art, New
 York, NY, United States

Contents

Acknowledgements

The exhibition *Picasso Working on Paper*, organized jointly by the Irish Museum of Modern Art and the Musée Picasso in Paris, brings together a group of works and documents, most of which, belonging in large part to the collections and archives of the Musée Picasso, have neither been published nor exhibited before. The museum has cherished the idea of this project for a long time now. Declan McGonagle, Director of the Irish Museum of Modern Art, has offered unwaveringly enthusiastic support.

From the start, the friendly encouragement of Pablo Picasso's children and grandchildren, as well as the logistic help of the Picasso administration, has allowed us to make the exhibition as comprehensive as its subject demands. I would like to express my gratitude to Marina Picasso, Paloma Picasso and to Bernard Ruiz-Picasso and Claude Ruiz-Picasso for the trust they once again placed in my work.

Generous loans from major private and public collections also played their part in its realization.

First, we must thank the Director of the Musée Picasso, Gérard Régnier, and his scientific and technical staff for their contribution to the project, which was mounted in just a few months.

I would also like to thank the staff of the Irish Museum of Modern Art for their crucial help: Director Declan McGonagle and Head of Exhibitions Brenda McParland, as well as Sarah Glennie, Karen Sweeney, Seán Kissane, Fiona Keogh and Evy Richard.

Heartfelt thanks also go out to the following people, whose generosity was indispensable to this exhibition:

Catherine Hutin-Blay, Janet F. Briner of the Fondation Silva-Casa, Evelyne Ferlay, Katie Lemon, Joëlle Pijaudier-Cabot, Director of the Musée d'Art Moderne de Lille-Métropole-Villeneuve d'Ascq, Luciana Price, Marie-Paule Arnauld, Director, and Savine Faupin, Curator of the Centre Historique des Archives de France, Laure Baumont-Maillet, Director of the Département des Arts Graphiques et de la Photographie at the Bibliothèque Nationale de France, Christine Nougaret and Sylvie Bigoy, curators at the Archives de France, Maria Teresa Ocana, Director of the Museu Picasso in Barcelona, Ernst Beyeler, Antoine Coron, Director of the Réserves des Livres Rares at the Bibiliothèque Nationale de France, Raymond Keaveney, Director of the National Gallery of Ireland, Jan Krugier, and Manuel Rovira I Sola, Director of the Arxiu Històric de la Ciutat de Barcelona.

We owe to Marie-Christine Enshaien, Claire Guérin, Florence Wrobel and Jérôme Monnier the solution to the particularly delicate problem of restoring the works presented in this exhibition. Françoise Boineau, librarian at the Bibliothèque d'Etudes Ibériques et Latino-américaines of the University Paris-Sorbonne, Anne-Marie Blanchenay of the Centre de Documentation Internationale Contemporaine of the University Paris-Nanterre, Françoise Bouché and Elisabeth Russo, research assistants at the Au Bon Marché Archives, Sylvie Bleton, Librarian, and Sabine Coron, Curator at the Bibliothèque de l'Arsenal in Paris, Josette Sagara of the Media and Communication Department of La Samaritaine, Sylvie Vautier, Sandra Poupaud and Christine Pinault, research assistants at the Picasso Administration, Sabine Baudouin and Marta Volga de Minteguiaga at Images Modernes, Luis Agusti of the Institut Cervantès in Paris, Bruno Blasselle, Director of the Bibliothèque de l'Arsenal in Paris and Manuel Rodriguez at the Arxiu Històric de la Ciutat de Barcelona were important sources of support and research assistance for this catalogue.

I would also like to thank my very good friends who work under my direction at the research department, the library and the archives of the Musée Picasso for their enthusiastic coming together around this project: Véronique Balu (catalogue secretariat), Sylvie Fresnault (archives), Jeanne-Yvette Sudour (library), Dominique Rossi (picture research), Yvonne Ricken and Alyse Gaultier (trainees), Pierrot Eugène (documentation) and Ivan de Monbrison (research assistant, specialist in the Hispanic field).

The quality of the catalogue owes much to the photography of Béatrice Hatala, to the graphic work of Bernard Lagacé, who helped me in its conception, and to George Collins, professor of aesthetics, and author, aided by Hélène Le Breton, of the translation. Their broad culture will help the English reader to appreciate a text replete with the metaphorical, visual and oral play so typical of the French language.

Lastly, without the exceptional contributions of Christian Phéline, Director of the Service Juridique et Technique de l'Information et de la Communication (Prime Minister), and of my assistant for this exhibition, Emma Laurent, research assistant and iconographer, this project would not have seen the light of day. I extend to them every expression of gratitude.

Anne Baldassari
Curator of the Archives, Library and Documentation Centre of the Musée Picasso, and organizer of the exhibition *Picasso Working on Paper*

Foreword

The exhibition *Picasso Working on Paper*, which this book documents and amplifies, includes works that use newspaper as a material made throughout Picasso's career: he used newsprint in early collages, as a ground for later neo-classical imagery and as a stimulus for visual and verbal associations.

Picasso's inexhaustible fascination with the image led him to draw, paint and sculpt throughout his life, using any available material and process. These works on paper and the related archive material – material that was consciously retained by the artist, who acknowledged his preoccupation with leaving behind a "documentation as complete as possible" – let us see the artist contemplating, annotating and playing with ideas, forms and processes.

Picasso played, in the most rigorous and creative sense, with newspaper: a surface marked and dated with reports of trivia as well as critical moments in time; originally disposable but now fixed in history as a result of the artist's intervention.

Elsewhere in this publication, Anne Baldassari, Curator of the Archives, Library and Documentation Centre of the Musée Picasso, Paris, examines this material within the totality of Picasso's practice, and asserts, in a closely argued text, that Picasso's use of newspaper as a chronicle, of the world on one hand and of his own practice of the other, represents a trace of something essential and fundamental in the artist's practice that needs to be understood.

The exhibition, which opens the New Galleries of the Irish Museum of Modern Art, and the book set out to examine these works as points of origin in the practice of a crucially important artist of the twentieth century, whose understanding of humanity's multiple rather than singular narrative took him beyond Modernism but is yet to be fully articulated in critical debate.

The Irish Museum of Modern Art is deeply indebted to Bernard Picasso, Marina Picasso, Paloma Picasso and Claude Ruiz-Picasso, who have loaned works for the exhibition, and to the Picasso Administration, as well as to the Sprengel Museum Hannover, the Archives de France, the Arxiu Històric de la Ciutat de Barcelona, the Ajuntament de Barcelona, the Institut de Cultura de Barcelona, the Museu Picasso, Barcelona, the Bibliothèque Nationale de France, the Musée d'Art Moderne de Lille-Métropole-Villeneuve d'Ascq, the National Gallery of Ireland and the Fondation Beyeler, Riehen/Basel. The museum is also indebted to a private lender.

We are grateful to Merrell Publishers, Gérard Régnier, Director of the Musée Picasso, Paris, for his co-operation and assistance, and in particular to Anne Baldassari, who curated the exhibition. The museum is also grateful to its outgoing Board members, and for the continuing support of the Minister and the Department of Arts, Heritage, Gaeltacht and the Islands.

Declan McGonagle
Director
Irish Museum of Modern Art

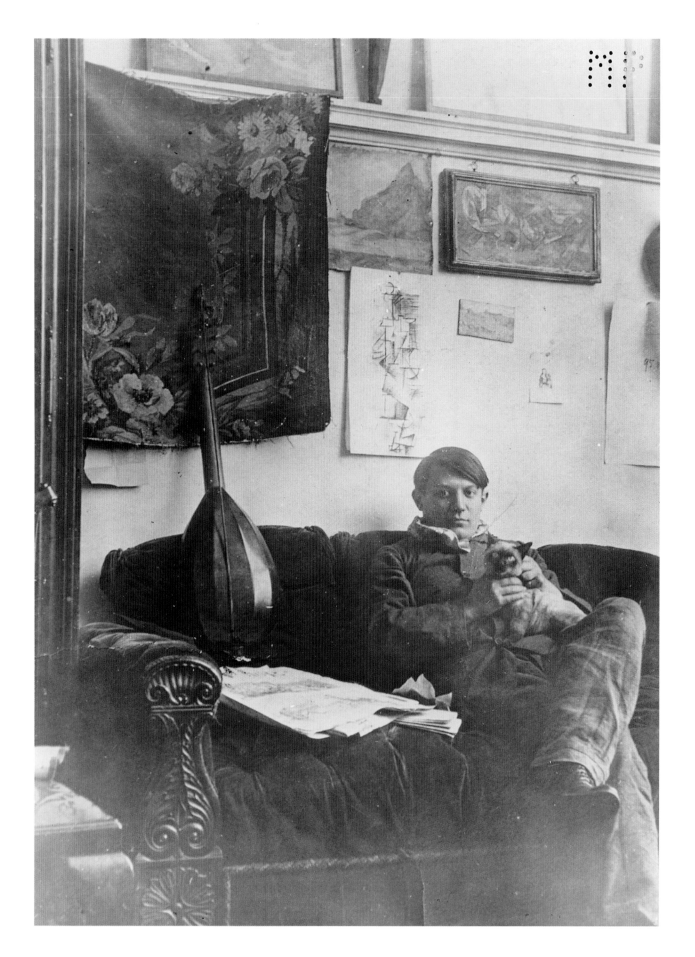

8 Picasso working on paper

"A new mankind, the world is its new representation", Guillaume Apollinaire, 'Picasso', in *Méditations esthétiques: les peintres Cubistes*, 1913

"Where is the end of the fortuitous and the beginning of the necessary once a distant fact has clearly begun to resonate throughout a new state of current events that, whilst all-pervasive, has already begun escaping our grasp?", *Picasso's Papiers Collés 1912–14*, exhib. cat. by Tristan Tzara, Galerie Pierre, Paris, February–March 1935

Picasso and the Press: A Journey Through the Century

"My dear friend Braque. I am using your latest papery and powdery procedures ...",[1] wrote Pablo Picasso in October 1912, after returning from Avignon to Paris. Picasso was referring directly to Braque's two-month-old innovations, which had led him to place imitation-wood wallpaper, sand and dust over parts of his paintings and drawings. Using Braque's experiments to his own ends, Picasso's *papiers collés* of the winter of 1912–13 replaced the imitation-wood wallpaper with press clippings. This systematic use of newsprint would henceforth mark the difference between his project and Braque's. As Edward F. Fry has pointed out, Braque used wallpaper or imitation wood "as sign-images to be incorporated into the surface of the painting", whereas Picasso "resorts to an increasingly intellectualized questioning of representations".[2] As material, object or surface for inscription, newsprint becomes a self-referential sign: newsprint is the printed paper of the newspaper whose name is *Le Journal*, as its title LE JOURNAL inscribed on newsprint, most certainly confirms. The tautological circularity of this object-sign conforms perfectly with Picasso's conception of his programme of *papiers collés*. Newsprint can be considered a sign-image, but also refers to its reality as object, as well as to time and to history. The incorporation of this object-sign into his work clearly demonstrates Picasso's contribution to this key moment in the genesis of modern art.[3] In what follows I shall attempt to understand the material specificity of his contribution, to reconstitute the inner logic of its procedures and to situate it in the chronicle of his work as a whole. It must be asked whether Picasso's use of newsprint is in fact a variant of the "cut-out and pasted colour-texture", as Isabelle Monod-Fontaine[4] describes Georges Braque's use of imitation-wood wallpaper, or whether, on the contrary, it will be necessary to abstract something from what the newsprint *says*, from the *sounds* it contains as well as the *images* with which it is illustrated.

"Documentation as Complete as Possible"

Supported by a systematic study of the artist's archives, research at the Musée

Fig. 1
Pablo Picasso
Self-Portrait
Studio at 11 boulevard de Clichy,
Paris, December 1910
Gelatin silver print
14.7 × 11.6 cm
APPH 2834
Picasso Archives, Musée Picasso,
Paris

Picasso over the past few years on the artist's complex relationship with photography has brought to light his frequent use, as of the early 1920s, of press photography as a support for drawing.[5] Each case of such use, considered separately, might seem to be only anecdotal evidence of Picasso's habit of trying everything out in his effort always to outdo himself. Further research, however, has produced a list, compiled from items within the Picasso archive and in his personal collection,[6] of works using press material as a support. I have thus managed to put together a *corpus* of drawings or paintings which, despite their limited number, cover a remarkable range in time. Beginning with the childs' papers of 1893–94, which represent Picasso's first confrontation with the journalistic form, he regularly resorted to this practice from 1902 to 1911. It became, during the period of the *papiers collés* from 1912 to 1914, the pre-eminent form of his work. Picasso's neo-classical period could conceivably have ousted all such 'realistic' material, but several works from the beginning of the 1920s can be seen to capitalize on its resources. In the course of the artist's Surrealist period, press photographs served intermittently as a pretext for visual associations. During the German occupation of France, newsprint was used as intensely as in 1912–14. Other examples can be cited well into the 1960s, when newsprint became the raw material for poem cut-outs, folding, collages, scale models, palettes *etc*. Lastly, Picasso's collection of newspapers conceal yet other surprises: automatic jottings, graffiti, handwritten glosses ... One has to bear in mind that the Picasso archive deals on the whole with documents (printed material, photographs or correspondence) dating from after 1916, the time of Picasso's move to Montrouge. Little remains from the preceding period, apart from a valuable stock of older photographs and a few letters. What is more, the material fragility of newsprint, its high sensitivity to light and the improvised or temporary nature of the works for which it serves as the support may have resulted in the loss or destruction of quite a few pieces. Therefore, the corpus we have reconstructed should be seen as a *trace*, pointing, no doubt, to a larger, more significant practice. Confirmation comes in the form of the recurrence of these practices over a period of sixty years, and their high level of plastic homogeneity.

My goal here, as in the case of my recent exploration of Picasso's use of photography, will be to reconstitute the artist's working procedures on the basis of this corpus. The study of the artist's recourse to photography, as practice, technique or source, yielded insights into the genesis of a part of Picasso's work. Something similar will occur here through an analysis of such a specific support as newsprint. We know through Picasso's statements, poems and the frequent inscriptions on his works that he was obsessed with the question of dates. Setting down the day and sometimes even the hour[7] when things would occur, when each work was born, *dating* everything and *keeping* everything: this all stemmed from the same powerful inner necessity. His friend the photographer Brassaï analysed it well:

> The minute nature of his dating is neither caprice nor mania, but a premeditated, thought-out act. He
> wishes to give to every event and gesture of his life historical value within the history of his life as

man and creator, placing them – before anyone else does – in the great annals of his stupendous life ...[8]

Brassaï remembers Picasso explaining his concern with dates:

> "Why do you think I date everything I do? It's not enough just to know an artist's works. You must also know when he did them, why, how, in what circumstances. A science one day will be invented, no doubt, which will be called 'the science of the human' and which will strive to delve deeper into mankind through the creative human ... I often think about a science like that and I would like to bequeath to posterity a documentation as complete as possible ...[9]

The very intention of documentary exhaustiveness is probably the force that drove Picasso to conserve everything in those monumental archives. The 'everything' of Picasso's archive is often tantamount to 'nothing': blotting paper, medical brochures, bits and pieces of just about anything, fragments, debris *etc*. The task of classification comes asunder again and again, for there is neither rule nor order to this sheer accumulation. At first sight, there is *nothing* to retain the eye, or at least nothing significant to the work. However, this flow of minute traces, constantly renewed by daily life, sometimes conceals the invisible machination whereby the banal forms of the real contribute to the genesis of the work. Picasso explicitly wanted to be "as complete as possible" in everything he carefully bequeathed to posterity. He justified himself in the following dialogue with Jaime Sabartès:

> **Sabartès:** I can't explain to myself how you manage to reconcile your mania for conservation and your innovative temperament.
> **Picasso:** You are confusing two totally different words, old chap! The point is I am no nitwit. I have what I have by keeping it, not by conserving it. Why should I throw away that which was good enough to happen to me?
> **Sabartès:** One understands that you conserve famous paintings and valuable objects.
> **Picasso** (shouting back): Rothschild has more admirers than the news vendor.[10]

Among the many things Picasso the 'news vendor' kept are numerous press clippings or cut-outs. Once gathered into a corpus, they form the framework of a singular philosophy of 'doing'. Newsprint here is an index of time: time present, time past, the time of life, of work, of history. Here are stories of daily, ordinary, miscellaneous events, weather reports, entertainment sections, but also the history of the entire century, from the Balkan Wars to the First World War, from the French Popular Front to the Spanish Civil War, from the German occupation to the war in Algeria: a network of events into which can be woven the history of the painter, the man, the citizen. In Picasso's quite conscious relationship to his time, newsprint specifically allows a short-cut to dating. It becomes the very tool of the chronicle of the artist and his epoch. Like photography, it is a sign-index inscribed as the durable trace of the rhythmic heartbeat of time. Picasso used both photography and newsprint to undo the codes of conventional representation. Their form is both elaborated and immediate in his work. Image or text, each acts by capturing the real and comes to stand in (the) place of the real.

Picasso the Illustrator, Picasso the Reader

"I don't know everything but I know many things, yes, many indeed. I am curious, very curious", confided Picasso one day to his friend the poet André Verdet, adding:

> I read the newspapers, the journals and magazines, I read them closely, I concentrate on what I read, and I listen to the news on the radio. And there too – this is quite mysterious – in very different places, there are always friends, someplace, somewhere, who write to me or telephone to tell me things. These friends know how much these things mean to me, so they make sure to tell them to me. You see, a whole skein of very useful information makes its way to me. I might start a newspaper.[11]

To start a newspaper ... this project would bring us all the way back to Picasso's early youth. On the back cover of his handwritten newspaper *La Coruña* of 16 September 1894, the young Picasso drew a sketch of La Torre de Hercules (fig. 4), symbol of the city of La Coruña. According to popular tradition, as taken down by Josep Palau i Fabre, this lighthouse, set on a promontory, is supposed to have contained "a magic mirror enabling one to see the image of everything happening in the remotest corners of the world".[12] Such a belief could be explained "by the confusion between the two words in vulgar Latin *specula* (watch-tower) and *speculum* (mirror)". Such a metaphor could be applied to the role assigned to these newspapers, reserved for his close friends by the thirteen-year-old artist, who, according to Jaime Sabartès, "played the role of publisher, editor, draughtsman and manager".[13] In a wider sense, the primitive form of the watchtower may be interpreted as a metaphor for observation, investigation and reporting – that is, for the very essence of modern journalism. As for the mirror, the planar surface of which reflects the infinitude of real objects and returns their appearance, it is the incarnation of Picasso's fascination with images. The mirror is the tool of 'capture' while the watch-tower refers to an act of vigilance, a time of watchful making when the mobility of the gaze and the mind reach out to signs of portent, to their decipherment and interpretation.

The precocious experience of *Azul y Blanco* (figs. 8–13) and *La Coruña* (figs. 4, 5) made evident for the first time Picasso's keen lifelong interest in written media, both as a regular reader and, on several occasions, as an active participant in the editorial process. Thus in the year 1901 – Picasso was then barely twenty years old – he created, along with the Catalonian Francisco de Assis Soler, the journal *Arte Joven*. Sharing the radical spirit of the generation of '98, the journal opened its columns to ideas close to anarchism. As was the case with *Azul y Blanco*, Picasso was, from its creation, a 'jack of all trades', at one and the same time its managing editor – the journal's official address was his home at 28 Zurbano – and its illustrator. He was thus able to glean on-the-job experience with printers (two of which followed one another in the publication of the five issues of the journal's duration) and undoubtedly took an active part in each issue's layout. From 1899 to 1902 Picasso contributed illustrations to the Catalonian journals *Joventut*,[14] *Pel and Ploma*[15] and *Catalunya Artística*.[16] In 1902 Picasso participated in a fully fledged newspaper, *El Liberal* (figs. 22, 23), for

which he contributed illustrations for the front page of the 5 October edition dealing with the feast of Merced (fig. 21), the patron saint of Barcelona. The newspaper, a Catalonian republican daily with anarchist leanings, was owned by his friend Carles Junyer Vidal, and began publication in Barcelona in April 1901.[17] This experience with newspaper layout continued into 1903, when Picasso, for the 10 August edition of *El Liberal* (fig. 24), illustrated an article by Junyer Vidal on 'Art at the International Exhibition in Paris'. In 1904 Picasso again illustrated an article devoted to his own work on the front page of the 24 March 24 edition of *La Tribuna* (fig. 25) of Barcelona, published with the subtitle *The Independent Newspaper*.

Picasso's identity as *reader* of the printed press throughout the twentieth century is revealed through two principal sources: first, the numerous newspapers and magazines kept by him and found today in the Picasso archive, and secondly, the graphic works on newsprint, using press clippings. The first source covers mainly the period from the Second World War onwards. Picasso's interest in the illustrated press of the previous century is, however, attested to by a group of issues of *Le Monde illustré*, dating from the 1880s, a page from the 20 December 1890 issue of *L'Illustration* containing an article and a plate dealing with shadow play, and four copies, dated 1865, of a Catalonian journal called *Un Tros de paper* (A Bit of Paper; fig. 20). For the first years of the twentieth century we have in the artist's archive an undated copy of *Pocholo*, "the best children's journal", and two issues (1909 and 1910) of *Papitu* (fig. 14), a Catalonian journal with anarchistic leanings, which recommended "irony as the transformation of language".[18] I shall show how his work on *Azul y Blanco* bears witness to Picasso's attentive observation of the graphic codes of this kind of press and, more specifically, those of *Blanco y Negro* (figs. 2, 3, 6, 7, 15, 17, 19), an art journal published in Madrid from 1890. More generally, Picasso's interest in old illustrated publications is similar to his penchant for collecting nineteenth-century photographs, *carte-de-visite* portraits, orientalist subjects, ethnographic documents, reproductions of masterpieces *etc*. Besides their purely documentary function, these images may have caught Picasso's eye in much the same way and for the same reason as the world of the press: because of the characteristics of their layout – portfolios on blue-grey paper, medallions and vignettes supplementing the captions or signature of the photograph – whereby image and text, set in the same code, erect the fantastic architectures of the signifier.

The Journal of the Work

With regard to those works by Picasso that use newsprint, research and debate have centred on that part of them which belongs to what Clement Greenberg called "the revolution of the *papiers collés*" in 1912–13.[19] But even a cursory review of Picasso's corpus points up the presence of works on newsprint throughout, and confirms the continuity and diversity of his interest in the press. A few of these works use publications such as *Le Vieux Marcheur* (figs. 43–45), a licentious journal decked out with vignettes that Picasso used as a support for a proto-Cubist sketch in 1907, or *Pan*

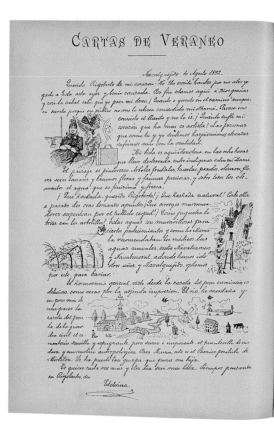

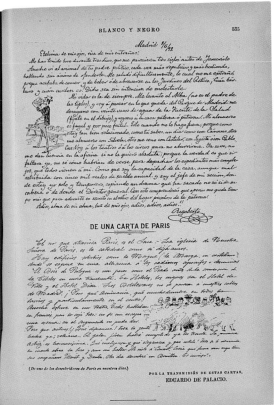

Fig. 2
Blanco y Negro no. 68
Madrid, 21 August 1892
Bibliothèque d'Etudes
Ibériques et Latino-améri-
caines of the University
Paris-Sorbonne, Paris

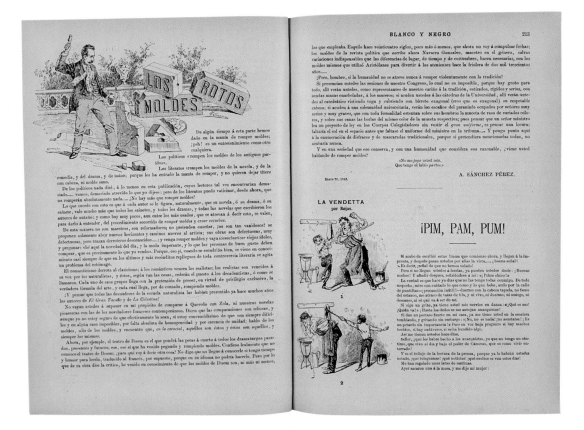

Fig. 3
Blanco y Negro no. 48
Madrid, 3 April 1892
Bibliothèque d'Etudes
Ibériques et Latino-améri-
caines of the University
Paris-Sorbonne, Paris

Fig. 4
Pablo Picasso
La Coruña
La Coruña, 16 September 1894
Handwritten newspaper: pen, brown
ink and pencil
21 × 26 cm
MP 402 R
Musée Picasso, Paris

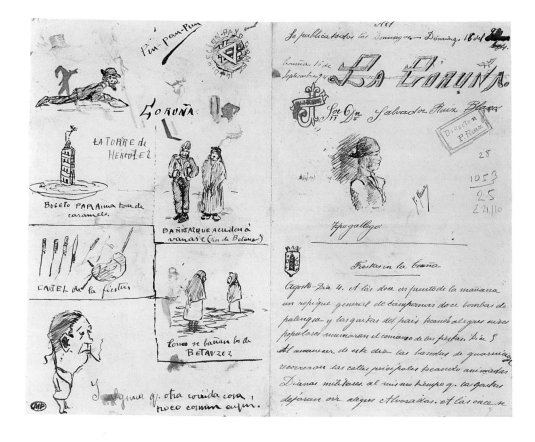

Fig. 5
Pablo Picasso
La Coruña
La Coruña, 16 September 1894
Handwritten newspaper: pen, brown
ink and pencil
21 × 26 cm
MP 402 V
Musée Picasso, Paris

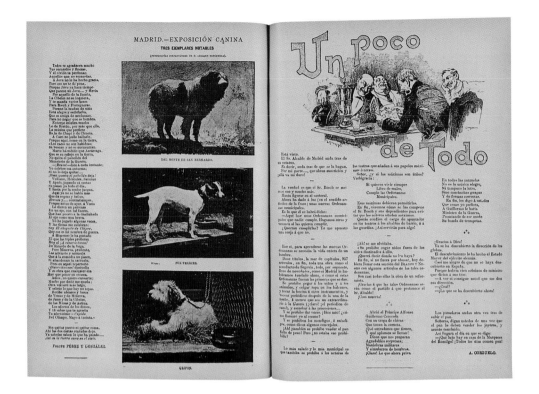

Fig. 6
Blanco y Negro no. 58
Madrid, 12 June 1892
Bibliothèque d'Etudes Ibériques et
Latino-américaines of the University
Paris-Sorbonne, Paris

(figs. 50, 51), a little-known journal of poetry, the pages of which, from 1910 to 1911, carry drawings. They can be compared to works using supports derived from objects of 'high culture': novels, poetry collections, invitations. However, it is mainly the titles of the major press organizations that most regularly appear in Picasso's work and seem to have caught his artist's eye as well as his reader's curiosity. The importance of headlines in his work has already been substantiated for the 1912–14 period, in which the daily paper *Le Journal* played a crucial role both for the *papiers collés* and in the form of a painted typographic motif in numerous paintings up to 1914.[20] Robert Rosenblum has analysed, in the case of the *papiers collés*, the metamorphoses undergone by the lettering in the title LE JOURNAL, which refers simultaneously to this particular newspaper title and to the generic reality of all newspapers.[21] However, as early as 1902 there is a case of the graphic use of *Le Journal*, the front page of which became a support for caricatures and graffiti. This daily paper belongs to the group of the 'four majors', including *Le Petit Journal*, *Le Petit Parisien*, and *Le Matin*, the last of which was frequently used by Picasso. These newspapers merged early on to form the 'Consortium', which, through the Havas news agency, aimed to control access to the advertising market. Their political positions were never clear-cut. On the first page of these dailies could be found miscellaneous news items (*les faits divers*) that upset the traditional information hierarchy. Thus *Le Journal,* printed in six columns, has hardly any subheadings and gives most of its front-page space to the '*Rubrique des petits échos*' column (containing miscellaneous news and events). Jean-Pierre Rioux gave a description of the editorial ideology of these 'one-penny rags':

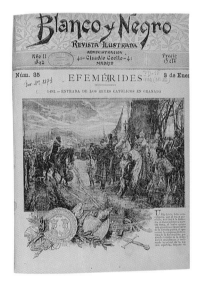

Fig. 7
Blanco y Negro no. 87
Madrid, 1 January 1893
Front page
Bibliothèque d'Etudes Ibériques et
Latino-américaines of the University
Paris-Sorbonne, Paris

Fig. 8
Pablo Picasso
Azul y Blanco
La Coruña, 8 October 1894
Handwritten newspaper: pen and ink
on paper
20.2 × 26.3 cm
MPB 110 863 R
Museu Picasso, Barcelona

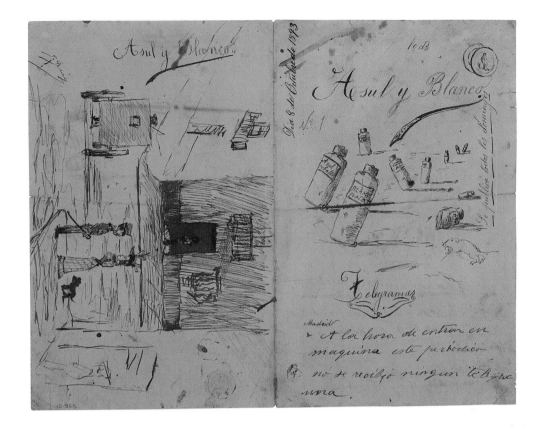

Fig. 9
Pablo Picasso
Azul y Blanco
La Coruña, 8 October 1894
Handwritten newspaper: pen and ink
on paper
20.2 × 26.3 cm
MPB 110 863 V
Museu Picasso, Barcelona

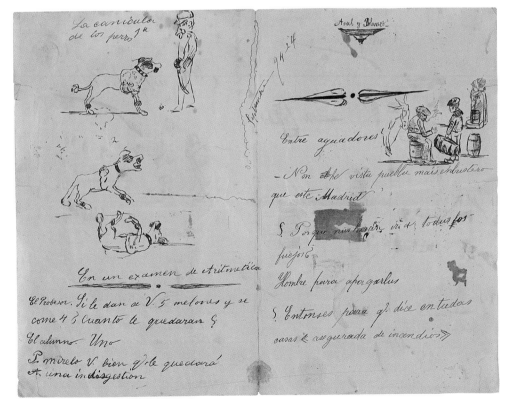

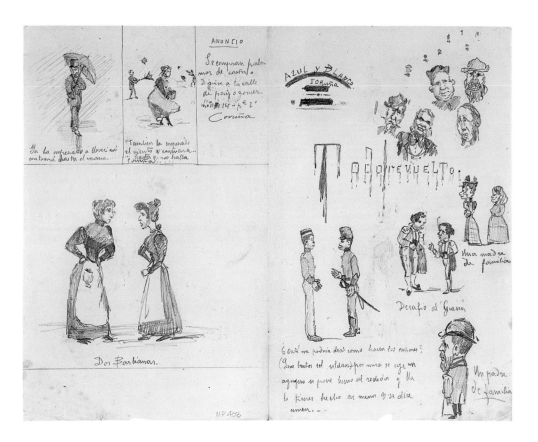

Fig. 10
Pablo Picasso
Azul y Blanco
La Coruña, 28 October 1894
Handwritten newspaper: pen and ink
on paper
20.5 × 26.5 cm
MP 403 R
Musée Picasso, Paris

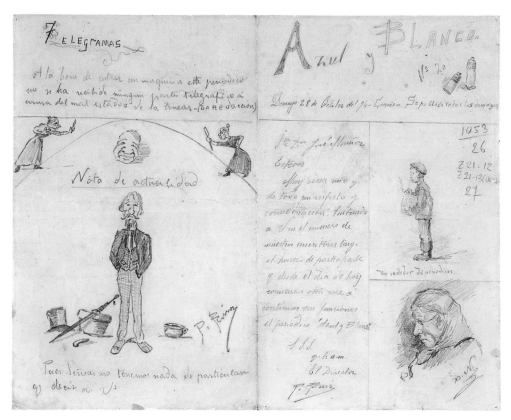

Fig. 11
Pablo Picasso
Azul y Blanco
La Coruña, 28 October 1894
Handwritten newspaper: pen and ink
on paper
20.5 × 26.5 cm
MP 403 V
Musée Picasso, Paris

Fig. 12
Pablo Picasso
Azul y Blanco
Numero de Navidad
La Coruña, 1895
Handwritten newspaper: pen and ink
on paper
20.5 × 13 cm
Z XXI, 15
Private collection

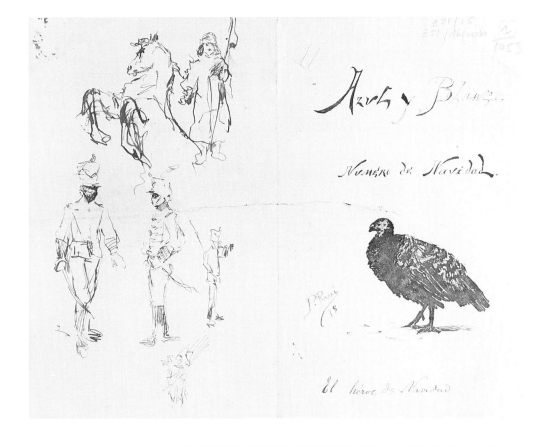

Fig. 13
Pablo Picasso
Azul y Blanco
Numero de Navidad
La Coruña, 1895
Handwritten newspaper: pen and ink
on paper
20.5 × 13 cm
Z XXI, 16
Private collection

The path to success will avoid all ideas, all effects of style; there will be only solid facts, last-minute 'tit-bits' of news in no particular order, useful 'discoveries' to help sing life along, sensational scoops, brutish interviews, and hordes of miscellaneous events – with a preference for sordid crimes, heroic mothers and wilted virtues – a decent serial and a generous choice of aphorisms flattering the wisdom of nations.[22]

The three headings on the front page of *Le Journal* on 17 October 1902 (figs. 26, 27), 'Plagiarism of Dante', 'The Happy Adulterer' and 'The Oracle', illustrate the policy that gave pride of place to the anecdote and little space to images. Only the geometric pictogram announcing a drawing by Caran d'Ache on page 2 and the '*Échos*' advertisement manage to interrupt the visual plan of the page. At the end of September 1905, a copy of *Le Matin* (fig. 28) appeared in Picasso's work, with graffiti and manuscript commentary. This edition of the newspaper exemplifies its editorial policy, marked by the use of photographs in one or two columns. Moreover, *Le Matin* proved itself capable of editorial self-mockery by accepting, between May and November 1906, the 'News in Three Lines' by the critic Félix Fénéon, a scathing parody of *fait divers* journalism. In December of the same year, editions of *Le Journal* and *Le Matin* would become supports for a group of studies belonging to the *Demoiselles d'Avignon* galaxy (figs. 32, 34, 35–40). From these works onwards, the newspaper was no longer used as a whole but was rather treated as specific material that could be cut up or torn, depending on the requirements of Picasso's project. In the *papiers collés* of 1912–13, *Le Journal* appears again and again, especially during the period November 1912 to January 1913. The greater part of the press clippings used by Picasso during this time concern the Balkan Wars, the dates of which enabled Robert Rosenblum[23] and Pierre Daix[24] to re-establish the chronology of the relevant works of this period. The theses of Patricia Leighten have kindled a fiery debate over the degree of political intentionality inherent in these testimonies to contemporary events.[25] Jeffrey Weiss has suggested that the references to current affairs in the *papiers collés* are less a matter of militancy than of a "joking spirit" comparable to the humorous inspiration of the *fin d'année* shows in Parisian music halls.[26] Pierre Daix recalls a conversation with Picasso during which the latter is supposed to have said, "Of course, I did it on purpose because it was an important event involving a hundred thousand people ... Oh yes, I found that in the newspaper, and it was my way of showing I was against the war", adding in laughter, once his interlocutor had pointed out that the *papiers collés* had at that moment not yet been shown to the greater public, "Well, I knew that people would find this later and understand".[27] Picasso's sense of humour aside, the last statement confirms his obsession with documentation for the future, the systematic historical indexing mentioned above in the context of Brassaï's statements. The newspaper fragment thus seems to have been for the artist, without having to take anything away from the specific formal qualities foregrounding it in the 'revolution of the *papiers collés*', a temporal marker, a trace of current affairs, a trace at once verbal and material of history on the move. This was what enabled Jean Paulhan to see in the fragment, while never once confusing it with age-old pictorial illusionism, a "new realism" that "refuses

to consider the most fleeting of perceptions without including in it our presence in the world".[28]

Besides the frequent use of *Le Journal*, several *papiers collés* used more unusual material such as the Barcelonian republican journal *El Diluvio*, dated March 1913,[29] or the Roman title *Lacerba* of the spring of 1914, the use of which in *Pipe, Wineglass, Newspaper, Guitar, Bottle of Old Marc*[30] and in *Glass, Wine Bottle, Newspaper, Plate, Knife*[31] was a clear sign of Picasso's sympathy with the Italian Futurists, who had published their manifesto in that daily paper. *Glass and Violin*[32] contains a clipping prior to 1910. Likewise, press clippings from the 28 May 1883 edition of *Le Figaro* have been identified by Robert Rosenblum in a series of works of 1913.[33] These occurrences question Picasso's episodic use of *old* newspapers. Rosenblum speculates that such paper "would have had a distinctly different colour from a contemporary newspaper, and that this brownish tone might in itself have attracted Picasso as a variation on the usual white paper ground".[34] The artist here would deliberately have taken advantage of the chromatic specificity of newsprint, so well described by Claude Frontisi: "its constitutive fragility, its extreme photosensitivity", resulting in the fact that "time confers a plastic and coloured value upon it which cannot be imitated by traditional artistic means. The dark tones, 'dead leaves' and lifeless newspaper pages work in harmony with the imitation-wood grain or sky-blue grounds".[35] Such interest in the vulnerability of visual material could be compared to Picasso's penchant for the photography of the previous century, which, as I have suggested, made a crucial contribution to the genesis of the pictorial monochromy of the 'blue' and 'pink' periods.[36] The chromatic attenuation that light creates in photographic substances as well as on paper results in a sepia toning that can easily be read as the sign of passing time. Picasso may very well have found in these 'sensitive' materials the tools he needed for a visual indexing of the existential experience of temporality.

Nevertheless, Picasso most frequently used press material in his work in the period immediately following the publication of the newspapers concerned. The research presented below has enabled the identification, in several major works of the period 1912–13, of the use of clippings from *Excelsior*, a newspaper whose presence in the works of this period has heretofore been attested to only in the *papier collé Bottle and Newspaper* (fig. 81).[37] A copy of *Excelsior* can be seen in a photographic self-portrait taken at the end of 1910 in the studio on the boulevard de Clichy (fig. 1),[38] which proves that Picasso read this daily paper from the beginning (the first edition appeared on 16 November 1910). The front page of the 23 July 1923 edition of the same paper would, more than ten years later, inspire a surprising neo-classical sketch drawn directly on to a press photograph (fig. 96). Picasso was interested from the start in *Excelsior*, the new illustrated daily newspaper that had revolutionized the French press with its wholesale use of photography. Of its twelve pages, three (front page, fifth and ninth) were exclusively reserved for photography, but more generally photography had become a means of telling a story through images, thus laying the foundation of what would later become photojournalism. In the period of the *papiers collés*, Picasso

had separate interests in the visual attractions of photography and the mainly typo-graphical borrowings from press material. Kirk Varnedoe has pointed out how Picasso and Braque "generally avoided the 'modernized' elements of illustration and virtually never extracted any of the pervasive photographic imagery".[39] Thus even the works of 1913 use only the textual elements of *Excelsior*, the lettering of the masthead[40] or the mainly typographical aspects of the advertisements. Picasso's graffiti at the beginning of the century gave precedence to margins and headline columns. Should a photograph attract the artist's eye, as in *Le Matin* in 1905 (fig. 28), this would result only in a brief handwritten caption. As for the Cubist cut-outs, they were strictly aligned on the news-paper layout plan, and followed the architectonics of the columns. Having reverted to a more figurative practice, Picasso would now initiate a new use for newsprint. From 1923 he began to extract front-page illustrations so as to intervene directly *upon* and *in* the image with a graphic commentary. The immediate inclusion of the journalistic image in Picasso's 'plastic universe' required the revolution that was Cubism to have become something commonplace. The written form runs over the press photograph in a semi-automatic gesture. Press text and image, the 'background noise' of everyday expression, prompted and influenced the artist's intervention.

On 12 November 1935 Jaime Sabartès, eyewitness to the daily life of the artist on rue La Boétie, noted the ritual arrival of the morning post and its daily reading:

> On his bed were the letters and papers he wished to read again: catalogues of auctions at l'Hôtel Drouot, invitations to art exhibitions and plays, journals and books. He hands over to me the clip-pings of the news agency Lit Tout [Read Everything] and, when they are worthwhile, we comment on them. *Excelsior*, *Le Figaro*, and *Le Journal* sprawl over the remaining space on the bed.[41]

A poem written that year, '*Maxima au sol*' (figs. 101, 102), shows how faithful Picasso could be to *Le Journal*, the fragments of which he reordered (figs. 103, 104). This daily paper, before falling into the hands of the German occupational forces, limited its reno-vative efforts to a few typographical innovations. Two years previously, however, a new title appeared in Picasso's work: *Paris-Soir* (figs. 97, 98). Founded in 1923, the daily had by then completely changed its style, adopting the photojournalistic model tested by *Excelsior* in order to impose an even more systematic use of illustration. *Paris-Soir* would reach record sales levels for France in 1939: more than 1,700,000 copies. Reserved for the main headlines, the front and second pages were exclusively devoted to photography. The image was now dominant in a mosaic of formats that, from 1937 onwards, would definitively upset the vertical order of the columns. Such photographic ubiquity in a destructured grid created image–image or image–text–typographical encounters of a thoroughly unprecedented nature (figs. 124–28). The eye, moving over the page and constantly reacting to visual jumps and starts, could initiate something like the 'automatic' reading with which the Surrealists were experimenting. The incon-gruity of these collisions between images was deepened by the notably poor quality of the reproductions. Haphazard framing, mediocre definition and ink-blotted printing made for much of the disorder of this novel journalistic form, the brutal reflection of a

disturbed era in which reality was now well beyond fiction. Thus a *Paris-Soir* photograph from the Moroccan War prompted a pen drawing by Picasso in 1933, *Moroccan Rebel* (figs. 97, 98).[42] An article in the same paper confirming France's decision not to intervene in the Spanish Civil War in 1937 prompted a drawing of a man with his fist raised in defiance (fig. 117). Picasso began the preliminary sketches for *Guernica* (figs. 119, 121) the day after reading a report published in the 30 April 1937 edition of *Ce Soir*, a daily that had just been founded by Louis Aragon. But once again it was in *Paris-Soir* on 1 May 1937 that, according to Jean-Louis Ferrier, Picasso is supposed to have found the visual source for several key motifs of the composition.[43] In the course of the same year, Picasso diverted himself with Surrealist images such as occur in a series of graffiti (figs. 111–16) recently discovered in the Dora Maar bequest, and which once again use *Paris-Soir* as their support.[44] During the Occupation this newspaper would remain one of his preferred supports. Between 1941 and 1943 the availability of *Paris-Soir* enabled him to paint a significant series of portraits in oil using, for the most part, whole pages of the paper (figs. 138–47). Such use of newsprint can certainly be explained by the lack of most other materials at the time. But it would be wrong to overlook the fact that Parisian edition of *Paris-Soir* had, since the arrival of the German forces, been requisitioned and would become the main organ of pro-Nazi propaganda in France. False and corrupted news, inaccurate captions, unverifiable images ... the 'magic mirror' had shattered, and, as never before, the discrepancy between signifier and signified was brought to light. Just as the *papiers collés* were set against the background of the Balkan War in 1912–13, so too the staging and layout of this manipulation of conscience became the backdrop of Picasso's work throughout the German occupation of France. The choice of *Paris-Soir* as a support for part of his work was tantamount to the inscription of some sort of physical marker of the unfolding political drama onto it. At the same time, the 'conflict' between the support and the draughtsmanship signals Picasso's brutal unpinning of surrounding semblance and pretence. A study also dating from this dark era,[45] reduced to the geometry of a table and a few objects, is one in the series of prosaic and disquieting compositions of the year 1943 of which *Skull and Pitcher*[46] is emblematic. The study is drawn on a fragment of the front-page headline of *Comoedia* on 14 August 1943 (fig. 157).[47] This publication, more literary than artistic, appeared again during the Occupation and strove to maintain a balanced editorial approach. In June 1942[48] it published an extremely violent attack against Picasso by Maurice de Vlaminck, entitled 'Free Opinions on Painting'. A courageous answer by forty painters, co-ordinated by Gaston Diehl, was published two weeks later.[49]

The drawing of the dove, which, after the War, would be used by the Communist Party as a symbol of peace, appeared for the first time in 1936, scribbled in a copy of *Marianne* dated 8 July (fig. 111). During this period of the French Popular Front, Picasso had chosen sides. Created in 1922 by Emmanuel Berl, the weekly magazine was overtly left wing in orientation: offset-printed in a thirty-two-page format, it used photography, at times in the form of photomontage, to denounce fascism. "Is it reality that creates

reality, or the constructed idea of reality that provokes it, causing it to appear?" (fig. 170.) With this written aphorism inscribed on a fragment of a cut-up newspaper, the first copy of *L'Humanité* made its appearance in Picasso's work. In fact the printed words "capitalist profits and all the more so" seem intentionally to have been left legible by the artist as a kind of signature. *L'Humanité*, founded in 1904, became in 1920 the official newspaper of the new Communist Party. A photograph in the edition of 28 April 1937, depicting the female victims of a bombing (fig. 119), may have been part of the visual genesis of *Guernica* (figs. 120, 121).[50] As early as 13 December 1944, *L'Humanité* published a photograph found on a German soldier depicting the bodies of Soviet victims (fig. 162). This was one of the first documents to *show* what the press would not reveal before the spring of 1945 with the opening of the concentration camps. *The Charnel House* (fig. 161), one of Picasso's major works of 1945, would appear to refer directly to this photographic document.[51] From the moment he became a member of the French Communist Party, in October 1944, Picasso would archive numerous editions of *L'Humanité*, as well as *Les Lettres Françaises*, the Communist Party periodical, directed by Louis Aragon, aimed principally at intellectuals, and *La Vie Ouvrière*, the union publication of the Confédération Générale du Travail (CGT). In 1946, Picasso would cut up *L'Humanité* in the shape of a skull, in a series of experiments reusing the shape of *Death's Head* (figs. 163–65), a bronze sculpture made during the Occupation.[52] Later he would occasionally intervene in these publications. As he had done for *El Liberal* in 1902–03, he illustrated the issue of *La Vie Ouvrière* devoted to Stalin's seventieth birthday in 1949 and, in 1953, would draw for the cover of the issue of *Les Lettres Françaises* commemorating his death a portrait considered blasphemous by most party heads and militants (fig. 173). Nevertheless, in 1950 another Communist publication, *Le Patriote*, a daily paper published in Nice, appeared in Picasso's possession, with the following written note (in Picasso's hand) in the margin: "You have to be really afraid to be frightened of a dove." (fig. 171.) This marked the beginning either of his participation in larger front-page drawings for this newspaper at the time of the Nice Carnival (figs. 179, 175, 176), or of his hand-engraving experiments of 1963, for which he chose as the support a flong[53] used for the printing of one of the pages of *Le Patriote* (fig. 180).

Throughout this period, Picasso, in each of his studios or from his 'watch-tower' at Notre-Dame-de-Vie, continued to examine the world. The newspaper *Le Monde*, one of the major papers created at the time of the French Liberation, would be of use to him in 1961 as a scale model for the sculpture *Infant* (figs. 177, 178).[54] This was an opportunity for him to chart the political convulsions summarized by the headlines: 'Political Reactions after Sedition in Algiers'. A major confrontation between de Gaulle and that faction of the French armed forces still in favour of a French Algeria, and the military coup by the French generals that destabilized the budding Fifth French Republic, gave Picasso another way, more aggressive than the Carnival 'crazy heads', to conclude his newspaper chronicle of the century.

To be *Seen* or *Read*?

The newspapers used by Picasso as material throughout his work provide an imaginative purchase on Picasso as a *reader* of the twentieth century's press. Before a more detailed analysis of these works can be undertaken, another question should be addressed: to what extent must the textual content of these press clippings be considered part of the works as artistic objects? Is it legitimate to consider this content as a pertinent element in the creative intention of the artist? This problem of methodology, applicable here to more than a half century of artistic activity, is far from new, and has been hotly debated in the context of Picasso's *papiers collés*. The standard approach to the problem has been for quite some time to consider the newspaper fragments as just so many visual signs "concealing texts, arbitrary or not, and which do not require deciphering".[55] Robert Rosenblum, before anyone else, strove, on the contrary, to 'decipher' the press clippings used by Picasso. Beginning with concern over the dating of the works, his approach led to the hypothesis that Picasso deliberately used some of these linguistic fragments as verbal as well as visual puns.[56] According to Rosenblum, these "permutations and combinations, to be understood, often must be *read* as well as *seen*".[57] In fact, cuts, displacements, aggregations of syllables put to use in the *papiers collés* seem actually to belong to the technique of *Klangwitz* – "the joke founded upon sonorities"[58] of which Sigmund Freud wrote: "Words are the plastic material with which all kinds of things are possible".[59] The debate intensified when the reading of the texts led to a decision to assign political weight to their choice by the artist. The confrontation with formalist interpretation thus led to diametrically opposed systems of interpreting the same fact – Picasso's use of a printed text 'upside down': some interpreted it as an expression of an even more radical political critique ("an image of the world turned on its head"),[60] while others saw it as definitive evidence that Picasso's press clippings have to remain 'illegible'. Cautioning against the risk of "intrusive reading",[61] Rosalind Krauss is, among the debaters, in favour of a visual interpretation of the typographic fragments as "an oddly material sign for light, atmosphere and, sometimes, transparency".[62] William Rubin[63] has opted for a pragmatic approach, as has Leo Steinberg. The latter has thus proposed "a distinction between the headlines, the headings and the solid blocks of type", adding, "Pictorially, they are not at the same level",[64] the former being able to serve as 'text' and the latter rather as 'texture'. Providing such an opposition is handled with care, this approach could not only lead to a principled 'reading' of some of the fragments used when in all likelihood their content was not fortuitously chosen, but could also allow for an analysis of their respective visual qualities in a more circumstantiated manner than has generally been the case with the 'formal' side of Picasso's use of them. This is the double discipline assigned to this study of Picasso's work on newsprint since the beginning of the century.





ANY II.—NÚM. 41. / 10 CENTIMS / BARCELONA 7 SETEMBRE 1909

PAPITU

 QUI SEMBRA VENTS... / Han fabricat un monstre artificial, pro que tard o d'hora pendrà vida pera devorarlos.

FONDS PICASSO

26 Picasso working on paper

ANY II.—NÚM. 41. 10 CENTIMS BARCELONA 7 SETEMBRE 1909

PAPITU

QUI SEMBRA VENTS...
Han fabricat un monstre artificial, pro que tard o d'hora pendrà vida pera devorarlos.

FONDS PICASSO

Chapter 1

1893–1911: Typo/Graphic Styles

Childs' papers

Named *Azul y Blanco* and *La Coruña*[1] by the adolescent Picasso, the few specimens of make-believe newspapers he produced in 1893 and 1894 fulfil the dual purpose of offering objects both to be *seen* and to be *read*. The youthful artist proves to be at once both expert in and ironically distanced from the semantic codes of the written praxis of his time. Just as in other fashionable illustrated publications of this period, the juxtaposition of text and image, each developed in the conventional forms of headlines, headings, columns, articles, vignettes and captions, engenders precisely that specific object, the *newspaper*, a composite construction of signs susceptible to a multiplicity of readings. This object can be handled, felt and scanned. If it is to be 'read', the reader must act as a watchman, deciphering and reconstructing his own message. In the case of these pastiches by Picasso for private, familial use,[2] we can observe his humorous vision of the world and his iconoclastic reading of those newspapers with which he was already familiar. Everything comes in for its share of derision, especially the very style of journalistic urgency. *Azul y Blanco* no. 1 (fig. 8) opens with the following announcement: "As this newspaper is going into print/we have as yet received no telegrams",[3] while a "note on current affairs" in issue no. 2 (fig. 11) admits: "Gentlemen, we don't have much to say".[4] The comments on the vignettes are in the same vein. Under a man with an umbrella: "It has already begun to rain and won't stop until summer." The woman next to him, striving to hold her skirt down: "A strong wind has blown up, and will continue until La Coruña is no more." Two conscripts exchange surrealist remarks: "Who can explain to me how cannons go off? (Soldiers are so brutish.) For example, just take a hole, put some iron around it, and you've got one quicker than it takes to say Amen." As for the advertisement "We are buying thoroughbred pigeons: contact Payo Gomez on 14th street, 2nd floor, in La Coruña", the joke is on José Ruiz Blasco, Picasso's father, who liked to compose his canvases using these birds. Picasso's scathing irony is proof of the liberal atmosphere within the family circle, and casts serious doubt on the conventional account of the relations

Fig. 14
Papitu
7 September 1909
Front page
FP 86
Picasso Archives, Musée Picasso,
Paris

between Picasso and his father, who is often reduced to the puny figure of an academic painter-failure. José Ruiz Blasco was a free-thinker who in his youth had mixed with the artistic fringe and the liberal and progressive cliques. In Sabartès's words, "it was a time of *pronunciamientos* and pitched battles, revolutions and uprisings, and political in-fighting between the two republican parties",[5] and Ruiz Blasco was known to have a sharp tongue, a caustic mind and picaresque adventures. This is the atmosphere – political tension, artistic debates and rebellious humour – of Picasso's childhood. In La Coruña, the Ruiz-Picassos made friends with don Ramon Perez Costales, of whom Sabartès remembered Picasso commenting: "Doctor don Ramon, a close friend of my father, was a dyed-in-the-wool republican who became Minister of Labour and Fine Arts. I am talking about the first republic. My first memory of republican flags was at his place; when Piy Margall[6] would come to La Coruña, there was a flag in every window."[7]

It is not known whether the issues of *Un Tros de Paper* (fig. 20) remaining in the Picasso archive were in the family home, and therefore conserved by the artist from childhood, or whether he acquired them at a later date. Of interest, however, is the fact that the layout and draughtsmanship of the vignettes and rebuses of the publication are quite similar to the childs' papers of the year 1894. In the same way, the now-commonly accepted hypothesis is that Picasso transformed the title *Blanco y Negro* (white and black) to *Azul y Blanco* (blue and white), simply substituting his favourite colour blue for black.[8] But, besides this simple borrowing of a title, a close study of the journal also makes it a likely graphic source of the young Picasso's newspapers. Originally based around numerous drawings, *Blanco y Negro*: *Revista ilustrada* offered an opportunity for the best Spanish graphic artists to make names for themselves. The journal set out on an ambitious programme of artistic and literary education: articles on the front pages of the issues of 1892 deal with the Spanish school of painting, Gustave Courbet, Ernest Meissonnier or Victor Hugo. The journal was outstanding, too, owing to its excellent techniques of reproduction. Hollow engraving and stereotypography combined to make a truly fine artistic journal that must have impressed both father and son. Illustrated headlines, grotesques, caricatures, charades, rebuses, special reports and advertisements made up the compositional grid of the journal into which Picasso would delve for his childs' newspapers. The calligraphy of the title *Blanco y Negro* directly influenced *Azul y Blanco*. On the front page of the 1 January 1893 edition of the paper can even be found a variation whereby *Blanco* is in white, *Negro* in black, and where the link '*y*' is in two colours; the very same formula can be found in the two-colour *Azul y Blanco* (fig. 7). The heading of the playful column "*Un poco de todo*" (a bit of anything and everything) is reversed by Picasso into "*Todo revuelto*" (everything upside down). Likewise, the heading '¡PIM, PAM, PUM!' of a humorist's chronicle in *Blanco y Negro* (fig. 3),[9] which challenged "the influence of the press" in whipping up the growing fear of anarchists ("So many telegrams! So much news! How many articles are we seeing these days!"),[10] was used by the young Picasso in the form 'PIN-PAN-PUN' (fig. 5) on both sides of the only issue of *La Coruña*, to which he added several facetious sketches. The layout of *Azul y Blanco* (fig. 5) follows the same principle as the articles

Fig. 15
***Blanco y Negro* no. 62**
Madrid, 10 July 1892
Bibliothèque d'Etudes Ibériques et
Latino-américaines of the University
Paris-Sorbonne, Paris

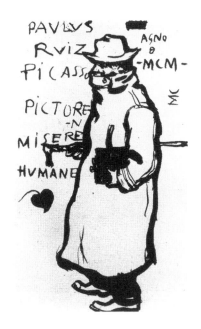

Fig. 16
Pablo Picasso
Self-Portrait
Paris, 1900
Pen and sepia on paper
20.5 × 12.6 cm
Private collection

Fig. 17
Blanco y Negro no. 61
Madrid, 3 July 1892
Bibliothèque d'Etudes Ibériques et
Latino-américaines of the University
Paris-Sorbonne, Paris

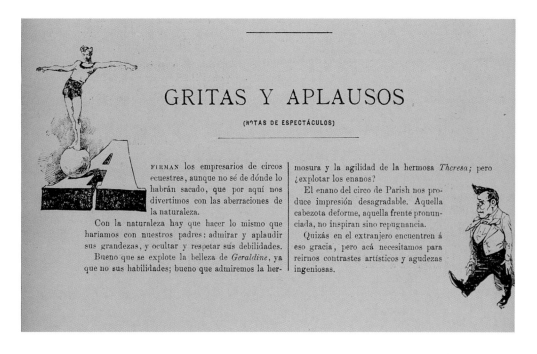

GRITAS Y APLAUSOS

(NOTAS DE ESPECTÁCULOS)

FIRMAN los empresarios de circos ecuestres, aunque no sé de dónde lo habrán sacado, que por aquí nos divertimos con las aberraciones de la naturaleza.

Con la naturaleza hay que hacer lo mismo que haríamos con nuestros padres: admirar y aplaudir sus grandezas, y ocultar y respetar sus debilidades.

Bueno que se explote la belleza de *Geraldine*, ya que no sus habilidades; bueno que admiremos la her-mosura y la agilidad de la hermosa *Theresa*; pero ¿explotar los enanos?

El enano del circo de Parish nos produce impresión desagradable. Aquella cabezota deforme, aquella frente pronunciada, no inspiran sino repugnancia.

Quizás en el extranjero encuentren á eso gracia, pero acá necesitamos para reirnos contrastes artísticos y agudezas ingeniosas.

Fig. 18
Pablo Picasso
Young Acrobat on a Ball
Paris, 1905
Oil on canvas
147 × 95 cm
Pushkin State Museum of Fine Arts,
Moscow

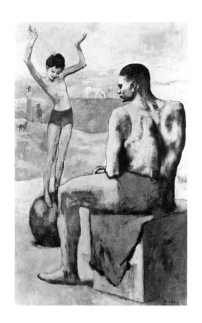

'*Cartas de Verano*' and '*De una carta de Paris*' (fig. 2), published in 1892 in *Blanco y Negro*[11] in the form of handwritten letters punctuated by humorous pen drawings. In a much more pointed way, *Blanco y Negro* undoubtedly acted as a manual of iconography for the young Picasso, leaving a long-lasting mark on his visual formation. There is more research to be done on this point, but two examples will suffice for the moment. *Picasso and Casegemas*,[12] the double portrait in ink and watercolour, dated 1899–1900, and the small self-portrait *Paulus Ruiz Picasso Pictore (*fig. 6),[13] dating from the first trip to Paris in 1900, are both obviously taken from a comical personage drawn by Mecachis, found on the page '*Autoridades Subalternas*' (fig. 15) in an issue of July 1892.[14] Likewise, among other '*Paginas para la historia*' frequently published in the journal by the same graphic artist, there are many silhouettes of students[15] or bohemians, which influenced the spirit and compositions of the portraits of the Barcelonian artistic milieu that Picasso put on show in February 1900[16] at his first exhibition at Els Quatre Gats.

In a different register, mention should be made of the vignette accompanying the article '*Gritas y aplausos*' in another issue of July 1892,[17] depicting a young virtuoso acrobat balanced on a ball leaning against an oblique ornate initial of the word "AFIRMAN" (fig. 17). It evokes the adolescent balanced on a ball in *Family of Saltimbanques*[18] or, even more strongly, the *Young Acrobat on a Ball* (fig. 18).[19] Not only do the posture and the costume recall the newspaper illustration, but the two images also share the same abstract space: in both, the sphere and the angular volume are close to one another: in one it is the stone block, in the other the sharp edge of the letter 'A' lying on the ground. Both images also have in common the play of shadow violently thrown back upon geometrically shaped bodies, and the indefiniteness of an ungrounded environment. The young Picasso in 1892 was probably enthralled by any and all images coming into his possession. Much later, in 1917 in Rome, Serge

Diaghilev, watching Picasso engrossed in an old painting hanging in his front room, enquired, "Pablo, why are you so fascinated by that picture?" The artist answered, "I am studying it closely, in order to learn how not to paint."[20] Such a strong will to distance oneself with the past teamed up in Picasso's case with an exceptionally accurate visual memory, evidence of which came in the reappearance, ten years later, of the graceful androgynous acrobat Picasso had briefly seen in *Blanco y Negro*.

Press Illustrations

The daring front page Picasso devised for the 5 October 1902 edition of *El Liberal*

Fig. 19
Blanco y Negro no. 59
Madrid, 19 June 1892
Bibliothèque d'Etudes Ibériques et
Latino-américaines of the University
Paris-Sorbonne, Paris

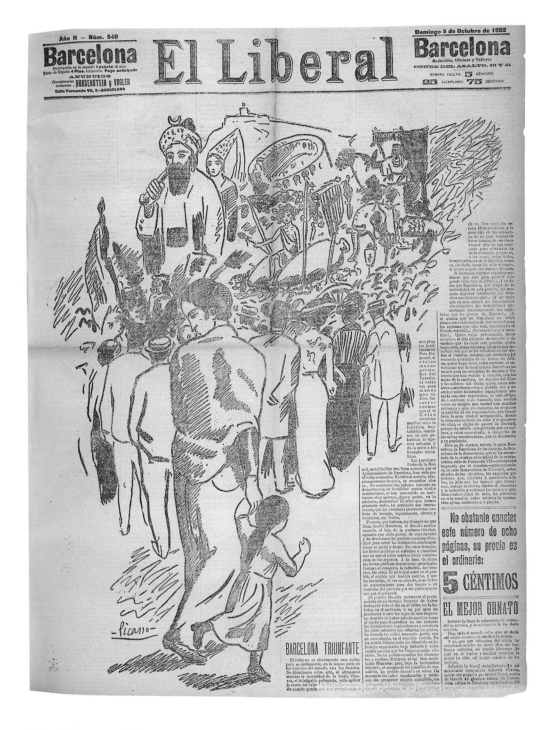

Fig. 20
Un Tros de Paper no. 6
25 June 1865
Picasso Archives, Musée Picasso,
Paris

Fig. 21
Pablo Picasso
Merced Festival
Illustration for *El Liberal*, 5 October
1902
Z XXI, 374
Arxiu Històric de la Ciutat de
Barcelona

(fig. 21) is proof again of his visual mastery, effective from adolescence, of journalistic codes. As Temma Kaplan has pointed out, in that year, during which the repression of the 17 February general strike had claimed many victims among the working classes, the traditional celebration of Merced took on the appearance of a consecration of the return to order.[21] According to Kaplan, this illustration showed Picasso to be "relatively apolitical", painting up "the victimization of the poor, not their courage".[22] In the background the bourgeois crowd is milling around two *gegants* (giant Catalonian puppets) and a parade float carrying Hannibal on an elephant, while the foreground shows a poor woman holding a little girl by the hand. This composition evokes the frontispiece of *Un Tros de Paper* (fig. 20) and an illustration for the Corpus Christi procession published in *Blanco y Negro* in 1892 (fig. 19).[23] The pose of the female figure and the graphic treatment of the folds of her dress relate her to the numerous figures of mothers and prostitutes characteristic of Picasso's 'blue period'.[24] The theme is not devoid of miserabilism, but worth noting is the composition's symbolic aspects, which can suggest a social attitude not confined to resignation: the woman turns her back on the bourgeois-costumed participants in the show – a gesture of defiance – and the tight-knit group formed by mother, daughter and the artist's signature create a physical and affective entity that remains outside the scene. These representations of excluded figures can also be linked to Barcelona's population of beggars and derelicts, composed of the mutilated and repatriated survivors of the Cuban and Philippine wars of 1898. From the formal point of view, this engraved drawing, in its size on the front page and in its relation to the organization of the text, turns the cover of *El Liberal* into a remarkable typo-journalistic manifesto. The hitherto austere daily paper suddenly benefits from the graphic freedom and audacious layout normally reserved for illustrated satirical publications. Lodged against the diagonal of the sheet, the triangular composition does away with the main heading and whittles 'BARCELONA TRIUNFANTE' down to the size of a small caption. The text, contrary to usual practice, is composed of three ascending columns, each taller than the preceding one, and which are each indented in turn to allow for the expansion of the motif. In a lower corner, an advertisement for the newspaper balances the dark tones of the composition. The typographical greyness extends the background hatching, thus giving an almost identical graphic expression to the text and the depicted crowd. Such a textual cut-out, along with the plastic use of lettering, audaciously anticipates the calligrammes of Guillaume Apollinaire[25] as well as the use of typographic columns as the raw material of *papiers collés*.

The two exercises in illustration that Picasso tried out in 1903 in *El Liberal* (fig. 24), and the following year in *La Tribuna* (fig. 25), have analogous traits: in both instances, engraved vignettes placed within the columns depict the works of Auguste Rodin, Eugène Carrière and Puvis de Chavannes, or those of the young painter himself. Such illustrations were still few and far between at the time, generally reserved for official portraits or maps. Not until 1904–06 would the daily press (notably in France) include iconography in their layouts, combining drawings and photography. Picasso

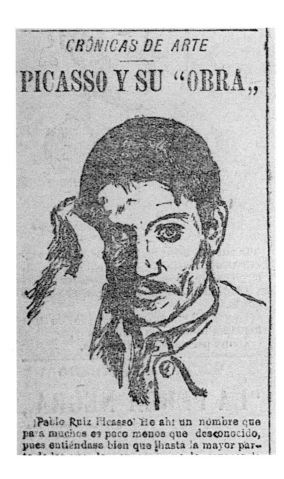

CRÓNICAS DE ARTE

PICASSO Y SU "OBRA"

¡Pablo Ruiz Picasso! He ahí un nombre que
para muchos es poco menos que desconocido,
pues entiéndase bien que ¡hasta la mayor par—

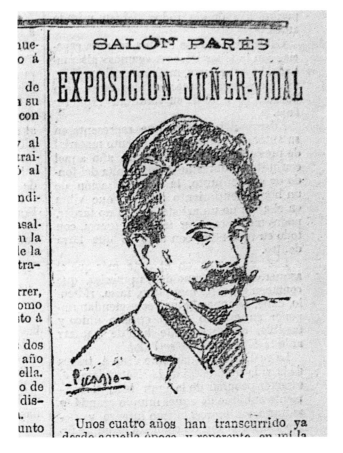

SALÓN PARÉS

EXPOSICION JUÑER-VIDAL

Unos cuatro años han transcurrido ya

opposite: **Fig. 25**
Pablo Picasso
Illustrations for
Miguel Sarmiento's
Article 'Picasso'
La Tribuna, 24
March, 1904
58.5 × 44.7 cm
Arxiu Històric de la
Ciutat de Barcelona

above left: **Fig. 22**
Pablo Picasso
Self-Portrait
Illustration for *El Liberal*, 24
March 1904
58.2 × 43.3 cm
Arxiu Històric de la Ciutat de
Barcelona

left: **Fig. 23**
Pablo Picasso
Portrait of Sebastià Junyer Vidal
Illustration for *El Liberal*, 16
October 1902
Arxiu Històric de la Ciutat de
Barcelona

above right: **Fig. 24**
Pablo Picasso
Illustrations for Carles Junyer-
Vidal's Article 'Art at the
International Exhibition of Paris'
El Liberal, 10 August 1903
58.5 × 44.7 cm
Arxiu Històric de la Ciutat de
Barcelona

NÚMERO SUELTO, 5 CÉNTIMOS

Diario de avisos, anuncios, noticias y telegramas.—Corresponsales telegráficos en todas las capitales de España y principales del extranjero.

Redacción y Administración: Rambla del Centro, núm. 31

La Tribuna

DIARIO INDEPENDIENTE

PRECIOS DE SUSCRIPCIÓN

Barcelona, al mes 1 peseta
Provincias, trimestre 4
Extranjero, ídem 6

Anuncios y esquelas mortuorias
Á precios convencionales

AÑO II.　　　Barcelona.—Jueves 24 de Marzo 1904　　　Núm. 358

EDICIÓN DE LA NOCHE

PIANOS ORTIZ & CUSSÓ

La fábrica española de mayor producción

GRAN EXPORTACIÓN Á AMÉRICA

Talleres, salones y oficinas, Ramalleras, 19 y 21.—DEPÓSITO: Paseo de Gracia, núm. 5

Abajo el telón

Hoy se leerá en las Cámaras el decreto de suspensión de las sesiones. El balance del último período legislativo no es ciertamente para enorgullecer á un Gobierno...

CURIOSIDADES

Superstición.—Ya no es el pueblo ruso el que guarda el privilegio de la superstición...

PICASSO

Es inútil buscarlos. Aquí en Barcelona no hay grupos, ni «capillas», ni granjerías. Cada pintor vive aislado; cada cual trabaja fuera de toda comunión con los demás pintores. Aquí, un bohemio—la palabra sugiere ideas de arte, de compañerismo y de amiga gris, algo risible, puramente decorativo que choca en este aislamiento, desolador para cuantos venimos á la gran ciudad pensando en Barcelona como algo que nos cobijase...

adopted similar layouts in *El Liberal* and *La Tribuna:* a self-portrait of the artist wearing a moustache replaced the bust of Rodin. The drawing *Tragedy* evokes Carrière's couple as well as Puvis's man wearing a backpack. Although the placement of the illustrations is more traditional than on the first page dealing with the Merced celebration, it is nevertheless worth noting the way in which the text, strangely cut out in the form of a cross, closely envelops the self-portrait in profile and the drawing of father and son, or, on the contrary, the way in which it leaves space around the guitar player and the prisoner looking up. Such a sophisticated layout is probably the work of Picasso himself. The scale of the self-portrait and its central position, just above the title PICASSO in bold capitals identical to those of the Egyptian font on the masthead EDICION DE LA NOCHE, give it the property of a visual signature whereby the artist makes the whole page his own.

Commentaries and Graffiti

The period beginning 1902–04, in the course of which Picasso made several contributions to Catalonian newspapers, was also the period in which the first examples of improvised graphic works using major Parisian newspapers as supports appear. Folded in half, the front page of the Thursday 17 October 1902 edition of the *Le Journal*

below left: **Fig. 26**
Pablo Picasso
Three Heads
Paris, 1905
Indian ink on newsprint from *Le Journal,* 17 October 1902
Z XXI, 371
Private collection

below right: **Fig. 27**
Pablo Picasso
Portrait of Alejandro Riera
Paris, 1905
Indian ink on newsprint from *Le Journal,* 17 October 1902
Z XXI, 372/373
Private collection

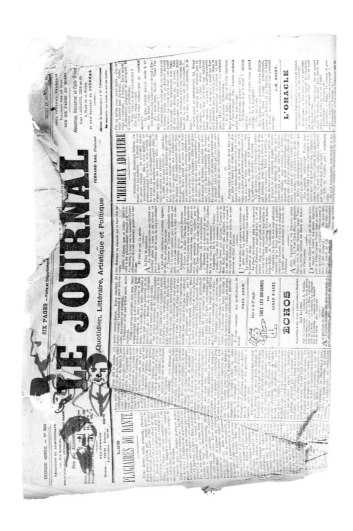

Fig. 28
Pablo Picasso
Study of Three Characters and Annotations to the Article 'Quatuor d'Innocents'
Paris, 1905
Ink on newsprint from *Le Matin*, 20 September 1905
Private collection

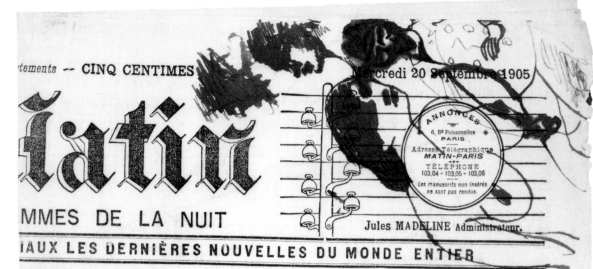
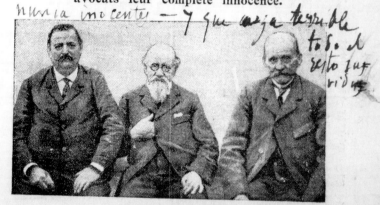

was, so to speak, the 'source book' for two groups of drawings in ink (fig. 26). In the upper section of the newspaper Picasso drew a profile and three male faces. Two of them might well be reminiscent of the work of the Catalonian sculptor Mateu Fernandez de Soto.[26] The third, resembling the studies[27] for *The Prisoner*,[28] is stuck, as if in the grid of a prison-door grille, between the horizontal double line and the Elzévir font of the heading. The solid blacks characteristic of this period's drawings merge hair and hats, and echo the extensive impasto of the typography. Working the page upside down on the other side, Picasso dashed off two caricatures of yet another regular customer of Els Quatre Gats: the art collector Alejandro Riera (fig. 27).[29] In one of the sketches, the stripes of the coat are superimposed on the lines of the text. Projecting forward, the two profiles overrun their frame, reaching the white space of the margin, cruelly underlining the myopia of the model. Three years later Picasso, on the same automatic impulse, filled the front page of the 20 September 1905 edition of *Le Matin* (fig. 28). A group of studies in ink lies next to a handwritten commentary in Spanish by Picasso on an article entitled '*Quatuor d'Innocents*', the story of a battle by former convicts to reverse a court decision. Picasso's double intervention is very revealing of the way he read the newspapers. With text after text, Picasso reacted to the sensational front-page report with a spontaneous gesture of solidarity that did not lack irony: "How funny that these poor people, without ever having been in jail, have never been innocent. And how horrible to live the rest of their lives with that."[30] His graphic improvisations link up in a totally free manner an erotic vision of a naked woman, a drawing of a profile and a sketch of a seated man. Gathered into the right-angle of the sheet, the sketches are superimposed on the printed date and the motif of post and telegraph lines – the emblem of *Le Matin*, the subtitle of which read: "The latest late-night/early-morning

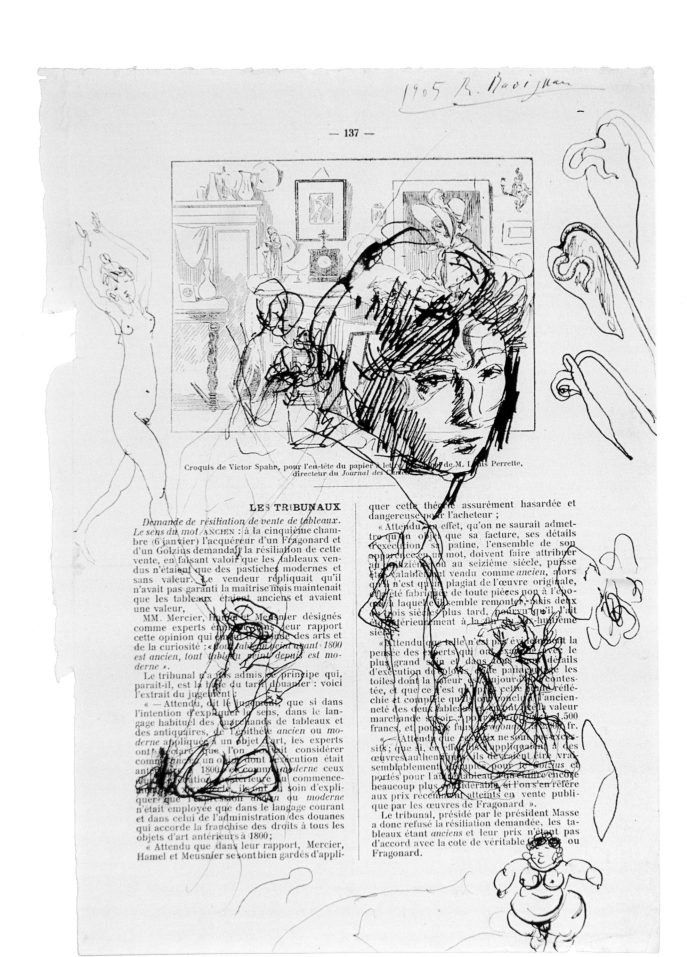

Croquis de Victor Spahn, pour l'en-tête du papier à lettre de M. Louis Perrette, directeur du *Journal des Chiens*.

LES TRIBUNAUX

Demande de résiliation de vente de tableaux. Le sens du mot ANCIEN : à la cinquième chambre (6 janvier) l'acquéreur d'un Fragonard et d'un Golzius demandait la résiliation de cette vente, en faisant valoir que les tableaux vendus n'étaient que des pastiches modernes et sans valeur. Le vendeur répliquait qu'il n'avait pas garanti la maîtrise mais maintenait que les tableaux étaient anciens et avaient une valeur.

MM. Mercier, Hamel et Meusnier désignés comme experts émettaient dans leur rapport cette opinion qui entre dans le monde des arts et de la curiosité : *tout tableau peint avant 1800 est ancien, tout tableau peint depuis est moderne* ».

Le tribunal n'a pas admis ce principe qui, paraît-il, est la base du tarif douanier : voici l'extrait du jugement :

« — Attendu, dit le jugement, que si dans l'intention d'expliquer le sens, dans le langage habituel des marchands de tableaux et des antiquaires, de l'épithète *ancien* ou *moderne* appliquée à un objet d'art, les experts ont déclaré que l'on devait considérer comme *ancien* un objet dont l'exécution était antérieure à 1800 et comme *moderne* ceux dont l'exécution était postérieure au commencement du siècle, ils ont eu soin d'expliquer que l'expression *ancien* ou *moderne* n'était employée que dans le langage courant et dans celui de l'administration des douanes qui accorde la franchise des droits à tous les objets d'art antérieurs à 1800;

« Attendu que dans leur rapport, Mercier, Hamel et Meusnier se sont bien gardés d'appli-quer cette théorie assurément hasardée et dangereuse pour l'acheteur ;

« Attendu en effet, qu'on ne saurait admet-tre qu'un objet que sa facture, ses détails d'exécution, sa patine, l'ensemble de son apparence en un mot, doivent faire attribuer au dix-huitième ou au seizième siècle, puisse être valablement vendu comme *ancien*, alors qu'il n'est qu'un plagiat de l'œuvre originale, qu'il été fabriqué de toute pièce non à l'époque à laquelle il semble remonter, mais deux ou trois siècles plus tard, pourvu qu'il l'ait été antérieurement à la fin du dix-huitième siècle;

« Attendu que telle n'est pas évidemment la pensée des experts qui ont examiné avec le plus grand soin et dans tous ses détails d'exécution de coloris la patine que les toiles dont la valeur est aujourd'hui contes-tée, et que ce n'est qu'après cette mûre réfléchie et complète qu'ils ont conclu à l'ancien-neté des deux tableaux et à leur valeur marchande savoir : pour le Golzius 3.500 francs, et pour le Fragonard 1.500 fr.

« Attendu que ceux-ci ne sont pas exces-sifs; que si, en effet, ils s'appliquaient à des œuvres authentiques, ils devraient être vrai-semblablement doublés pour le Golzius et portés pour l'autre tableau qui réunit encore beaucoup plus considérable, si l'on s'en réfère aux prix récemment atteints en vente publi-que par les œuvres de Fragonard ».

Le tribunal, présidé par le président Masse a donc refusé la résiliation demandée, les ta-bleaux étant *anciens* et leur prix n'étant pas d'accord avec la cote de véritable Golzius ou Fragonard.

telegrams." The network of parallel lines becomes the threaded screen for the bust of a woman, while the circular stamp of the editor centres the composition. This voluptuous nude signalled the end of a period ruled by skinny Harlequins or slender figures like *Woman in a Chemise*.[31] They conjure up the presence of Fernande Olivier, who had just come to live with Picasso on rue Ravignan early in September. Likewise, the woman's profile, worked by means of dark shadows on a clear ground, could be compared to portraits of Fernande,[32] which, conversely, depict a clear face on a background striated with black. The angle of the page sets up the drawing of a male figure who could very well have been jotted down in a café, or perhaps was suggested by the pose of the three prisoners shown in the press photograph. The tracing of the jacket follows the same semicircle as the edge of the stamp. In all these sketches, we can detect the relations established between the blacks of Picasso's pen scratchings, the layout grid of the newspaper and its contrast between typography, drawing and photography.

In the course of this period, 1902–05, it was not unusual for Picasso to cover other types of printed objects with sketches, as he used to do with editions of *Le Journal* or *Le Matin*. Three groups of studies, one done on a leaflet for the French edition of the journal *Onze Kunst* (fig. 29), another on a page of the Spanish edition of *Madame Bovary* (fig. 30), and the third on a page of a journal's legal column, can complete this analysis of the various ways in which Picasso's drawings play with and against typographical forms (fig. 31). The leaflet for *Onze Kunst* gave Picasso the idea for a series of fantasy pieces[33] as counterpoints to the Art Nouveau foliage of the typographical ornamentation (fig. 29). A tear running down the two sheets is reminiscent of a mastaba, where the seeming disorder of the drawing sets up secret symmetries. A landscape of pyramids faces a figure in profile like an Egyptian bearing a lotus leaf, while at the same time representing an ironic response to the angular geometry of a photograph of some modern-day furniture. Drawn horizontally in the lower margin, a pipe-smoking monkey balances the masthead. The other margins feature vegetable motifs evocative of a mask. The page torn from the novel *La Señora de Bovary* carries a drawing, *Kneeling Couple*,[34] of 1905 (fig. 30). The depiction of lovers calls to mind the painting of the same year dedicated to Apollinaire, *The Embrace*,[35] which is assumed to represent a female couple – a theme of several other works of this period.[36] The linear drawing of the figures and their poses is also reminiscent of *Le Bonheur de Vivre* by Matisse, also of 1905, the year of its exhibition at the Salon d'Automne. The ink sketch is in that part of the page left vacant, where it occupies the position normally held by the classical 'illustration'. It is worth noting that this passage from Flaubert's novel begins with a scene of an evening at the theatre in Rouen, an evening that will lead the novel's heroine, Emma Bovary, to her second adulterous affair. The erotic potential of the situation is concentrated in this simple note: "*Emma se compro un sombrero, guantes, un bouquet.*"[37] Could it be the discreetly fetishist evocation of such an outfit that stirred in the artist the sensual dream-state that was the genesis of this sketch? In any case, what should be noted is the obvious formal

homology between the arabesque of the typographic tailpiece and the motif of intertwining legs that it may have inspired. There is a group of studies, also of 1905, which use as their support a printed page with a legal column and an illustration for the letterhead of the editor of *Le Journal des Chrétiens* (fig. 31). In the middle of the sheet is a superb face of Fernande modelled in ink by cross-hatching, similar to a study for *Fernande with a Mantilla*.[38] The drawing is superimposed on an engraved vignette in which a woman wearing a hat can be seen reading in a room cluttered with devotional objects. Fernande's hair extends into a drawing of a mother changing her child. On either side of this are a study of a female nude with raised arms and sketches of strelizzia flowers seen from three different angles. In the lower margin, a few marks represent a reclining body whose head is replaced by a grotesque female nude. The lower section of the page contains a legal column dealing with the case of paintings attributed to Fragonard or Golzius, and to the debate over notions of 'truth' and 'falsehood', 'modern' and 'ancient'. The paper's two columns of text become a kind of grained texture for the sketches of figures that are part of a series of studies for the painting *The Family of Saltimbanques* of 1905.[39]

Cut-Outs

From the period immediately preceding *Les Demoiselles d'Avignon* come three drawings that use, as their support, daily papers of the year 1906. It is an established fact that two of them, self-portraits in pencil, had been executed on the 30 December 1906 edition of *Le Matin*. The source of the third, *Standing Nude Woman*,[40] has now also been identified: it comes from the miscellaneous news section of the 25 December 1906 edition of *Le Journal*. For the first time in these works the newspaper is either torn or cut out following an outline that, in the case of *Standing Nude Woman*, corresponds exactly to the outline of her body (fig. 40). In this work, the drawing is done perpendicular to the direction in which the text is read. The intercolumniation divides the body at the level of the shoulders, waist, pubis, knees and feet (which spill over into the margin) in a way similar to certain proportion studies for *Les Demoiselles d'Avignon*.[41] But this female nude seems to refer to other studies depicting a reclining woman (fig. 39).[42] The shape of the advertisement 'Reveillon au Champagne Prudhomme-Hemery' is found sitting squarely on the thigh, the volume of which it retraces. Likewise, the words "Les Gouttes Livonniennes" and "SOURIRE D'AVRIL" extend this shadow along the leg's calf, the chromatic modulation of the modelling being provided by the typography of the advertisements. This effect is a prefiguration of the use of printer's lettering as "an oddly material sign for light", as Rosalind Krauss describes it in reference to *papiers collés*.

The drawing *Nude Self-Portrait* (fig. 34) belongs with the studies for *Self-Portrait with Palette* (fig. 33).[43] Drawn for the front page of the 30 December edition of *Le Matin*, the figure is bolstered by two printed columns, its tight fists enclosed on each of the vertical lines of the intercolumniation. The line dividing the fragment in half thus becomes the mirrored line whereby the model's back is reflected. Here, too, the

Fig. 32
Le Matin
30 December 1906
Front page
Bibliothèque de l'Arsenal, Paris

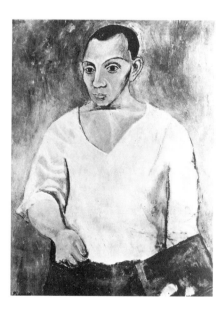

Fig. 33
Pablo Picasso
Self-Portrait with Palette
1906
Oil on canvas
92 × 73 cm
Philadelphia Museum of Art, PA, United States

Fig. 34
Pablo Picasso
Nude Self-Portrait
Paris, winter 1906–07
Black pencil on newsprint from *Le Matin*, 30 December 1906
32.5 × 13.5 cm
MP 527
Musée Picasso, Paris

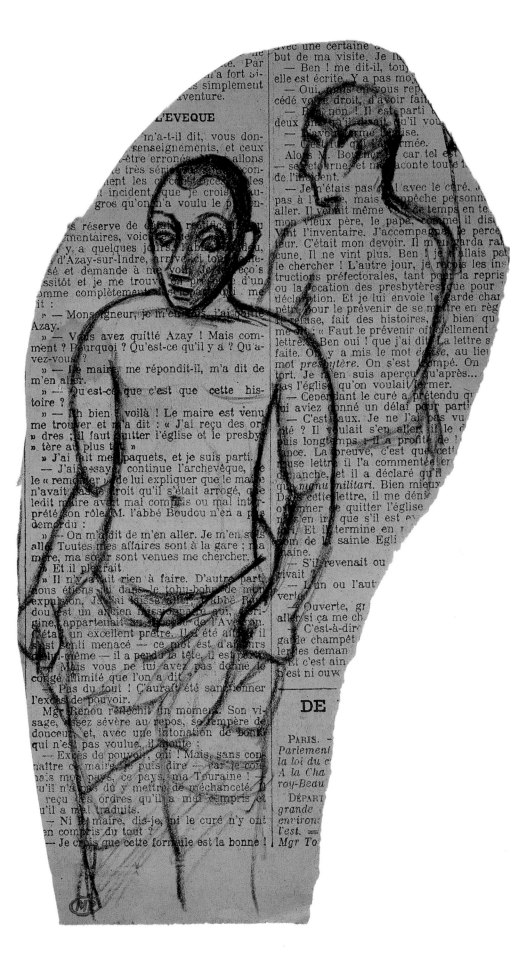

drawing plays with and against the plasticity of the typography: shadowed zones or tracings correspond with full lines, spaces or spacings with clear areas, such as above the eyebrows, the weave of the breast or the white of the belly. As in the previous drawing, the legs disappear into the vacant space of the margin. The paper is cut down the left side along the intercolumniation. The drawing and the cut bring out of the drab ground of the text the heading "L'EVEQUE" [The Bishop] (in the upper right-hand corner, in the heading of the page's main article about an episode in the separation between Church and State, the closing of the church at Azay-sur-Indre), the article "DE" in the lower right-hand corner and, just above it, the word "PARIS" in small capital letters. With this first 'papery' play on words, "*L'Evêque/de/Paris*" may indeed be read as the title bestowed on this nude self-portrait by Picasso. The model also seems to clench with both hands a cloth – a loincloth – similar to the *perizonium* of the crucified Christ. This piece of cloth indicates the artist's sex, situated precisely above the words "*un excellent prêtre*" [an excellent priest]. The reflection in the mirror, moreover, creates a doubling up of the face/profile and underscores the specular nature of this self-portrait. In this respect it echoes numerous studies of this period in which Picasso depicts his own hand executing his self-portrait or bringing the brush to the palette. These various motifs all relate to the same sexual metaphor. Thus in *Self-Portrait with Palette* (1906) the thumb of the left hand, jutting up from the centre of the palette, can be seen quite explicitly as the painter's exposed penis, suddenly uncovered (fig. 33). This theme of the artist undressing so as to enter *qua* his body into his painting, is not mere chance, occurring as it does at the very moment when Picasso, with the *Les Demoiselles*, is on the verge of an unprecedented rupture with the figurative tradition. In a painting of 1914, *The Painter and his Model*, which can be interpreted as an emblem of the return to figurative painting, the model Eva is shown in the nude, and, significantly, she is wearing this same cloth, the cloth of baptism or of death, as if in this painting she had reappeared on the other side of the formal experiments of the Cubist years. In the self-portrait of 1906–07, the painter's body literally emerges from a *textual* veil, but it is impossible to tell if it is coming out or going in. This cloth could be a symbol both of the firmly gripped canvas of a painting that would free itself from illusionism and of the new conceptual space-time that the painter is symbolically charting. Picasso paints himself, in this 'trans-figuration', as at once its victim, priest, enchained slave and redeemer. The phallic form of the paper cut-out, like the thumb jutting out of the palette at the source of the myriad colours, vigorously indicates its direction.

Another fragment from the 'late news' section of the same edition of *Le Matin* features a self-portrait seen from behind (fig. 36) in which, on practically the same scale as in the corresponding part of the *Nude Self-Portrait*, Picasso offers a close-up study of his neck, with an academic style of notation for the outlines and shading. From one drawing to the other, Picasso effects something of a close-up, prompting a closer reading of the surrounding image and text. The intercolumniation and the capitalized word "EXPRESS" are incorporated into the composition. The rather jagged tear of the paper gives this small drawing extra force. It resembles a caricature of a

Fig. 35
Le Matin
30 December 1906
Page 8
Bibliothèque de l'Arsenal, Paris

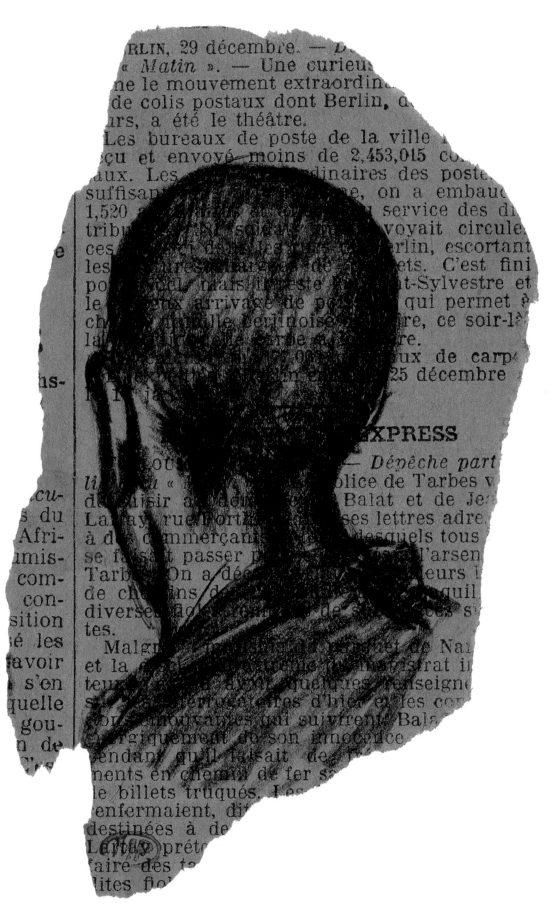

Fig. 36
Pablo Picasso
Self-Portrait Seen from Behind
Paris, winter 1906–07
Black pencil on newsprint from *Le Matin*, 30 December 1906
12.5 × 7.7 cm
MP 525
Musée Picasso, Paris

Fig. 40
Pablo Picasso
Standing Nude Woman
Paris, winter 1906–07
Pen and ink on newsprint from *Le Journal*, 25 December 1906
48 × 31.5 cm
Z XXII, 347
Private collection

Mephistophelian profile. It is, then, a forerunner of the roughly torn-out paper masks and newspaper skulls that Picasso made between 1943 and 1946, or else of the *sombras*, those silhouettes of shadow theatre he had discovered in 1899–1900 in the Barcelonian cabaret theatre Els Quatre Gats.[44] In the drawings of 1906–07, the shapely cut-outs of the depicted woman, the half-naked man and this devil's profile would be three characters in a fairy tale still to be staged. From a formal point of view, a leap has occured: the studies from 1902 to 1905 on newsprint, mere drawings on a backdrop of typographic lettering, leap by means of the cut-out into animation, embodying themselves in the text, at once material, texture and signifying fabric.

Vignettes, Letterheads, Tailpieces

Another series of three drawings on printed paper belong to the period corresponding to the finishing stage of the *Les Demoiselles*. According to Pierre Daix, at this time "it can be proven that whenever Picasso can indulge his habit of taking advantage of the good spots in the papers he happens upon, he does so immediately".[45] Therefore, the date of the supports of printed paper can indicate the chronology of the studies under scrutiny here. On 15 June 1907 the Credit Minier et Industriel published a commercial newsletter announcing the discovery of a new mineral deposit in the Pyrenees; Picasso used the front and back of this letter as support for the *Sheet of Studies*.[46] A pen drawing, *Head*,[47] was executed on the text of an erotically inspired narrative published in the journal *Le Vieux Marcheur* on 23 August 1907.[48] Lastly, an invitation to Othon Friesz's exhibition, which opened on 4 November 1907, features three *Studies of Legs* [49] that belong to the group of geometrical experiments centred around the painting *Three Women*.[50]

The first drawing of this series, *Sheet of Studies* (figs. 41, 42), may be compared to *Sheet of Studies: Portraits of André Salmon*.[51] Adam Gopnik has made the latter into "the art-historical equivalent of the intermediate fossil that is the dream and despair of the paleontologist"[52] and that would, then, provide the link in the process beginning in caricature and ending in the fixation of a primitivist aesthetic prototype. In this analysis, the modelling of the shading becomes, through an "inspired visual pun", "a striated pattern that echoes the scarification of African art".[53] This analysis concurs with William Rubin's, who showed how the two figures of the poet André Salmon and Josep Fontdevila, the innkeeper at Gosol, intertwine throughout a vast group of studies for a sculpture in wood that was never finally executed.[54] Although the precise chronology of this research remains vague, *Sheet of Studies* provides a useful element for dating. A frontal caricature on the recto is lacking in the variation for the portraits of André Salmon, which repeats the morphological vocabulary: big nose with wide nostrils, large cheek bones, sagging chin. The wrinkles in the forehead, indicated by two symbols – circumflex accents – and underscored by a printed capital M, establish the link to the figure of Fontdevila. On the back of the sheet, an animal's profile offers an interpretation of the caricature in the upper corner of the sheet. It becomes the matrix for the archaistic schematization present in the *Sheet of Studies*. This same page has

two other drawings on it: on the left side is what is probably a female nude with arms raised and legs open, on a background of chevrons. Her eyes and hatched nose place the drawing in direct relation to the figure on its right, a prefiguration of the *Nude with a Large Ear;*[55] its face is redrawn on a larger scale on the back of the page. As for the study on the left, it is close in style to the 1907 woodcut *Standing Nude,*[56] characterized by the rugged play of chevronned slashes, several variants of which exist. On the back of the page, the sketch of a male nude with bandy legs evokes the drawing *Standing Nude, Portrait of André Salmon.*[57] Other woodcuts of 1907, such as *Nude with Raised Arms* [58] or *Study for Nude with Drapery,*[59] with their chevronned or ligneous backgrounds, confirm this: the drawing is here a direct preparation for the work of the gouge leaving its grooves in the wood.

Close scrutiny of this page shows how Picasso marshals every feature of the layout of the printed page: margins, blocks of text, recesses *etc*. Thus, the front side of the page, taken horizontally, divides in half. The printed text seems to serve as the basis for the outline of a body seen from the front. On the left, the zone reserved for the date contains a study, supported by the oblique of a printed stamp, which might be the preparatory stage of *Pitcher, Bowl and Lemon*[60] or *Composition with Skull,*[61] as is suggested by the juxtaposition on this page of Fontdevila's/Salmon's head with the pitcher and fruit dish. Appearing again on the right side, the rimmed openings of the pitcher and dish form a surprising echo of the eyes of the scarred face: the large ear almost directly recalls the handle of the pitcher.[62] The signature to the study, "Picasso", complements the anonymous M, establishing the artist as the addressee of this form letter. The telegram quoted at the beginning of the letter from the Crédit Minier announcing the opening of new deposits at the Bentaillou mine also deserves attention. For most readers, the technical language of the engineer is incomprehensible, but here it forms a kind of hermetic poetry, a symbol of an industrial adventure made twice as exciting by the speculative jubilation of the stock-market advertisement. Throughout the text, the deposit is mysteriously described in terms of "banks" and "columns", terms undoubtedly more familiar to Picasso in their printing rather than their geological sense. However, there was no need to know if the deposit in question was gold or coal: it was sufficient to proclaim the impetuous 'bull market' that would be prompted by its discovery. Perhaps Picasso was keen on the metaphorical extensions offered by this promise of stock surplus value in the commercial art world. On the back of the page the written figure "1000" can be deciphered, placed under an expression used to persuade the bank's correspondents to "give them the privilege of [their] orders", and a hardly legible word that is possibly the name "Vollard". At that time Vollard, the art dealer, was in fact finishing payments on his purchase of Picasso's studio stock. But the new artistic vein the artist had undertaken to exploit with the *Les Demoiselles* offered him new vistas. Daniel-Henry Kahnweiler visited his studio at this time, having just convinced the London branch of his family, owners of gold mines in Africa, to let him open a gallery on rue Vignon.[63] As Picasso would philosophically express it decades later: "Ojo: Art means business!"[64]

Fig. 41
Pablo Picasso
Sheet of Studies
Paris, 1907
Indian ink on leaflet of the Société
générale du Crédit Minier et
Industriel
27 × 21 cm
Private collection

Executed on a page of *Le Vieux Marcheur* (figs. 43–45), the superb drawing *Head* (fig. 46) belongs with the studies for *Nude with Drapery*,[65] which, according to Pierre Daix, was finished in September 1907. It is the version in which the head's position in the fold of the arm is the most systematically expressed and in which the face and chin are depicted in the most angular fashion. The reliance on the resources of an atypical support makes it stand out from the series of studies for *Nude with Drapery*. The double typographic line and the Art Nouveau flourish extending it become elements in the hairstyle and the contour of the arm. The difference between the thicknesses of the printed lines, one bold, the other light, prompted Picasso to use two types of line, one thicker than the other. If the text is looked at vertically, the lines provide an equivalent to the hatched background of several of the other studies in the group. Picasso

48 Picasso working on paper

Fig. 42
Pablo Picasso
Sheet of Studies
Paris, 1907
Indian ink on leaflet of the Société
générale du Crédit Minier et
Industriel
27 × 21 cm
Private collection

vigorously stresses the oblique traits of the chevrons and superimposes them over the printed black letters so as to accentuate the modelling. This play of conflicting hatching becomes more acute in *Nude with Drapery*, the yellow/black/grey register of which is not far from the restrained colour palette of this study on printed paper. Truncated by the cut edge of this fragment of *Le Vieux Marcheur*, an engraved vignette (fig. 45) offers a dark pedestal for the face: the neck thus rises out of a mesh of dark and clear rectangles through which the line of a naked arm can be glimpsed. The entire engraving in fact represents a woman seated on a bed, whose pose and bare breast could have prompted Picasso to remember his illustration of a poem by Joan Oliva Bridgman, 'The Complaint of the Virgins', published on 12 July 1900 in *Joventut*.[66] The whole initial structure of the support – the typographic framing, the journal's title, the columns of

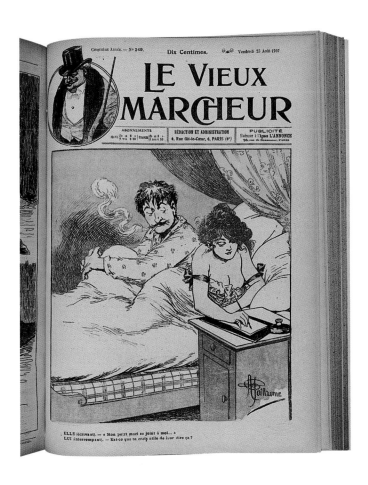

left, above **Fig. 43**
Le Vieux Marcheur no. 249
23 August 1907
Cover
Bibliothèque de l'Arsenal, Paris

left, below **Fig. 44**
Le Vieux Marcheur no. 249
23 August 1907
Page 6: '*Le Repas de l'Ogre*' (The Meal of the Ogre), short story by Montrachet
Bibliothèque de l'Arsenal, Paris

below **Fig. 45**
Le Vieux Marcheur no. 249
23 August 1907
page 7: '*Le Repas de l'Ogre*' (The Meal of the Ogre), short story by Montrachet
Bibliothèque de l'Arsenal, Paris

Fig. 46
Pablo Picasso
Head
Paris, 1907
Ink drawing on page 7 of *Le Vieux
Marcheur*, 23 August 1907
15.5 × 9 cm
Z XXVI, 259
Private collection

text, the illustrations and the angle of the cut – thus form a linear matrix of verticals and obliques from which, logically, appear the triangle of the head and arm, the essential traits that reappear in the final painting. In part hidden by the drawing, crossing the forehead of the figure, the word "*magicienne*" can be made out, underlined by a pen stroke, as if the empty eye sockets, enlivened by the typography and the enigmatic nature of the face, were those of a being doomed to soothsaying and metamorphoses. The flesh of the arm is filled with a paragraph left intact by the artist, and which reads as follows: "I never had a love affair. I loved the woman in women too much to restrain myself to the chain of a single tenderness. I preferred the swindlings and drunken binges when trollops were aplenty, when the brunette and blonde could be kissed at the same time, when you could take delightful baths of lust in heaps of flesh ..." These words can be compared to Gertrude Stein's statement on the raw material of Picasso's pictorial work: "Heads, faces and bodies",[67] which the artist uses in the attempt to build the impossible equilibriums of new creatures: massive women, disarticulated and sculptural, whose radiating tension structures and disrupts the space of the canvas. Transposed into painting in *Nude with Drapery*, hatching produces a depth that, without being annulled, is almost controlled, brought back to the limited relief of woodcut gouges. Here we can observe how scarification and woodcutting inscribe themselves on the body in an identical linear sign, on the printed paper, in the wood of the woodcut, in the background of the painting. In his interpretation of *Les Demoiselles*'s thematic structure, Michael Leja pointed out that this fragment of *Le Vieux Marcheur* (figs. 44, 45) came from a story called 'The Meal of the Ogre', which Picasso is said to have interrupted when the storyteller, rendered impotent by hemiplegia, progressively yielded to the impulse of a kind of olfactory cannibalism: "at length and deliciously, I fed myself delectable juices, with an aroma of almonds and exquisite sweets ..." The woman with raised arms undoubtedly shares the seductive attraction of these "*magiciennes*" with "bare breasts" that haunted the erotic confession of the storyteller.[68] The story of this man with an exhausted libido engaged in the fantasized devouring of female bodies offers a striking image of the barbarian *danse* that Picasso seems to have performed throughout the stages of that pictorial workshop, *Les Demoiselles*. "Love all things, and eat them alive", as the artist went on to say.[69] A constant ambiguity in the male and female figures (signalling a fear of looming castration) is typical of the painting of this cycle. Combining the Salmon/Fortdevila descriptive scheme – the large ear, the reversed '7' of the nose-turned-arm, an androgynous bust and the scarifications – the large figure on the *Sheet of Studies* mentioned above would recur in *Nude with Drapery* as well as in other female nudes of the period.

Studies of Legs (which might date from October 1907; fig. 47) brought to a close this series of drawings on printed paper in the group of experiments on the corporal scheme based on the Salmon/Fontdevila portraits. Half of the invitation, listing works by Friesz, was torn off, and Picasso used the white flap facing it as a full page. All three studies are executed in strict alignment with the lines of the text that seem to be their

Fig. 47
Pablo Picasso
Studies of Legs
Paris, 1908
Pencil and violet ink on invitation to
Othon Friesz's exhibition, dated
4 November 1907
30 × 15 cm
Private collection

pedestal. Just as the typography alternates between regular and italic letters of unequal size, so the drawing combines pencil and violet ink. The alternation between hatching and blank spaces corresponds to the identical rhythm in which lines and spaces between lines follow one another. This discreet correspondence suggests that Picasso's familiarity with the typographic forms may have played a part in his ongoing analysis of corporeal representation. According to Apollinaire, "Picasso studies an object like a surgeon dissects a corpse".[70] The art of the scalpel is nevertheless proximate to the murderous ardour of the ogre's meal. For, as the poet pointed out, anatomy at the time was being "reinvented", and at stake was an actual "assassination" to be carried out "with the science and the methodical application of the great surgeon".[71]

A drawing in Indian ink, entitled *Study of a Man with a Guitar* (fig. 49),[72] possibly dating to 1910, was executed on the bottom of a torn page on which there is a poem by Fabien Colonna, written in October 1909. At this time Picasso was working on a project to illustrate *Saint Matorel* by Max Jacob (published by Kahnweiler) and this study is very close to those centred around the figure of Mademoiselle Léonie. The drawing could then represent, rather than a male figure, a woman with a mandolin, as confirmed by its numerous affinities with the *Portrait of Fanny Tellier* dating from early 1910.[73] The tear in the page reveals the first words, *"De ... exquise de femme"*, which would seem almost Mallarméan were it not for the more ordinary poetics in the remaining text. Picassso's drawing in this case is set slightly off-centre from the column of text, but the vertical line holding the figure up extends the alignment of each verse's initials. The entire hairstyle lies between the last words of the poem and the line indicating the date, while the bottom of the page cuts off the body at an oblique. Here again, light hatchings echo the dull grey of the type. The elegance of this formal composition is on a par with the care Picasso expended on the layout of and illustrations to *Saint Matorel*, as confirmed in his correspondence with Kahnweiler.[74]

The charcoal drawings *Study of a Woman, Head Reclining on Her Hand* (fig. 51)[75] and *Palette* (fig. 50)[76] are both executed on tables of contents of the poetic publications of Editions du Pan. The two pages used come respectively from the December 1910–January 1911 issue and the May–July 1911 issue of *Pan*, "a free-thinking journal appearing monthly", and published by Jean Clary and Marcel Rieu.[77] As in the 1906 nude (fig. 40), the lines of the text cross the female body at the level of shoulders, breast and navel. The bent arm takes hold just above the separating line, whereas the line devoted to the work of Charles Clarisse, *La Loi profonde* [The Profound Law], is tangential to the curve of the skull. This framing and the woman's pose are directly linked to the 1909 paintings, such as *Bather*,[78] or *Woman with a Book*,[79] as well as to studies preceding the latter, in which the head is at times inclined in the opposite direction.[80] It would appear that Picasso reused the motif a year later in a graphic treatment paving the way to the next stage of analytic Cubism. In the right-hand corner of the page, a tiny geometrical study systematizes the landscape motif – a triangle set on two fluted vertical lines – which, on the same spot, closes off the space

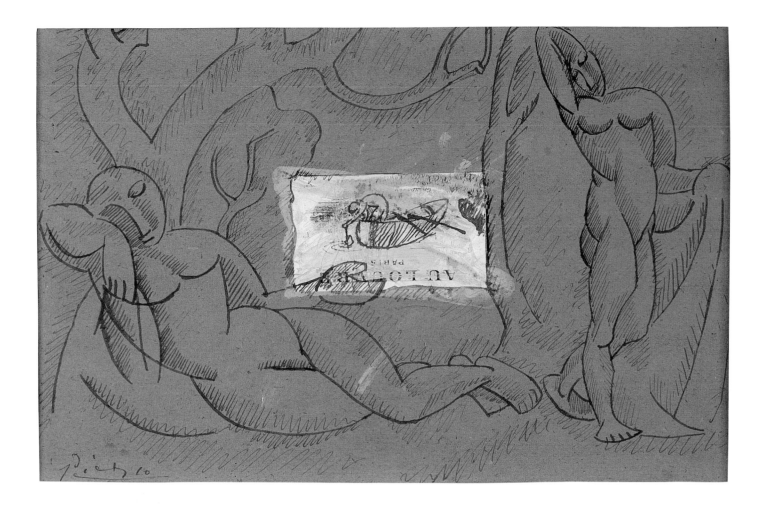

Fig. 48
Pablo Picasso
The Dream
Paris, 1908
Pen, ink, gouache and collage on
cardboard
45.5 × 26 cm
Z II*, 66
Private collection

of *Woman with Book*. For *Palette*, Picasso also used the block of text as a background for his drawing, in which the circular motif is exactly centred between the title and the lower line. The lettering: "PICASSO ARTISTE PEINTRE 11 BD DE CLICHY"[81] uses the same bold type as that used for the line "AUX EDITIONS DE PAN". The palette, although part of the major emblematic stages on Picasso's creative route – the *Self-Portrait 'Yo Picasso'* of 1901,[82] the *Self-Portrait with Palette* (fig. 33) of 1906 or the photograph *Self-Portrait with 'Man Leaning on a Table'* of 1915–16[83] – does not belong to the group of the most commonly recurring symbols in Picasso's art. A formal equivalent could be found in the small targets of newsprint on several *papiers collés* of the spring of 1913 in Céret, [84] where they indicate the sound hole of the guitar (fig. 87). On the other hand, the guitar can frequently be interpreted, in the work of the Cubist years, as the metaphorical sign of the painter's instrument *par excellence* and as the most common synonym of the palette. Sharing a sexual symbolism, guitar and palette constitute a planar surface punctured by a circular orifice through which the artist's finger surges up into the third dimension. This paradoxical erectibility of the guitar/palette will materialize literally in the 1912 *Guitar*,[85] in which the instrument's sound hole is marked by a jutting metal cylinder. During his apprenticeship Picasso was already expressing an ambivalent conception of such an object in the ironic caption to a drawing for *Azul y Blanco* giving instructions for cannon construction: "For example,

you take a hole and put iron all around it ...”[86] Later, the palette would take on a more classical appearance, as for example in the drawings of 1930–35 around the theme of the painter and his model.[87] But in 1938 the palette/text motif of this 1911 drawing was brought together in large still lifes[88] depicting the palette and the printed page, open book or half-folded newspaper. These compositions, placed in the harsh light of a candlestick, are all dominated by a bull's muzzle stuck on a Cubist pedestal; three paint-brush *banderillas* force their way through the palette. These are references to the symbolic vocabulary of *Guernica* and to the events of the Spanish political drama unfolding each day in the pages of the daily newspapers.

The period preceding the invention of the *papiers collés* ends with several drawings of the summer of 1911, executed on the headed paper of coffee shops of the Céret region in French Catalonia. Three studies of a woman in the Musée Picasso collection thus use the headed paper of the Grand Café as a support (figs. 52–54). An Indian-ink composition, *Cubist Still Life: Apple*, was drawn on the letterhead of the Hôtel and Café Gardes in Arles-sur-Tech, located in the eastern Pyrenees. Here Picasso used sheets on which the company name and address were, so to speak, the typographical emblems of the place. A feeling of the provincial resort combines the Mediterranean sound of the family names (Gardes, Justafré ...) and the ceremonial elegance of the lettering. The costumed Céretonians, sewing or knitting – Picasso found these thematic sources on regional postcards[89] – are here reduced to Cubist diagrams aligned on identical pages of Café Gardes letterhead. In *Cubist Still Life: Apple* (fig. 55), the entire composition seems to spring from the letterhead motif incorporated as one of its elements. The flowery stamp cutting across the horizontal label bearing the name “Gardes” produces a series of circles of unequal diameter, imparting a rhythm of sorts to the surface of the paper. In the right-hand section of the drawing, these circles are cut into by cylinders – this happens twice – as if, by giving it a volumetric translation, Picasso had given a latent thickness to the letterhead. Similarly, the technique of horizontal comma hatching, while a trait of the Signac style both Braque and Picasso were trying out at the time, also increases the delicate interlacing of the foliage in the hotel logo. Of interest, too, are the capital letters of “GARDES”, reigning here as the major visual element in the composition. If this drawing was in fact done in Céret during the artist's first stay there in 1911, as is probably the case, then it would help to specify the chronology of Braque and Picasso's respective inventions. Pierre Daix has pointed out that the latter's *Still Life with Fan (L'Indépendant)*,[90] dating from the same stay in Céret, was the first to contain this “new object: the newspaper with its heading”.[91] At this stage, the gothic letters of the Catalonian daily's title, *L'Indépendant* remain nevertheless ‘imitated’ by brushwork. At the same time, Braque's contribution to the painting *Le Portugais* would have been to have kept the typographic motifs in their “mechanical aspect of type by doing them in stencil”.[92] In Picasso's *Cubist Still Life: Apple*, however, the incorporation of a pre-existing typography inserts the printed word in a much more direct and radical way, both “a quite remarkable reference to the real” and as an “absolute graphic invariant”.[93] Having

Dè...
Exquise de femme,...
Avec votre cœur pour partager votre vie.
Tandis que dans le soir précoce les aromes
Agrestes sont plus frais, que la pourpre et les chromes
Du couchant se dissolvent avec l'heure brune
Où monte au ciel d'automne un blanc quartier de lune,
Nous attendent en la calme pièce fleurie
Les lampes, le fauteuil, la bonne causerie.

Fabien Colonna.

Château de Naudet. Octobre, 1909.

shunned any imitation or modification of this sign, Picasso thus anticipated the procedure of spatio-temporal selection or displacement epitomized in the 1912 "revolution of the *papiers collés*". It is far easier to understand how quickly the artist went from painting with Braque's stencil technique to the collage of a postmarked stamp in *The Letter*,[94] or that of a piece of oilskin in *Still Life with Chair Caning*.[95] For, with the drawing studied here, as with all his previous experiments in confrontation between graphic gesture and printed sign, Picasso had already made the question of the relation between letter and image his own. Not limited to the role of formal quotation, typographic lettering was already for Picasso a "reference to the real",[96] an object-sign and a signification of the current state of the world.

AUX ÉDITIONS DE PAN

BOYER d'AGEN. — **La Légende Hugolienne.** 1 volume in-8°
illustré. Prix **3 fr. 50**

CHARLES CLARISSE. — **La Loi profonde.** 1 volume in-16.
Prix. **3 fr. »»**

ÉMILE COTTINET. — **Le Livre lyrique et sentimental.**
1 volume in-16 carré. Prix **3 fr. »»**

JEAN CLARY :
 D'Or et de Soleil. 1 volume in-16 carré. Prix . . **2 fr. »»**
 Quelques lames de la mer sauvage. Une plaquette, petit
 in-16 à l'italienne. Prix **» fr. »»**

JOEL DUMAS. — **Quatorze poèmes pour exciter mon dé-**
sir. Une plaquette in-16 carré **1 fr. »»**

VIENT PROCHAINEMENT :

ROBERT SCHEFFER. — **Plumes d'aigles et plumes d'oies.**
1 volume in-16 carré. **3 fr. 50**

FERSEN. — **Paradinya.** Une plaquette sur papier de luxe in-4°,
avec couv. de Belkowski, tirage à très petit nombre **3 fr. »»**

POUR PARAITRE :

A.-R. D'YVERMONT. — **Les Soirs pensifs** (poèmes).

ALBERT MERCADER. — **Fulvio** (légende dramatique).

MARCEL RIEU. — **Méandres.** 1 volume in-24 coquille.

HENRI MAASSEN. — **Mes après-vêpres.** Une plaquette in-16
 à l'italienne.

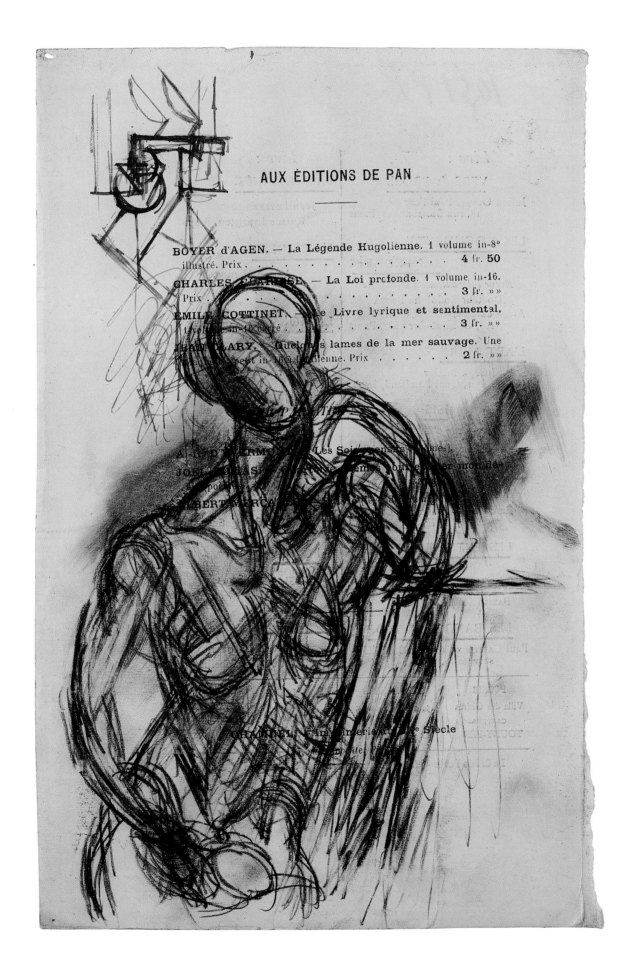

AUX ÉDITIONS DE PAN

BOYER d'AGEN. — La Légende Hugolienne. 1 volume in-8°
illustré. Prix 4 fr. 50
CHARLES FOARESE. — La Loi profonde. 1 volume in-16.
Prix . 3 fr. »»
EMILE COTTINET. — Le Livre lyrique et sentimental.
1 volume in-16 carré 3 fr. »»
JEAN LARY. — Quelques lames de la mer sauvage. Une
. petit in-16 Hollienne. Prix 2 fr. »»

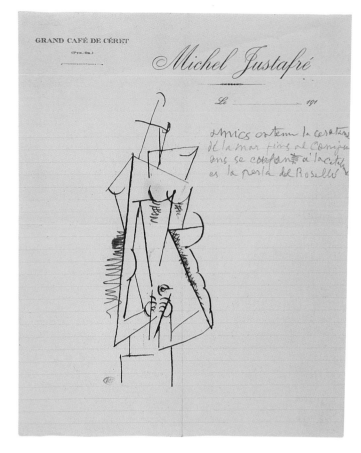

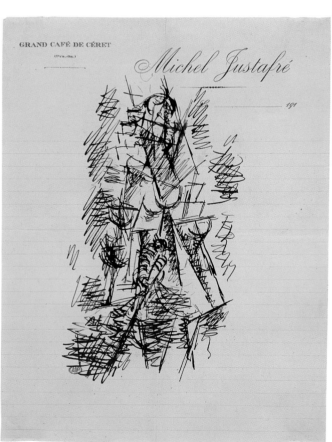

above left **Fig. 52**
Pablo Picasso
Study of a Woman
Céret, summer 1911
Pen and brown ink on headed
lined paper of the Grand Café de
Céret/Michel Justafré
26.8 × 21.4 cm
MP 654
Musée Picasso, Paris

above right **Fig. 53**
Pablo Picasso
Study of a Woman
Céret, summer 1911
Pen and brown ink on headed
lined paper of the Grand Café de
Céret/Michel Justafré
26.8 × 21.4 cm
MP 653
Musée Picasso, Paris

left **Fig. 54**
Pablo Picasso
Study of a Woman
Céret, summer 1911
Pen and brown ink on headed
lined paper of the Grand Café de
Céret/Michel Justafré
26.8 × 21.4 cm
MP 655
Musée Picasso, Paris

opposite **Fig. 55**
Pablo Picasso
Cubist Still Life: Apple
Arles-sur-Tech, summer 1911
Indian ink on sheet of headed
paper of the Hôtel et Café
Gardes, Arles-sur-Tech
30.5 × 19.5 cm
Z XXVIII, 22
Private collection

HOTEL & CAFÉ

GARDES

Arles-sur-Tech,

(Pyrénées-Orientales)

19

62 Picasso working on paper

Chapter 2

1912–13: Press Clippings

During the exhibition *Picasso and Braque Pioneering Cubism* at the Museum of Modern Art, the debate on the genesis of the *papiers collés* touched on the possible anteriority of an ink and gouache drawing by Picasso dating from 1908, entitled *Bathers* (fig. 48).[1] This drawing contains at its centre a label from the large department store Magasins du Louvre. Agreeing with Pierre Daix,[2] William Rubin proposed to consider this drawing "the earliest *papier collé* ... though an inadvertent one".[3] Christian Gheelhaar does not agree that the label was added by Picasso, but sees it as an integral part of the cardboard advertisement on which the drawing was done. Consequently, Rubin proposed to consider it a "*papier collé trouvé*" proving, at least, Picasso's precocious "collage instinct".[4] The words "AU LOUVRE/*Paris*"[5] are visible beneath the white gouache, and refer ironically to the great museum while simultaneously helping to set out the clear rectangle of the label and to make it into a drawing *en abîme*. Pierre Daix stresses this fact:[6] within this post-Cezanne composition, the motif of the figure leaning over the rowing-boat is an explicit quotation of the squatting woman who, in the full light of day, fills the background of Edouard Manet's *Déjeuner sur l'herbe*. The effect of a luminous break-through born of the contrast between the matter of the cardboard and that of the printed label "as a spatial indicator, plays an essential role in this miniature composition's realization of depth and its visual relationship with the broader one".[7]

Revue in Three Acts

Leaving aside the case of this "accidental discovery",[8] whereby collage, commercial printing and drawing carry on a dialogue across the abyss separating high and low culture, the actual invention of the *papiers collés* was at the end of 1912. On 23 September 1912 Picasso sent a telegram from Sorgues to Daniel-Henry Kahnweiler: "We are leaving Avignon this evening at 9.57. Kind regards, Picasso." Once in Paris, he settled into his new studio at 242 boulevard Raspail. On 9 October he wrote to Braque: "I am using your latest papery and powdery procedures ...". He specified that "I am imagining a guitar and using a little dust on our horrible canvas ...".[9] William Rubin[10]

Fig. 56
Pablo Picasso
Violin
Autumn 1912
Coloured paper, wallpaper and piece of newspaper pasted on cardboard, charcoal
65 × 50 cm
MP 367
Musée Picasso, Paris

links these statements to Picasso's work on *Guitar and Musical Score*,[11] which contains fragments of wallpaper and scores and was thus the first of the artist's *papiers collés*. Rubin also links these statements to the cardboard construction *Guitar*.[12] The first work to include a press clipping, *Guitar, Sheet Music and Glass*[13] is, on the other hand, slightly later, since it includes a piece of the 18 November 1912 edition of *Le Journal*, with the headline "LA BATAILLE S'EST ENGAGE …" (THE BATTLE HAS BEGUN …). In fact, the ten or so *papiers collés* (notably fig. 56) catalogued by Pierre Daix following this work[14] could have been done between October and the end of November 1912, concurrent with the completion of *Guitar* and accompanying the development of the 'constructive' novelty of that work. This process initiated a series of large drawings done mainly in charcoal, on which Picasso pasted newsprint clippings.

Picasso's procedure is made known to us though three photographs taken of these works during their execution. I have insisted elsewhere[15] on the highly concerted

Fig. 57
Pablo Picasso
Installation of** papiers collés **in the studio at boulevard Raspail, no. 1
Paris, winter 1912
Print from original glass negative, no. 112 (9 × 12 cm)
Picasso Archives, Musée Picasso, Paris

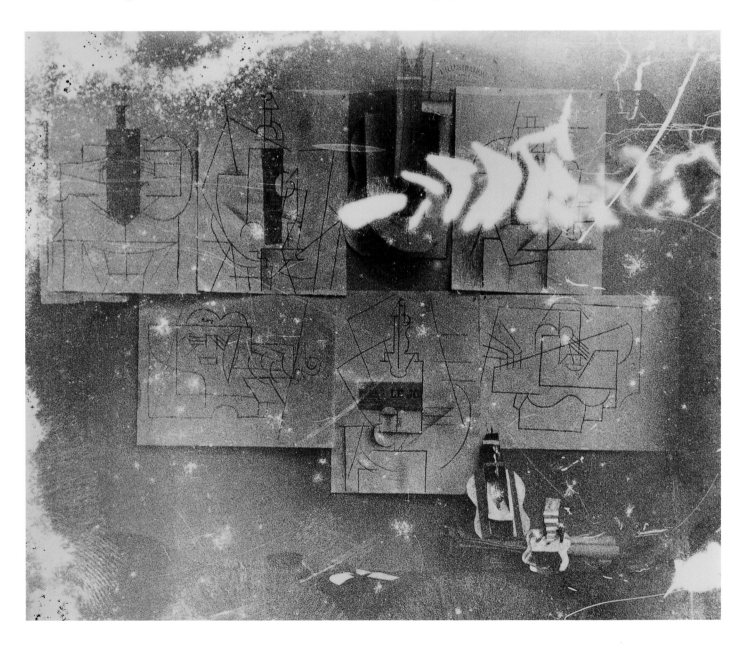

nature of this spatial staging, wherein the camera records the work in progress while simultaneously playing a role in it. Photography intervenes as a kind of spatial as well as temporal cutter: the photographic act interrupts the energy of the productive process, allowing the artist's gaze to 'distance' its object, in the Brechtian sense of the term. Analysis of this sequence is therefore all the more interesting in that time is at the heart of the project: both through the index of current events introduced by the newspaper fragments and in the productive concatenation of one work to the next.

The chronology of the sequence of photographs can be precisely reconstituted using the dates on the press clippings used. The first shot (fig. 57) to have been taken would undoubtedly be the one for which the negative was recently found in the Picasso archives. In it, the works can be seen hanging on two levels: on the upper level, from left to right, are the *papiers collés Bottle and Violin on a Table* [16] and *Bottle and Glass*,[17] the cardboard construction *Guitar*, a cover of the journal *L'Illustration* and the *papier collé Bottle and Glass*.[18] On the lower level, from left to right, are a drawing that cannot be identified in either the Zervos or Daix-Rosselet catalogues, *Bottle, Cup, Newpaper*[19] and *Guitar on a Table*.[20] Besides this last work, which would be completed by the addition of a piece of ruled paper, these *papiers collés* were photographed in their definitive state and that the press clippings used are all dated 3 or 4 December. On the floor are two cardboard constructions, both called *Guitar*,[21] as well as paper fragments that attest to the fact that the shots followed closely on the execution of the works. This viewing by photography could be considered something of a trial run for the works, testing their constructive effectiveness.

The second photograph in the chronological sequence (fig. 58), published by the *Cahiers d'Art* in 1950,[22] was for a long time thought to be the first. Following the same disposition as the preceding example, the following works are grouped together, pinned up and thus in part superimposed: the completed drawing *Violin and Fruit Bowl*,[23] the outline of *Violin*[24] as it appeared prior to the affixing of pieces of newsprint, the 'construction' *Guitar*, the cover of *L'Illustration* and the drawing *Guitar*.[25] On the lower level, from left to right, are the *papiers collés Bottle and Glass on a Pedestal Table*,[26] *Bottle, Glass and Newspaper on a Table*,[27] *Head of a Man with Bowler Hat*[28] and lastly *Composition with Violin*. While the other works contain clippings from 3 and 4 December, this last *papiers collé*, which is listed neither in Zervos nor in Daix-Rosselet, contains a press clipping dated 8 December 1912.[29] On the floor are four pieces of paper and newsprint, one of which displays the letters "URNAL" taken from *Le Journal* heading. I wish to draw attention to this fragment, dated 18 November 1912, because of the phrase "E FURIEUSE ...ALDJA", which was missing from the headline "LA BATAILLE S'EST ENGAGE"[30] used in *Guitar, Sheet Music, Glass* (the complete title is, in fact: "LA BATAILLE S'EST ENGAGEE FURIEUSE SUR LES LIGNES DE TCHATALDJA" ["The battle has begun in fury on the Tchataldja lines"]. This photograph, moreover, ascertains, for a work in progress such as *Violin*, that the drawing was begun prior to the pasting of the pieces of paper and that the charcoal lines were later moved or extended on to the piece of newsprint. *Composition with Violin* (at the lower right side

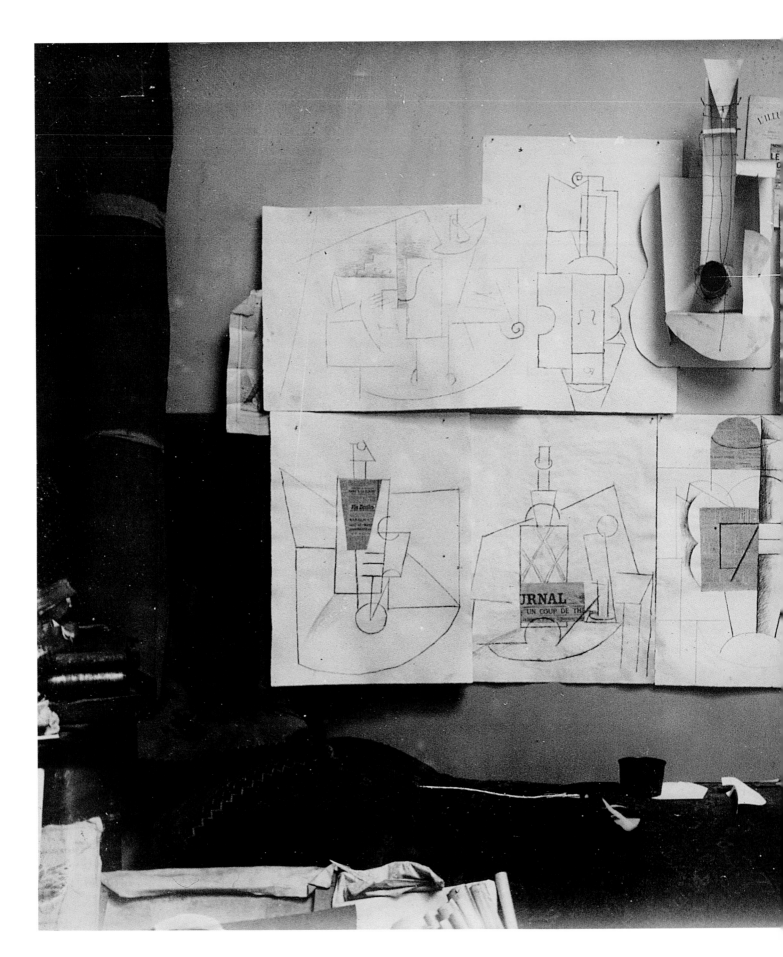

66 Picasso working on paper

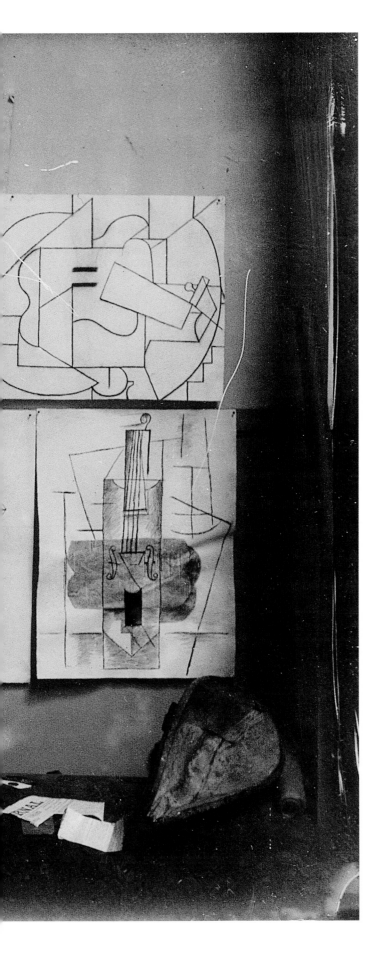

Fig. 58
Pablo Picasso
Installation of papiers collés *in the*
studio at boulevard Raspail, no. 2
Paris, winter 1912
Gelatin silver print
8.6 × 11.5 cm
Private collection

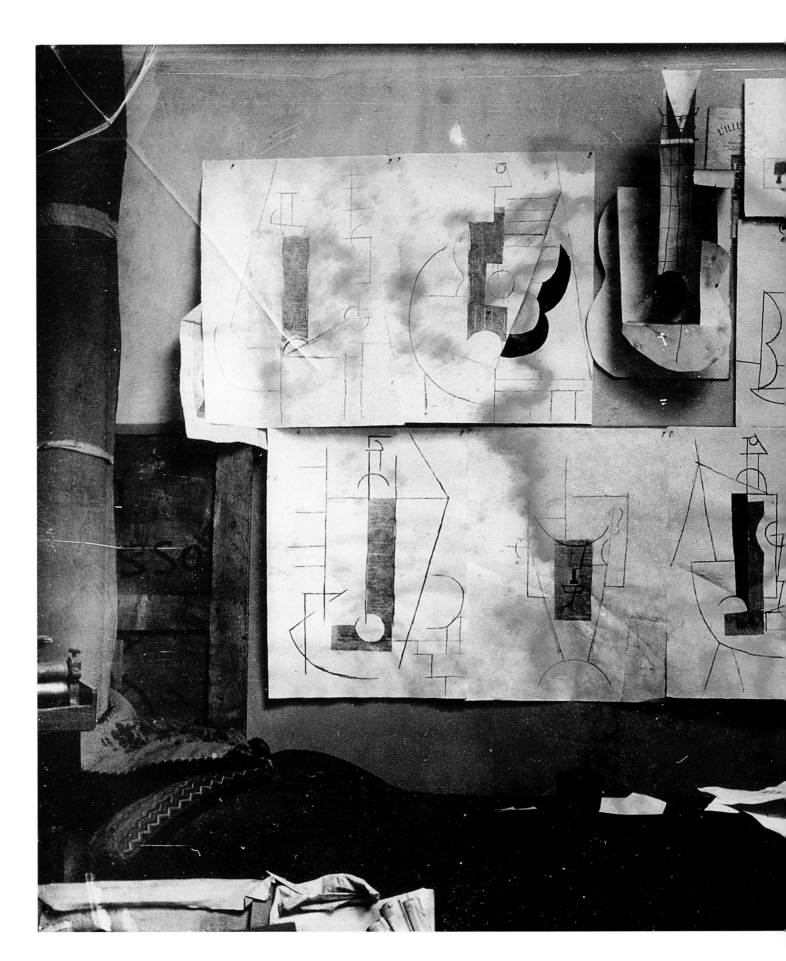

Fig. 59
Pablo Picasso
***Installation of** papiers collés *in the
studio at boulevard Raspail, no. 3*
Paris, winter 1912
Gelatin silver print
8.6 × 11.9 cm
Private collection

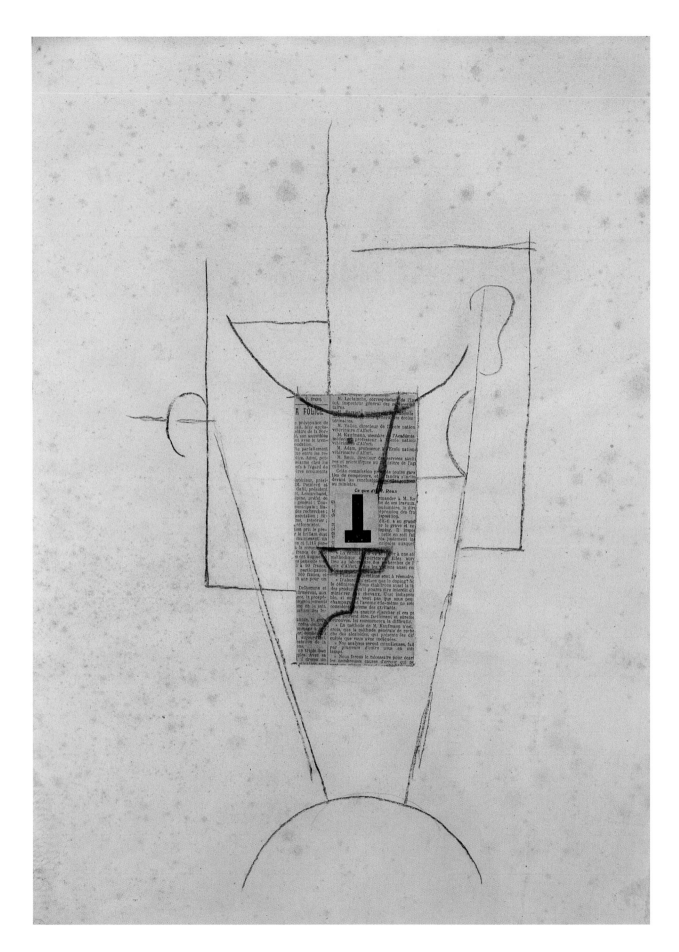

Fig. 60
Pablo Picasso
Man's Head
Paris, December 1912
Pencil on piece of newsprint pasted
on paper
63 × 47 cm
DR 538
Donated by Genevieve and Jean
Masurel
Musée d'Art Moderne de Lille-
Métropole-Villeneuve d'Ascq, France

of the photograph) juxtaposes an element of newsprint and pencil lines, indicating, by hatching, the shadow or the structure's suggestion of depth. It would therefore be excessive to assign to the typographic material the function of a plastic materialization of depth or chromatic modulation.

The third and last photograph (fig. 59) displays, in the same disposition as before, at its upper level, from left to right, the *papiers collés Bottle and Glass*[31] and *Bottle and Guitar on a Table*,[32] the construction *Guitar*, the journal *L'Illustration*, two smaller-sized superimposed drawings (the one on top was dated 1909 by Christian Zervos)[33] and the drawing *Bipartite Violin*;[34] on the lower level, following the same order, *Bottle on a Table* (fig. 64),[35] which Pierre Daix dates to slightly before 10 December 1912, *Man's Head* (fig. 60),[36] *Bottle and Glass on Pedestal Table*[37] and *Man's Head*.[38] On the studio floor, in a foreground section that has been more closely examined following recent access to the original prints developed by Picasso, are several large piles of paper, clippings and a bucket – of glue, no doubt. Close scrutiny of the photograph has led to the identification on these sheets of two other *papiers collés*: *Bottle and Glass on a Table*,[39] here in its final state, and, visible beneath, the lower right angle of *Bottle and Glass on a Table* [40] (the charcoal touch-ups depicting the table legs are clearly visible, whereas the piece of newsprint of 14 December 1912, pasted in the middle of the composition, cannot be seen here).

Given the date of the latest clippings appearing in the photograph, we can consider that it cannot have been taken prior to 9 or 10 December 1912, and, if *Bottle and Glass on a Table* was already completed, then the photograph would date from later than 14 December. Likewise, given the newspapers used and their dates, the first photograph would have as its *terminus post quem* 4 December and the second, 9 December. The presence in these photographs of fragments of newsprint waiting to be used in collage, the bucket of glue, the sheets piled up waiting to be hung on the wall or having just been taken down, confirms, moreover, the hypothesis of a work in progress developing in a short period of time and for which the newspapers dating from the middle of November or the beginning of December would have been used simultaneously. It can thus be observed, in the second photograph subsequent to 8 December, that the *papier collé Guitar, Sheet Music, Glass*, if it includes a clipping from 18 November, has just been completed because the cut-out from *Le Journal* can be seen falling to the floor; its execution is therefore concurrent with that of the other drawings shown in the photograph, especially *Violin*, which, as yet unfinished, contains the clipping dated 9 December. If only for a period no longer than a few weeks, this would support the thesis according to which Picasso "had a lot of different newspapers lying around the studio which he used almost like a palette".[41]

Picasso's photographic recording of what were undoubtedly the inaugural sessions of the invention of the *papiers collés* allows, moreover, the following observation: out of the seventeen works, completed or in progress, exhibited on these three successive hangings, only five used clippings dealing explicitly with the Balkan War;[42] the other drawings were either left in their uncompleted state, or glued on to adver-

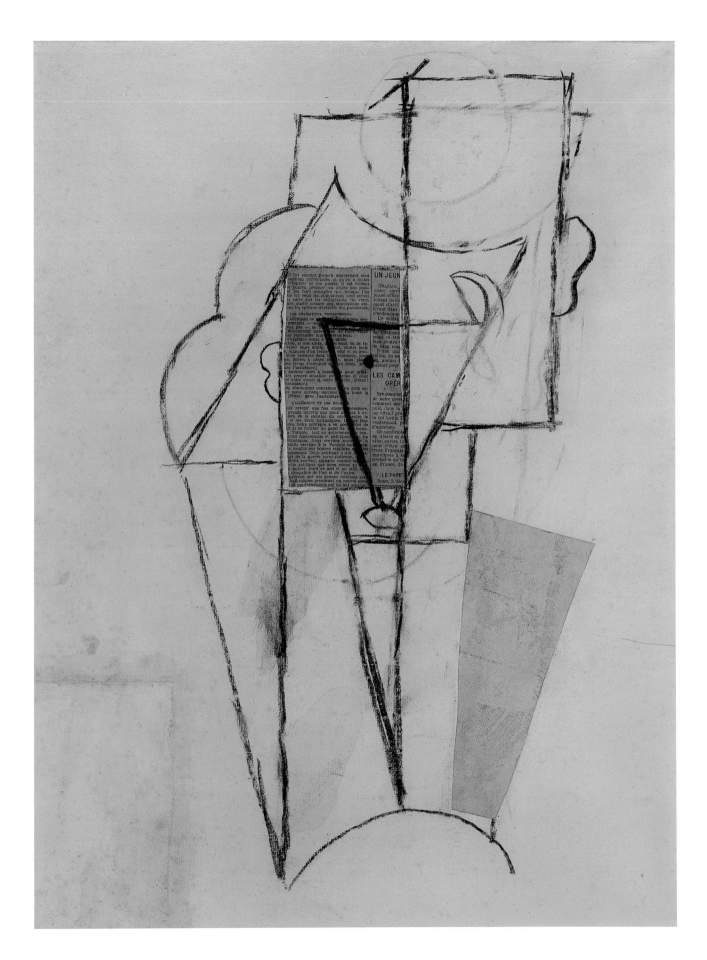

tisements or miscellaneous news (*faits divers*) clippings. According to Patricia Leighten, references to the Balkan War appeared in more than half the works of 1912–13, including the newspaper pieces.[43] The references to this major current event of the day are not then to be considered negligible or purely fortuitous. They remain nevertheless too partial to justify an interpretation that makes this sequence into a political manifesto. As David Cottington has pointed out, many *papiers collés* play on the juxtaposition within a single clipping of "background/public events and foreground/private concerns".[44] A similar dissonance can be observed within the series executed at the boulevard Raspail and, as Jeffrey Weiss would have it, the references to current wartime events take on an importance similar to the references made by music-hall shows and parades, in which the major political events as well as the society gossip of the year gone by pass in a revue, like a *journal joué* (a staged journal).[45]

Positive/Negative

The Indian-ink drawing *Violin*[46] (fig. 62) accompanied the photographed work sessions of late 1912. Instead of applying the newsprint to the drawing, here the drawing, following the example of the works of 1906–07, is superimposed on to the press clipping. The drawing is lodged along the width of the printed column, using the margin and other unprinted spaces, including the intercolumniation and the horizontal spaces, to construct the motif of the violin. The printed text provides the basis of the orthogonal geometry of the space: upper and lower, right and left, can be deduced in the same way that the two-dimensional nature of the surface ends up reasserting itself.

This drawing can lead to a closer reading of the use of newsprint in the *papiers collés* themselves. During the winter of 1912–13, the clippings, used either in the direction of reading or the other way around, were positioned vertically. This placement follows the initial layout of the newspaper. The cut-out blocks out the background of the columns of the text and generally respects the imperatives of legibility. Likewise, the heading, and the front-page headline, despite their new framing, remain perfectly identifiable. *Glass and Bottle of Suze*[47] and *Fruit Bowl with Fruit, Violin and Glass*[48] weave the strips of newsprint into a solid pictorial surface. There was to be, in 1913, a variant of this principle applied to sculpture with the construction *Violin* (fig. 85). The vitality of the journalistic layout can be substantiated in *Bottle on a Table* (fig. 63),[49] which, exceptionally, uses a full page of the 8 December 1912 edition of *Le Journal*. Turning the page devoted to the "Economic and Financial Week" upside down, Picasso masked the two centre columns with the superimposition of a white paper cut-out. Conversely, in the 'positive' version of this *papier collé*, *Bottle on a Table* (fig. 64),[50] a printed column takes up the equivalent space, likewise cut out at the junction of heading and text. More generally, it can be observed in the *papiers collés* that, if the column is sometimes incised, cut on the bias or as a trapezium, the vertical or horizontal line of the printed type and the margins of the lines continue to control the space of the drawing (fig. 61). This discreet angular architecture, designed to accompany and codify the reading of the paper, is thus reused to construct the work and guide its vision. A curi-

ous retrospective analogy could be made in this respect between the press clippings as Picasso used them in 1912–13, and the impact of military censorship on the layout of newspapers during the war years 1914–18 (fig. 65).[51] Prohibited articles and images were simply put in reserved areas, heading and text effaced, routed out (to use the standard phrase of the profession) at the time of printing. Their placement in the journalistic grid appears in negative on the rest of the printed sheet. Thus, albeit from an incomplete reading one can nevertheless tell exactly everything that has been taken away. This formal resemblance confirms *ad absurdum* to what extent Picasso's method conformed to the rules of typo-journalistic practice. It is as if he were proclaiming: "I don't particularly care about the subject, but the object is of the utmost importance to me. You must respect the object!"[52] Anticipating the example of the work of censorship, the selection and cut-outs that Picasso used led to a *diversion* that proved to be as ideological as it was material. Starting with *Le Journal* – the incarnation of right-thinking, populist, warmongering France – he made his own newspaper. Thus, in perfectly transparent fashion, *Violin* transforms the heading of the article "*Les crédits pour l'armée*" ["funds for the armed forces"] into "*Les crédits pour l'ar[t]*" ["funds for art"]. The rest of the text, left legible, certainly gives the lie to this pun but the drawing itself clearly frames the words "*d'accorder*" and "*plus des*", which results in "*accorder/plus des/crédits pour l'art*" (grant more funds to the arts). Picasso, while remaining fully aware of the threat of the arms race in Europe, succeeds in this humorous cut-out of the text and its partial restitution both in his own type of censorship and in a kind of ideological unpinning: here, the drawing, the press clipping and the cut-out superimpose their antagonistic significations upon one another while maintaining their respective identities. The drawing is the obvious project, the press clipping is the commonplace and the cut-out is the artist's commentary. Each entity retains its legibility, its distance, while interfering with the others. This is the difficult game Picasso played, combining heterogeneous semantic objects while accentuating each of their own reactive natures. The *papiers collés* must remain in a permanent state of suspension. What is most characteristic of newsprint, more so than any other material, is its eminently impervious nature, the way it resists all forms of assimilation. For Picasso, the newspaper alone had sufficient force of identity, for it was and remains – in the face of all opposition – the newspaper, as such capable of resistance to aesthetic, plastic or decorative reduction. Newsprint is the marker of denial. In this it must be distinguished from wallpaper, which combines an affirmation of its two-dimensional nature with a conventional register of decorative motifs grounded in chromatic contrast, illusion and *trompe-l'œil*. Newsprint, even when it is sometimes used as 'colour' or 'modelling', remains fundamentally the irruption within the very graphic code of what normally escapes: the world, politics, war, or any event whatsoever. Pinned-up or pasted, it makes little difference: the press clipping says a radical no to pictorial aestheticization and to delectation. It is in no way a window opening on to an exterior perspective, or closing, or even half-opening. It is the noise of a door slamming.

Fig. 62
Pablo Picasso
Violin
Céret, spring 1913
Pen and Indian ink on
newsprint
5 × 11 cm
Z XXVIII, 307
Private collection

overleaf, left **Fig. 63**
Pablo Picasso
Bottle on a Table
Paris, autumn/winter 1912
Pasted papers, ink and char-
coal on newsprint from *Le
Journal*, 8 December 1912
62.5 × 44 cm
MP 369
Musée Picasso, Paris

overleaf, right **Fig. 64**
Pablo Picasso
Bottle on a Table
Paris, December 1912
Charcoal and piece of
newsprint from *Le Journal*,
8 December 1912, pasted on
paper
62 × 47.5 cm
Z XXVIII, 204; DR 552
Fondation Beyeler,
Riehen/Basel, Switzerland

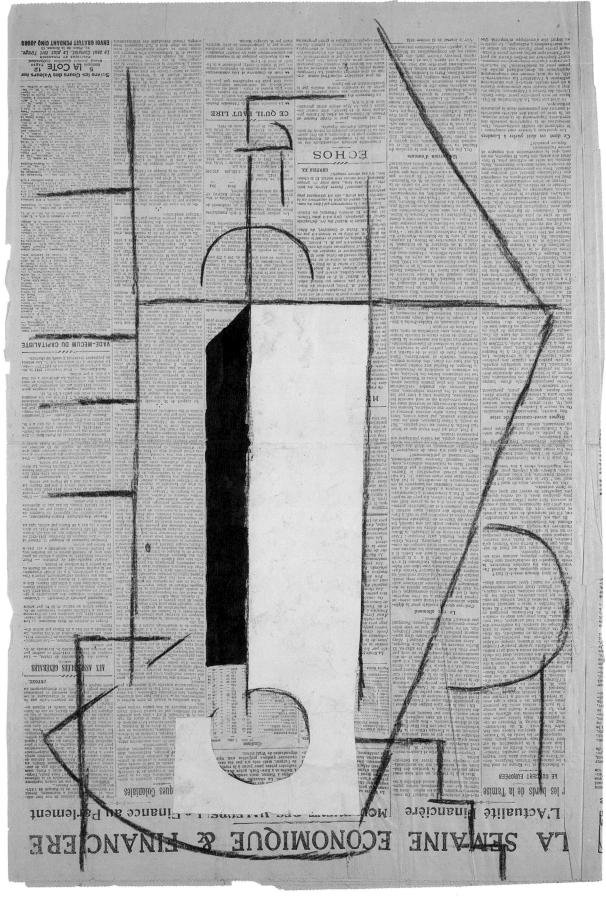

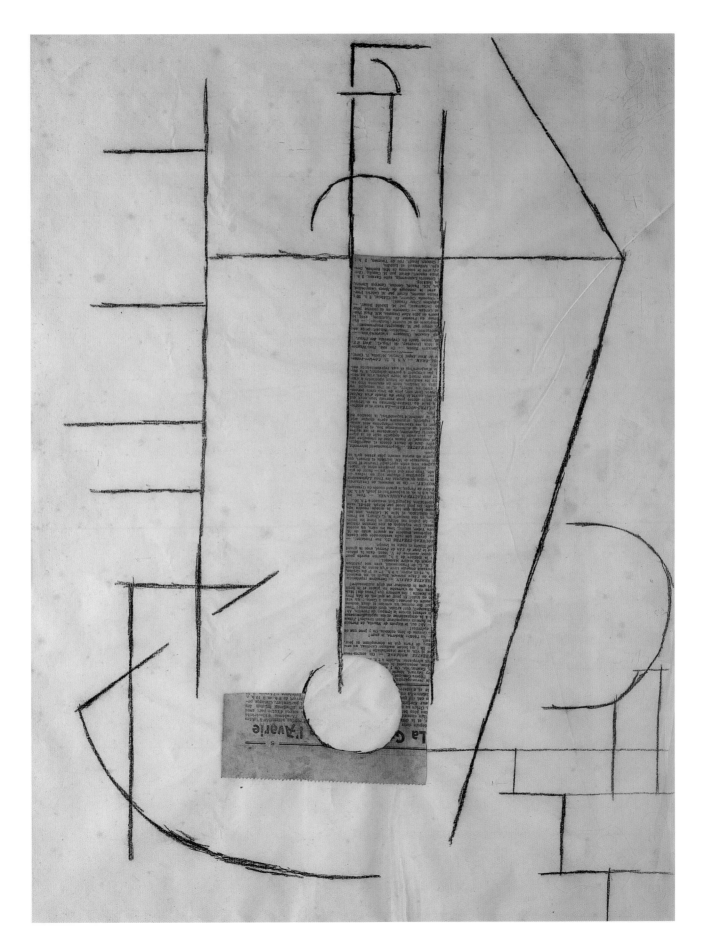

From the "Old Man" to the "New Man in the Making"

William Rubin remarked in his analysis of "the logic of this wall arrangement" that "the cardboard *Guitar* is at the centre of groups of newsprint *papiers collés*, alluding to its role as a *generator* of this idea". The project of graphically reproducing in a variety of forms the cardboard *Guitar* – the 'pattern' of the group – does in fact appear to have become the key to the photographic sequence of the boulevard Raspail. André Salmon expressed in the most literal way possible this concept of a reproducible model – by multiplication and by variation – when he mentioned the sheet-metal version of this same *Guitar*,[53] "the plans of which can be shipped to every ignoramus in the universe capable of building it as well as him".[54] Elisabeth Cowling has developed this analysis of *papiers collés* and constructions as all belonging to a "fine art of cutting" comparable to the piece-by-piece cutting and assembling of the artisan tailor. The first photograph, which juxtaposes *Guitar*, the cardboard construction matrix, with the variations produced by the *papiers collés* and the two small guitars, which thus appear to be its reconstitutions, forms a kind of manifesto of procedures for such a project for the constructive self-begetting of motifs and forms.

I should nevertheless like to draw attention to the presence of an issue of *L'Illustration* in each of the three photographs mentioned above, on the wall of the

Fig. 65
L'Homme Libre/L'Homme Enchaîné
Censored issues, 1914–17
Document Louis Guéry, *Visages de la presse*, 1997

Raspail studio. This title, visible next to *Guitar*, seemed at first to serve as a kind of caption for this image of work in progress.[55] A more accurate interpretation, however, was made possible once we were able to identify this copy as a 1911 issue of *L'Illustration théâtrale*, a supplement to *L'Illustration*, devoted to a play by George de Porto-Riche entitled *Le Vieil Homme* (fig. 66).[56] In the second photograph, the title of the play is perfectly legible in the typographic scroll in the centre of the cover. This five-act play, first performed on 12 January 1911 at the Théâtre de la Renaissance, was, along with *Chantecler* by Edmond Rostand, the major theatrical event of the season. The fame of the playwright was then at its peak, and the press had been waiting for news of the play while it was being written for almost fifteen years. It is interesting that Porto-Riche, accounting for this long genesis, explicitly identifies his own work as that of a painter hanging sketches.[57] In much the same way, the description of the set, a provincial printer-publishing house, calls to mind an artist's studio: "Books, leaflets, papers piled up everywhere on seats and furniture, everything bespeaks of intellectual activity and life."[58] Although the plot of *Le Vieil Homme* is little else than a rather daring bourgeois drama – the father, the father-in-law and the son all want the same woman, the son finally kills himself – the symbolic relations between the characters bear some relevance to those of Picasso's family circle. Here too, the father's skill must be passed on to the son (who, for a moment, seems to prefer painting): "Printer: the job would not be unpleasant ... I will end up a publisher like you ... "[59] And a curt exchange between mother and son brings us back in a surprising way to the obsession with cut-out papers shared by don José and his son Pablo:

> **Mother:** Please, I beg you, don't ruin that leaflet with scissors.
> **Son:** It's an old catalogue.
> **Mother:** I hate this habit. When your father was upset, he would cut up paper into tiny pieces.[60]

Roland Penrose recalls how Picasso's father loved to prepare his large pictures of pigeons: "To get them arranged properly, he would first paint individual birds on paper, which he would then cut up, combining them in different ways until a composition began to take shape."[61] It is more than likely that Picasso was attuned to such coincidences at that special moment in his life when he was going back and forth to Barcelona and which came to an end in early May 1913 with the death of his father.[62] One conclusion could be that an unconscious motive for the invention of the *papiers collés* was the remembrance of the attributes of the painter that his father, faced with the superiority of his talent, had solemnly entrusted to him.[63] For "the brushes and colours were not in the least the only tools of the trade", adds Roland Penrose; "knives, scissors, pins and glue also played a part".[64] And Palau i Fabre imagined the gaze of the young Picasso on the cut-outs and collages of don José: "No doubt his son looked on with wonder as objects moved about and that he was disappointed when they took up their permanent positions, which he must have thought were those of their death."[65]

To return now to the play by Porto-Riche, Picasso could not have been unaware of the polemical repercussions of *Le Vieil Homme* early in 1911 at the opening night.

69638

69639

ANNÉE. — 170

21 Janvier 1911

L'ILLUSTRATION

THÉÂTRALE

Journal d'Actualités Dramatiques

PUBLIANT LE TEXTE COMPLET DES PIÈCES NOUVELLES
JOUÉES DANS LES PRINCIPAUX THÉATRES DE PARIS

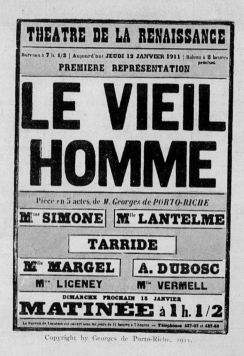

THEATRE DE LA RENAISSANCE

Bureaux à 7 h. 1/2 | Aujourd'hui JEUDI 12 JANVIER 1911 | Rideau à 8 heures précises

PREMIÈRE REPRÉSENTATION

LE VIEIL HOMME

Pièce en 5 actes, de M. Georges de PORTO-RICHE

Mᵐᵉ SIMONE **Mˡˡᵉ LANTELME**

TARRIDE

Mˡˡᵉ MARGEL **A. DUBOSC**

Mˡˡᵉ LIGENEY **Mˡˡᵉ VERMELL**

DIMANCHE PROCHAIN 15 JANVIER

MATINÉE à 1 h. 1/2

Le Bureau de Location est ouvert tous les jours de 11 heures à 7 heures — Téléphones 537-03 et 427-69

Copyright by Georges de Porto-Riche. 1911.

ACTES I, II et III

L'Illustration Théâtrale paraît mensuellement et publie des numéros spéciaux chaque fois que l'exige l'actualité dramatique.
Aucun numéro de L'Illustration Théâtrale ne doit être vendu sans le numéro de L'Illustration portant la même date.
Tout abonné à L'Illustration est abonné de droit à L'Illustration Théâtrale.

Prix du Numéro : UN FRANC. — Abonnement annuel : FRANCE, 36 francs ; ÉTRANGER, 48 francs.

13, rue SAINT-GEORGES, PARIS (9ᵉ).

MICHEL, charmé. — Tu es la séduction en personne.

THÉRÈSE. — A quoi ça sert avec un être aussi nomade?

MICHEL. — A l'enchaîner.

THÉRÈSE. — Deux ou trois jours... Ah! que ne suis-je toutes les femmes!

MICHEL, avec tendresse. — Tendre obstinée!... Je contestais tes griefs quand tu m'accusais, à la minute, mais, au fond, j'en sentais la justesse.

THÉRÈSE. — Tu en conviens?

MICHEL. — Ingrat que je suis, je t'inquiète à chaque instant; et, cependant, je sais d'avance ce qui est de nature à t'alarmer. Quoique méchant, je comprends tout.

THÉRÈSE.— Tu comprends tout, mais tu n'éprouves rien.

MICHEL. — Nous allons reprendre nos chères habitudes d'amour et d'amitié, et nous réaliserons ce recommencement, sans nous préoccuper de la présence ou de la disparition de Mᵐᵉ Allain.

THÉRÈSE. — Dans ce cas, je suis sûre de perdre immédiatement l'austérité que tu me reproches.

MICHEL. — Présomptueuse.

THÉRÈSE. — Peut-être même me viendra-t-il bientôt, comme par enchantement, quelques-unes des qualités de l'autre, de ces qualités horribles, qui communiquent la bonne humeur.

MICHEL. — Tu me fabriqueras des confitures.

THÉRÈSE. — Me vois-tu installée devant une machine à coudre ou fourbue par les soins du ménage?

MICHEL. — Pas précisément. Mais je consens à n'importe quoi, pourvu que tu ne cesses pas de m'aimer. Je tiens à ton amour. Par vanité, par plaisir et par intérêt. Ta passion n'est-elle pas la source inépuisable qui alimente mon pauvre cœur? Et puis, je ne conçois pas cette maison sans amour.

THÉRÈSE, très gaie. — Bienfaisante ou funeste, il nous en faut, pas vrai?

MICHEL, chantant.
Il nous faut de l'amour, n'en fût-il plus au monde!

Thérèse, qui, depuis quelques minutes, était assise sur le tabouret du piano, entame la partition de *la Belle Hélène*.

THÉRÈSE, fredonnant.
Amours divins, ardentes flammes!
Vénus! Adonis! Gloire à vous!
MICHEL, debout à côté d'elle, continuant.
Le feu brûlant vos folles âmes,
Hélas! ce feu n'est plus en nous!
MICHEL et THÉRÈSE, chantant ensemble.
Ecoute-nous, Vénus la blonde,
Il nous faut de l'amour, n'en fût-il plus au monde!

MICHEL, à Thérèse qui vient d'aborder un autre motif. — Quel est ce morceau-là?

THÉRÈSE. sans s'interrompre. — L'air d'Hélène.

Scène X

LES MÊMES, AUGUSTIN, Mᵐᵉ ALLAIN

Mᵐᵉ ALLAIN, dansant et chantant.
Pars pour la Crète.
MICHEL, de même.
Pars pour la Crète.
AUGUSTIN, de même.
Pars, pars, pars, pars.

Thérèse, qui n'a pas cessé de jouer, arrive au troisième acte de la partition.

MICHEL, dansant et chantant.
Je suis gai, soyez gais, il le faut, je le veux.
THÉRÈSE, avec mélancolie, au piano, et chantant.
Il est gai!
Mᵐᵉ ALLAIN, dansant et chantant.
Soyez gais!
AUGUSTIN, de même.
Soyons gais!
MICHEL, de même.
Je le veux!
Et tsing, tsing, balaboum, balaboum!
AUGUSTIN, de même.
Balaboum poum, poum!
Lalaïtou, poum, poum!

MICHEL, à Mᵐᵉ Allain. — La jolie jambe.

Mᵐᵉ ALLAIN. — J'en ai une seconde toute pareille.

MICHEL, bas à Mᵐᵉ Allain, tandis qu'Augustin continue à danser et à chanter. — Sérieusement, si vous étiez bon garçon, vous vous arrêteriez ce matin à la Commanderie, et je vous y rejoindrais.

Mᵐᵉ ALLAIN. — Je suis bon garçon, mais pas jusque-là.

AUGUSTIN, à Thérèse. — Bravo, mère, continue.

MICHEL, à Mᵐᵉ Allain. — Seriez-vous de celles qui disent toujours non? Avant, pendant et après?

Mᵐᵉ ALLAIN. — J'entends ne causer de chagrin à personne.

MICHEL. — Comme ça se trouve! Justement je cherche une liaison qui ne rendrait pas ma femme malheureuse.

THÉRÈSE, au piano et chantant.
Elle vient, c'est elle.
Elle vient, la voici!
AUGUSTIN, chantant et dansant.
Mon Dieu, qu'elle est belle
Malgré son souci!

Il fait un faux pas et trébuche.

MICHEL. — Hé! Prends garde, Augustin!

THÉRÈSE, s'arrêtant. — Tu es tombé?

AUGUSTIN. — A moitié. Je n'ai pas le pied sûr, aujourd'hui!

"Nothing has ever been more difficult or more novel than this",[66] exlaimed the young critic Léon Blum, adding: "The most faithful admirers of M. de Porto-Riche, while listening to this *old man*, felt they heard the voice of a new man in the making." Others echoed his judgement: "A frank disposition that says it all, the beautiful and the ugly, almost shocking ...";[67] "An elegant corruption of art ...";[68] "A resemblance to the Renaissance masters".[69] But a violent anti-Semitic reaction set in quickly, conducted over several weeks by Gustave Téry, the general editor of *L'Œuvre*, under the heading '*Les Juifs au Théâtre*'.[70] The campaign accused the plot of amorality and was shocked by the seduction scenes, but the reaction was also fanned by the formal audacity of the dialogue. Téry attacked "these characters who are always cutting in on the conversation, who look like they're taking the words out of your mouth",[71] as well as the play's

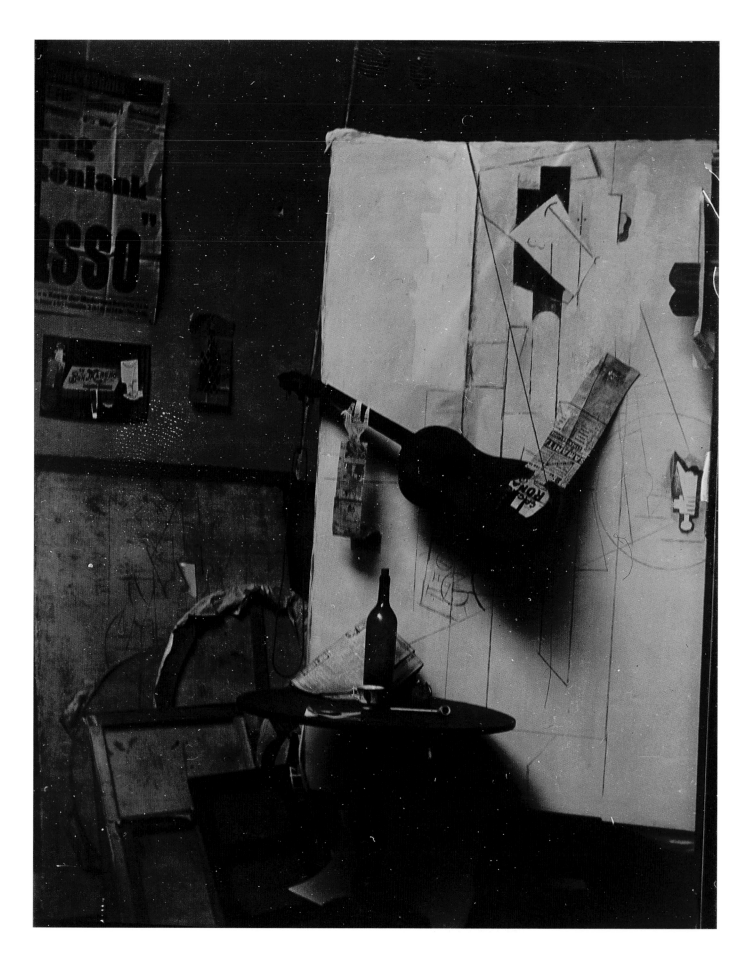

82 Picasso working on paper

Fig. 68
Pablo Picasso
*Photographic Composition with
'Guitar Player'*
Studio at boulevard Raspail, Paris,
January 1913
Gelatin silver print
11.8 × 8.7 cm
Private collection

rejoinders, whose "only purpose is to cut the dialogue into tiny pieces".[72] The verbal exchanges between the characters, shot through with cynical allusions and *double entendres*, constantly change register, jumping suddenly from money to work, to sex. "It looks like a film shot too fast" as a critic wrote after the War.[73] The dialogue, which might be described as an edited 'cut', moreover includes multiple, brief incidents concerning life at a printer's. The characters call themselves "the Elzevir family";[74] they are always talking about correcting proofs, headline articles, linotype machines, rotative folding machines, fonts, photographs, layouts, invoices *etc*. These realistic details enraged some critics, as in the following article published in *Le Correspondant* in 1911: noticing only "an insignificant accumulation of material details", the critic wonders: "why are at least half of the first three acts taken up by statements or actions concerning the printing shop, workers, business, balance-sheets, publishers, orders, financial backers and diverse technical elements of typography?"[75] The play is in fact staged like the front-page 'news in brief', and at times takes on the appearance of an advertising campaign, as with the commercial slogan that the young hero suddenly repeats automatically: "*Breton frères, papiers sans colle, papier de Chine!*" (The Breton brothers, glueless papers, Chinese paper!)[76] This moment of the play is one of its most surprising verbal and typographic 'collages', mixing exchanges that are close to nonsensical between two of the characters, verses from *La Belle Hélène* by Offenbach sung by three characters with a piano accompaniment ("I am happy, be happy, we must, I want to ...") and pure onomatopoeia: "And tsing, tsing, balaboum, balaboum!"[77] (fig. 67.) One realizes how receptive Picasso must have been, at the decisive moment when he opted for press clippings as the main element in his formal revolution, to the audacious writing of Porto-Riche, his use of cut-and-paste technique in dialogue, his borrowings from ordinary speech, the proliferation of details chosen from the typographic milieu, and his weaving into language, just as the *papiers collés* would do, clues to make "allusions and illusions of the real intermingle".[78] The *Guitar* construction, the title *L'Illustration* and the homage to *Le Vieil Homme* would symbolize the founding rule of the 'game' of *papier collé*: the *Guitar*, a dreamed object out of which no sound will ever come, in place of the real thing; *Le Vieil Homme*, a manual of textual montage as much as a dedication to don José; *L'Illustration*, the programme of the sequence when it is a matter of *illustrating* the model *Guitar* – of translating it from three to two dimensions – and with it the daily drama of history to which the cut and pasted press fragments refer.

The *Guitar Player*

The famous collage *Still Life 'Au Bon Marché'* (fig. 71)[79] has been discussed at length by scholars of Cubism. Pierre Daix has pointed out that it contains, in the lower left-hand corner, the fragment of an article, dated 23 January 1913, about the assassination of the Turkish minister Nazim Pacha. I have now established that the press clipping depicting a woman in a night-gown, with the letters "SAMA", is from an advertisement for a spring sale at the department store La Samaritaine (one of the main competitors of Bon Marché) published on the last page of *Excelsior* on 25 January

1913 (fig. 72). The clipping singled out by Daix comes from the article 'How Nazim was Murdered', published on page two of the same edition (figs. 74, 75). As for the typographic fragments arranged beneath, at the centre of the collage, the sexual *double entendre* they form, "LE TROU ICI" ["here the hole"], has become a classic instance in the debate on the 'readability' of the *papiers collés*.[80] I have verified that the superimposed letters "Lun/B/TROU" come from a vertical cut in the advertisement identified above for La Samaritaine with the following: "*Lundi 27 Janvier*/BLANC/TROUSSEAUX" (fig. 72). I have also been able to establish that the syllable "ICI" was taken from the title "L'ARMISTICE EST CONCLU", found on the 'Late News' page of an older edition of *Excelsior*, dated 1 December 1912 (fig. 73). These indications confirm that the collage was probably completed by late January or early February 1913.

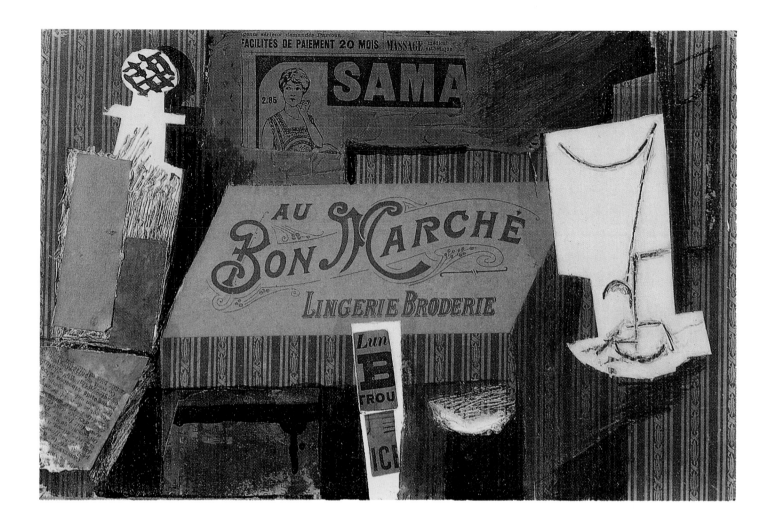

Another group of studies for which newsprint is the support and the raw material can also be dated to this period. Having remained in Picasso's personal collection, some of them have only recently been discovered and others have yet to be published. They have hitherto not been analysed with respect to the logical chain leading to *Construction with Guitar Player* (fig. 68), a sculptural project that was never completed and that found material form in the major painting of 1916, *The Guitar Player*.[81] Until now dated 1912, *Study for a Sculpture* (fig. 76)[82] includes such variants as the ink drawings *Man with Guitar, Bust*[83] or *Three Heads*.[84] *Study for a Sculpture* was executed on partly cut-out and torn paper that was pasted on to a fragment of newsprint, itself roughly excerpted from what appears to be the front page of *Le Matin*. In the lower right-hand corner of the composition, the linear rhythm of the telephone cables decorating the headline and title band of the newspaper can be made out. The headline article, left partly visible, mentions the turmoil following the death of Nazim Pacha and reports a communication dated 29 January. It is in fact the 30 January 1913 edition. This evidence moves the date of the series of studies forward to early 1913 and contributes to a closer study of the entire sequence of experiments leading to the construction. The fragments of subtitles – "E 170 BLESS...", "...EVOLTE COMMENCE", "LES EME... MULTIPLIENT" – give a sharp sense of the political and military context. The newspaper

Fig. 71
Pablo Picasso
Still Life 'Au Bon Marché'
Paris, January 1913
Oil, paper and pieces of newsprint
from *Excelsior*, 1 December 1912
and 25 January 1913, pasted on
printed cardboard
23.5 × 31 cm
DR 107
Private collection

was dealing with a new development in the Balkan War. "*La Révolte commence*" ("The Revolt Begins") of late January 1913 recalls "*La Bataille s'est engagée*" of the preceding 18 November, a headline that, like the other, is at once physically and historically the ground of the work in progress. At this stage, the figure of the guitar player is based on the rhythmic deployment of a sphere, trailers, connecting rods and transmission belts. The series of drawings usually depicts these volumes three-dimensionally. The collage, a volumetric drawing on newsprint, breaks here with the flat surface of the *papiers collés* that is itself affirmed by the two-dimensionality common to the drawing

and the newsprint. Here, on the contrary, the tearing of the support, combined with the angular cutting edge of the trailers, the profile of which juts out on to the printed text, is yet another dramatization of the physical irruption of the character. The circular stamp of *Le Matin*, standing out from the network of telegraph lines, is used in the composition in place of what, in other studies, represents the guitar. As in the graffiti completed in 1905 on another front page of *Le Matin* (fig. 28), Picasso thus incorporated into his drawing both the stamp and the parallel telegraph lines characteristic of this daily. This recurrence, after an interval of almost a decade, confirms the graphic automatism whereby Picasso immediately assimilated the visual promptings of the support.

The sequence that in early December 1912 opened with photographs of the hanging of *papiers collés* dedicated to *Le Vieil Homme* is echoed by the staging of *Photographic Composition with 'Guitar Player'* (fig. 68). A large drawing, the pencil lines of which, are visible at this stage, features the assemblage of a real guitar and two newsprint arms. Close examination of the photograph has confirmed that at least one of these artificial limbs – the one on which fragments of advertisements for La Samaritaine and Cacao Rona (fig. 70) can be distinguished – comes from the advertisements of the 1 December 1912 edition of *Excelsior*, the very edition from which derives the "ICI" of *Still Life 'Au Bon Marché'* (fig. 69). The photographic composition nevertheless dates from after late 1912 since it depicts precisely this last work, which includes clippings dated 25 January 1913. The most probable hypothesis is that *Still Life 'Au Bon Marché'* and *Construction with Guitar Player* were completed, in the state in which they appear in the photograph, in the course of the same work sessions during the last days of January.

In a small sketch-pad dating from the spring of 1913[85] Picasso sketched about one hundred drawings and studies for *Man with Guitar*. It is possible to follow the evolution from the volumetric studies with which the notebook begins: a man with a hat, a guitar, or seated in an armchair, are progressively 'flattened out'. The check pattern of these sheets is perhaps a factor in this transformation, allowing for an actual 'squaring' of the work. In the sequence of sheets 42 to 46, Picasso inserted a piece of newsprint displaying an advertisement for female underwear, directly echoing the one used in *Still-Life 'Au Bon Marché'*. A woman dressed in what seems to be a long corset, suspenders and stockings remains visible at the top of the clipping, pasted upside down, along with the words "TOUS ... QUI ILLUSTRENT" (fig. 79). The fragment is jaggedly cut out and placed in the middle of the squared sheet of paper. The penned line in black ink reuses the structure of the guitar player on the preceding sheets. The geometric head of the figure seems to hang like a metronome at the end of a rod, the axis of which is anchored on the suspender of the female model and points to the cruciform motif of the advertisement. On the next sheet, this motif is reused in the moustache of the guitar player. Sheets 63 and 65 of this 1913 sketch-pad perspectivally deptict a double page of what seems to be a book opening onto four then two massive columns of type. Sheet 77 verso (fig. 80) is completely covered with a pasted-

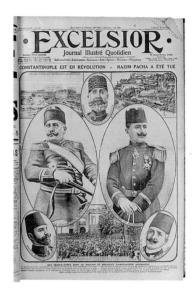

Fig. 74
Excelsior
25 January 1913
Page 1: '*Constantinople est en révolution*' (Constantinople is in revolution)
'*Nazim Pacha a été tué*' (Nazim Pacha has been killed)
Bibliothèque de l'Arsenal, Paris

Fig. 75
Excelsior
25 January 1913
Page 2: '*Comment fut tué Nazim Pacha*' (How Nazim Pacha was killed)
Bibliothèque de l'Arsenal, Paris

Fig. 76
Pablo Picasso
Study for a Sculpture
Paris/Céret, spring 1913
Indian ink on paper pasted on
newsprint from *Le Matin*, 30 January
1913
16 × 12.5 cm
Private collection

down business column (fig. 78) that I have managed to identify as coming from page 11 of the 8 May 1913 edition of *Excelsior* (fig. 77), the front page of which is devoted to the arrival in Paris of the King of Spain, Alphonse XIII. A drawing once again takes up the motif of sheet 76 verso, a study for the *Guitar Player* containing colour and material indications. Where Picasso jotted "Ground, the colour of the canvas" is where the printed texture of the newsprint appears, which underscores the chromatic neutrality given to it by Picasso.

Another work dating from this same day in early May 1913 uses a full page of a newspaper, which is unusual. Picasso drew in charcoal a large head of a man with a moustache (fig. 83).[86] The drawing crosses the entire sheet, placed in reverse direc-

Fig. 77
Excelsior
8 May 1913
Front page
Bibliothèque de l'Arsenal, Paris

Fig. 78
Excelsior
8 May 1913
Page 11: business column
Bibliothèque de l'Arsenal, Paris

Fig. 79
Pablo Picasso
Character
Céret, spring/summer 1913
Pen and black ink on newsprint pasted on page of sketch-pad
13.5 × 8.5 cm
MP 1865-45 R
Musée Picasso, Paris

Fig. 80
Pablo Picasso
Guitar Player
Céret, spring/summer 1913
Pen and black ink on newsprint from *Excelsior*, 8 May 1913, pasted on
page of sketch-pad
13.5 × 8.5 cm
MP 1865-77 V
Musée Picasso, Paris

Quatrième Année. — N° 903 LE NUMÉRO QUOTIDIEN 10 Cent. — Étranger : 20 Cent MARDI MAI 1913.

·EXCELSIOR·

Journal Illustré Quotidien

Directeur : Pierre LAFITTE
« Le plus court croquis m'en dit plus long qu'un long rapport. » (NAPOLÉON).
88, Champs-Élysées, PARIS

ABONNEMENTS (du 1er au du 16 de chaque mois)
France : Un An : 35 fr. — 6 Mois : 18 fr. — 3 Mois : 10 fr.
Étranger : Un An : 70 fr. — 6 Mois : 36 fr. — 3 Mois : 20 fr.

Informations - Littérature - Sciences - Arts - Sports - Théâtres - Élégances

TÉLÉPHONE (3 lignes)
Wagram : 57-44, 57-45, 28-64, 28-66, 28-68
Adresse Télégraphique : EXCEL-PARIS

LE ROI NICOLAS DE MONTÉNÉGRO ET LA PRISE DE SCUTARI

LE ROI DE MONTÉNÉGRO VIENT DE RECEVOIR UN DRAPEAU PRIS AUX TURCS À SCUTARI

LE ROI ET LA FAMILLE ROYALE ENTRANT À LA CATHÉDRALE DE CETTIGNÉ

(1) LE ROI (2) PRINCE DANILO (3) LA REINE (4) ET (5) SOLDATS BLESSÉS À SCUTARI

LE SOUVERAIN CELEBRE A CETTIGNÉ LE SUCCES DE SES ARMES

Le roi Nicolas de Monténégro avait dit : « Je retournerai à Cettigné après avoir conquis Scutari, ou je n'y retournerai pas. » Il a tenu sa parole. Est-il utile d'insister sur l'ovation que publions de l'entrée à la cathédrale que la reine et les dames de sa cour donnent le bras à des blessés de la guerre.

lui fit son peuple à son retour dans sa capitale ? Le souverain célébra la victoire monténégrine par des réjouissances et des actions de grâces. On remarquera dans la photographie que nous

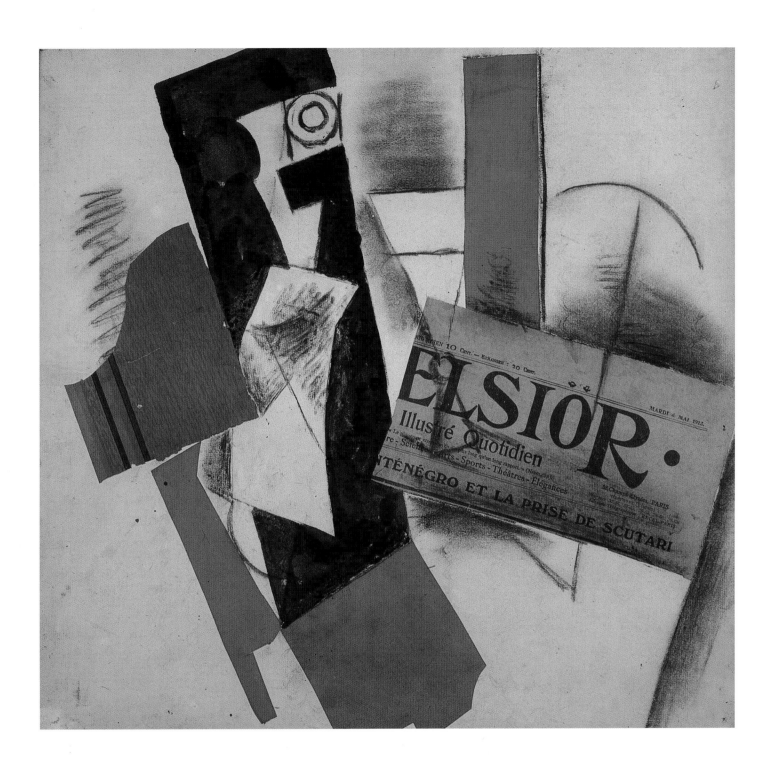

opposite **Fig. 81**
Excelsior
6 May 1913
Front page: '*Le Roi Nicolas de Monténégro et la prise de Scutari*' (King
Nicolas of Montenegro and the Siege of Scutari)
Bibliothèque de l'Arsenal, Paris

Fig. 82
Pablo Picasso
Bottle and Newspaper
Céret, spring 1913
Piece of pasted newsprint from the front page of *Excelsior*, 6 May
1913, charcoal and Indian ink on paper
45 × 48 cm
Z II**, 406
Courtesy of the National Gallery of Ireland, Dublin

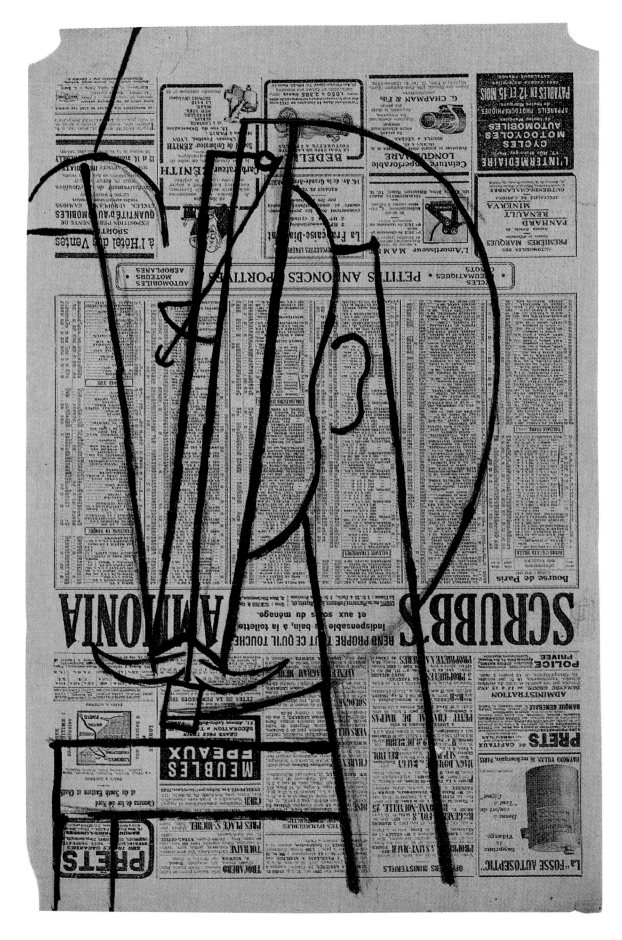

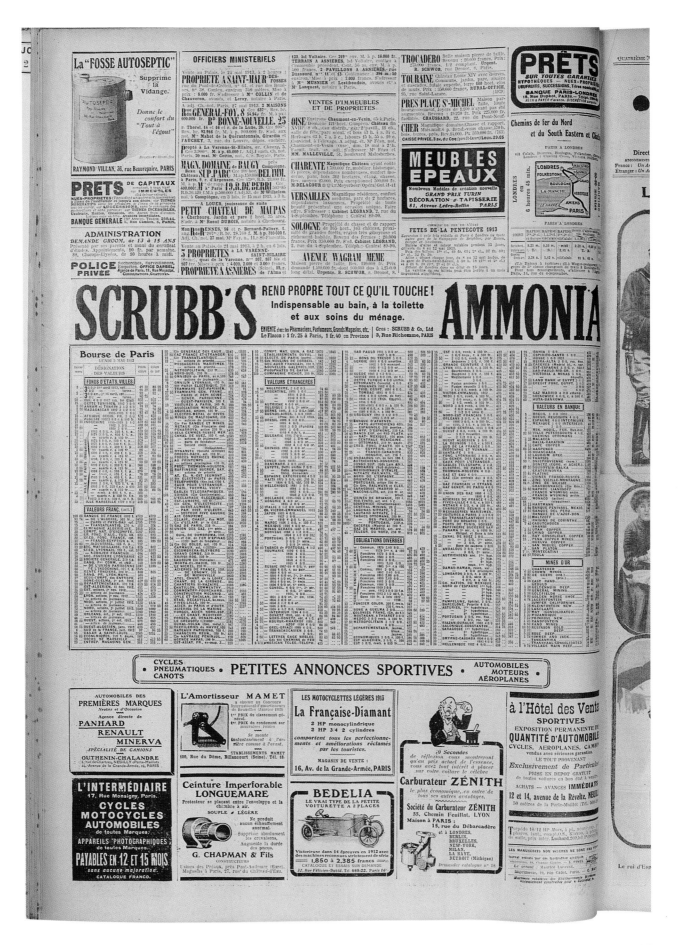

previous pages, left **Fig. 83**
Pablo Picasso
The Violinist
Céret, spring 1913
Indian ink on the last page of
Excelsior, 6 May 1913
55.5 × 37.4 cm
Private collection

previous pages, right **Fig. 84**
Excelsior
6 May 1913
Last page: advertisement for
Scrubb's Ammonia
Biblithèque de l'Arsenal, Paris

Fig. 85
Pablo Picasso
Violin
Paris, 1913–14
Cardboard box, pieces of newsprint,
gouache, charcoal, chalk on card-
board
51.5 × 30 × 4 cm
MP 248
Musée Picasso, Paris

tion (relative to that of reading), and its structure is determined by the geometry of stock-market notices and advertising boxes (fig. 84). The scheme of the figure's head is a stage in its metamorphosis, combining a sphere split in half with the constructive lines of the guitar itself. There is a whole series of drawings in which Picasso thus collapses the schema of a man and his instrument together. Nevertheless, this full page can be identified as being from the 6 May 1913 edition of *Excelsior* (fig. 81), the headline and masthead of which were used in the *papiers collé Bottle and Newspaper* (fig. 82).[87] Joan Sutherland Boggs believed she could read in the fragment of the title "ELSIOR" in this last work a *memento mori* of the artist's father:[88] "Each time I draw a man," Picasso said, "I think of my father. For me a man is always don José and will remain so for the rest of my life ..."[89] Executed a few days before don José's death, this large portrait on newsprint, hitherto entitled *The Violinist*, could be the painter's ultimate monumental homage to the father figure, and would close the long sequence of work initiated by the hangings of the boulevard Raspail, presided over by the mourning of *Le Vieil Homme*.

"The Newspaper that Speaks and Responds"
Journalistic textuality, through its indifferent reporting of 'the real', its anonymous ideology, its appeal to the reader, purports to be *the* language of reality. This is why the use of newsprint, in which politics and society, violence and commerce, arbitrarily coexist, was meant to lend the most radical expression to the *papiers collés* as being a semantic revolution. The totality of the verbal and visual signs of the press object, their shapes and their hierarchy are thus reported into art. This 'direct' language of the newspaper thus appears as a kind of surface that physically looks out on to the real: a planar projection of the rumours of the world. If, simultaneously, the newspaper can be considered as chromatic material, it is in a singular and quite different manner from the use of wallpaper or the materials in *trompe-l'œil*. Newsprint inevitably links to a 'colour' a mode of reading. And in fact, these two terms are always engaged in the contradiction of their signifying registers. To consider the lined effect of newsprint as a grey tint or as hatching implies a shade or shadow, a modelling if not a depth. The eye, conversely, usually sees the printed text as both material surface and as the formal sign of a plan. The newspaper clipping is, then, an anti-illusionistic trap-door, the colouring of depth immediately expressing its *lack of depth*, its non-depth. At the same time, the eye cannot help but see the material of the *papiers collés* marked with verbal signs that are capable of being 'read' as well as 'seen'. I have addressed the question of the legitimacy of such 'reading'. But the question must be asked what the genesis of the *papiers collés* implied for Picasso himself in terms of the eye and the mind, with respect to their journalistic raw material. The artist did not leave any commentary on his experiences during the years 1912–13, but he did, on the other hand, think to compose a coded poem in 1935 that gives us direct access to his unconscious mode of semantic reading and editing. As he indicates himself on the manuscript of the poem, '*Maxima au sol*' (figs. 101, 102),[90] Picasso used as a point of departure pages 2 and 3 of the 8

December 1935 edition of *Le Journal* (figs. 103, 104). These pages include items of gossip, the society calendar, advertisements, special offers, '*Le Conte du Journal*', a comic strip devoted to the adventures of Doctor Nimbus[91] and the miscellaneous news – that is, the matter that gives Picasso his favoured material. A reader of this daily newspaper since 1902, Picasso found in it once again the favourite object of his experiments of 1912–13, this *Journal* whose title is the same as the common noun. By giving us the key to this automatic poem, Picasso deliberately reveals his way of reading the papers as well as the inner 'spring' of his textual cut-and-paste.

'*Maxima au sol*' (fig. 101), the title and the opening line of the poem, comes directly from the '*Météo*' (weather forecast) section on page 2 (fig. 102). Picasso lists the major towns of the French départements and stops at Perpignan: Perpignan is close to Céret and to Spain and the temperature is 11°C whereas the temperature in Paris remains at 5°C. From there he moves on the adjoining column, devoted to news, and where he retains the titles of several conferences listed after the announcement of the opening of the Salon d'Automne. The eye moves towards the opposing angle of the

Fig. 86
Pablo Picasso
Glass, Bottle of Wine, Pack of
Tobacco, Newspaper
Paris, March 1914
Pasted papers, newsprint, gouache
and charcoal on paper
49 × 64 cm
MP 1997-1
Musée Picasso, Paris

page to pick up the words "*après l'appel des morts ...*" in the news of '*La Conférence du Stage*'. Then, laterally, the eye notes the phrase beneath the photograph of the article about "*donneuses de lait*" (wet nurses). Here Picasso adds the title and two paragraphs of the '*Le Conte du Journal*', also including another excerpt of news. Each sentence, retained in its entirety, is signalled in the manuscript by a dash, which graphically marks the *collure* (glued joint).[92]

The other page (fig. 102) of the manuscript refers to page 3 (fig. 104) of *Le Journal*, containing miscellaneous and legal news. Here the reading is altogether different: it begins by colliding, in the upper right-hand corner of the sheet, a headline in Egyptian type of an advertisement for a telephonic newspaper called SVP (for *S'il vous plaît*, or 'please'). Picasso reproduced the advertisement, respecting the size and thickness of the type. He added points between the capitals, which could make them appear as the initials of a proper name: "S.V.P." (the P for Picasso?). Next, the eye moves towards the subtitles in lower case of another miscellaneous news item (a failed kidnapping), then towards that of a murder case, squeezes in elements of the title of two other articles on a shooting, before returning to the bold type of the headline of the first article. The words "*Et ce n'est pas tout*" come, again, from the advertisement for the telephoned newspaper. As for the word "kidnapping", it reproduces the sans serif lettering and small capitals of the newspaper title. After a crossing-out, Picasso continued with the slogan "*C'est un journal qui parle et qui répond*" ("It's a newspaper that speaks and responds"), then descended to pick up a sentence from an advertisement for a foot ointment, Le Diable. He then took from '*Le Crime de Raymond*' a phonetically written dialogue to capture the meridional accent and finished, in the lower right-hand corner of the page, with an advertisement for Fournier liqueur. The date of *Le Journal*, a signature and a dividing line conclude this reading of page 3. Picasso then points out that he will return to page 2 of the newspaper and to the headline about the "*donneuses de lait*". A new reference to the Conférence du Stage follows, then the titles of the 'Propos' column and the society calendar, then diverse titles of articles taken from the left- and right-hand columns. The '*Météo*' returns in the form of its title, followed by two rejoinders taken from '*Le Conte du Journal*'; then come the subtitles of the social register. After the announcement "*Merveilleuses et Muscadins*" [the ultrafashionable men and women of the Directoire period], the poem ends with a premonitory paragraph dealing with the rules set down by the Reich against Christmas and its "religious sentimentality": "*Domage!*" (*sic*: What a shame!) answers Picasso while introducing, indifferently, a typographical error.

From one page to the next it is clear that different modes of reading coexisted for Picasso. Nothing really jumps off the drab grey of the page. In large part, it is the random scanning of the eye that guides the textual cutting. On page 2, first attracted by the lower-case letters of the weather forecast, the eye moves in a spiral to the news area, then takes a triangular path that sweeps rapidly across the rough surface of the sheet: a topological automatism drawing its route on the paper. The analogy could be noted between such a visual diagram and the constructive schema of *Heads of Women*

(figs. 138–47), painted in 1941 on the full pages of *Paris-Soir* and based on the same rapid zigzag movement on the surface of the sheet. Here, however, Picasso composed close to half his text from '*Le Conte du Journal*', concerning the departure of a pair of artists, "migrating birds". Was this narrative an unconscious echo for Picasso of the couple – painter and ballerina – that he had previously formed with Olga? The 'flame of memory' would, then, be that of this amorous reminiscence and the entire sheet would be a kind of self-portrait. Likewise, at this time, when the birth of Maya (in September 1935) had just put a definitive end to Picasso's conjugal life with his wife and his son Paulo, the reading of the miscellaneous news section hovers three times over around the title "A Family Man Wanted to Play the Kidnapper" and mixes up the violent death of a young woman and shootings perpetrated by drunken men. All three of these anti-heroes from the 'news in brief' section fail: the first in his kidnapping attempt, the second with respect to his boss, and the third by missing the café owner but wounding his wife. These wretched events give to the troubled Picasso and to his ironic self-consciousness an opportunity to identify with these mishaps. As for the assassinated nurse, she evokes *Woman with Stiletto*[93] and the scenes of massacre in which Picasso symbolically got even with Olga. Here the eye reacts like a billiard ball off the cushions of the table. After the attack in grandiloquent type – the SVP advertisement – the ball rebounds off the subtitles and miscellaneous heading, periodically to return to the lettering of the advertisement for the telephonic newspaper. Then, at the end of the poem, there is the lovers' departure, engagements, marriages and deaths; nostalgia for the *merveilleuses* and tension towards this same regret: "*Domage!*". Ten days before Christmas 1935, Picasso, separated from his two children, was perhaps dreaming of a kidnapping, of "the Christmas tree of the little Italians" and "angels, saints, and kings", whose celebration Hitler had just banned.

Besides the hypothesis of such unconscious associations, the order in which one reads the printed page teaches us that Picasso, against the conventions of readability or typographical hierarchy, moves from small to large type. We learn how sensitive he is to the layout of the page in so far as it is a globally significant object, the columns, symmetries and transitions of which he respects. From this very year, 1935, Picasso increased the number of variations in the transcription of his poems and watched over their layout solutions. Each text could be handwritten, once or several times, enhanced with graphic marks (underlining, dashes, paragraphs in dark ink or in colour), illuminated with drawings, with handwritten calligraphy in French or Spanish, and then typed in one or the other language. The proliferation of versions and variations thus becomes a constitutive of Picasso's poetic work. This obstinate, almost obsessional interest in written text takes on the issues of written drawing or drawn writing as much as it does the mechanical rules of writing and typography. The relations between form and meaning are questioned as well, in the suppression or reinvention of a code of punctuation. "When Picasso started to write, some years ago", remarked Jaime Sabartès on 12 December 1935, "he would separate sentences with dashes, some large, others less so. A close reading, taking account of the length of pauses, will allow the reader to

Fig. 87
Pablo Picasso
Guitar
Céret, spring 1913
Coloured paper, charcoal, pencil, piece of newsprint pasted on cardboard
44 × 32.7 cm
MP 372
Musée Picasso, Paris

Fig. 88
Pablo Picasso
Bottle of Vieux Marc and
Newspaper
Céret, spring 1913
Pinned wallpaper, charcoal, chalk on
Ingres paper
47.8 × 62 cm
MP 373
Musée Picasso, Paris

Fig. 89
Pablo Picasso
Three Still Lifes
Avignon, summer 1914
Pen and brown ink
38 × 49.5 cm
MP 743
Musée Picasso, Paris

opposite Fig. 90
Pablo Picasso
Glass, Pipe, Newspaper and Playing
Card
[Spring] Paris, 1914
Pencil on paper
32.2 × 23.5 cm
MP 765
Musée Picasso, Paris

know how to read and interpret the text. Soon Picasso would do away with this convention and, in his current writing, there are no full-stops, commas, parentheses or capitals."[94] Sabartès states, moreover, that late in February 1936 a discussion took place with Braque on this question:

> Picasso affirmed that punctuation is a loincloth hiding the 'private parts' of literature ... He insists that he does not believe in the quality of what he writes, but does not want to be nudged into facility by removing the obstacles. Braque agrees: "In painting, the rules come afterwards ..." They agree that a well-turned sentence has no need of periods or commas. With or without them, so long as it is solidly constructed, the sentence cannot invite an erroneous interpretation. At five in the afternoon, they are still talking. For Picasso it is not sufficient to get rid of punctuation: "I would like to write without spaces between the words. What do you think of that?" There is no doubt this would make reading difficult. But Picasso sees everything in terms of painting and imagines compact paintings of printed lines with reduced margins, like frames adapted to the format of the page.[95]

It must be recognized that this last comment is an exact description of a column of newsprint. And the Spanish text "*muycercaapocoskilometrosdelacapital ...*" (fig. 105)[96] in which, over some forty lines without spaces between words, or punctuation, Picasso applied this programme, its direct illustration. It is the typed equivalent of the printed journalistic column as it appears running between the two long, narrow, white margins, that enable one to scan the block of text, with no further help whatsoever.

In the centre of a handwritten drawing-poem of 11 March 1936, Picasso pasted a narrow strip of text typed on a typewriter, on which the words "LE CRAYON QUI PARLE" (THE SPEAKING PENCIL) are set out in capitals like the artist's rejoinder to the slogan "the newspaper that speaks and answers". A piece of newsprint can be *seen* as a mass, but it is also there to be *read* and to be *enunciated*. It is at once both a block for the eye, a message for the mind and a sound in the mouth. It is not so much a question, for Picasso, of making the printed text say something other than what it says, or of making it into the matter of fiction, but, on the contrary, of allowing the very form of journalistic expression to keep developing: here, *Le Journal* "speaks and answers". It harbours all the expectations of the reader, and you have only to let the meaning go where it will. The layout of the text is already the text, presupposing all texts. Anticipating MacLuhan on the logic of the media, Picasso looked at and read the newspaper knowing full well that the medium *is* the message. The order, the rule, the form, the column, the style, the type: these are also part of the message. And, in the final analysis, the text could be reduced to its form, its nomenclature: news in brief, courtroom news, 'echoes', quotes of the week, society calendars, weather forecasts, wedding engagements, marriages, deaths ... The column headings direct the procession of the living, effacing all particular history in the anomie of the generic. On to this architectural framework are attached details, fragments of reality that are as the shadows of presences, incarnations, of things truly seen and experienced. Of this conjunction of the particular and the banal is born something uncanny comparable to that which Picasso sensed in the old '*carte-de-visite*' portraits he used to collect. Just

as the singularity of the individual is to some extent lost in the collective uniformity of the representative code, so every type of day-to-day historical event ends up dissolved in the laws of editorial layout. But the newspaper is also a form of oral culture. Titles and headlines are made to be shouted by street vendors. Its text, although written, is fuelled by the sounds of the world and echoes them. Unlike Mallarmé, for whom the printed press was the harbinger of the death of the written word, Picasso would see even more value in the impurity of the journalistic text, its effect of noise-making. Highlighted, in bold type, with ink blots, in sans serif font, capitalized, italicized: words give off the appearance of being a score of sounds. You have only to read *Maxima au sol* out loud to feel the force of the oral quality of the journalistic text. And at bottom it is the same both optical and potentially aural vibration that is inscribed in the 1912–13 *papiers collés* by the dissonant play of typographies. The association guitar/ score/newspaper at work in some of them[97] would tend to confirm this analysis. The musical score, as with the newspaper, encrypts the sound, its height, its tone, and induces its instrumental restitution, indeed its vocal restitution, since it is most often a question of popular street music. The press clippings can also be considered as grids of aural notations: consider the continuous buzz of journalistic 'echoes', like a back-ground noise on which Picasso sometimes (though seldom) exploded the words of the headlines: "UN COUP DE THÉ ..."; "LA BATAILLE S'EST ENGAGÉ". Indeed, the artist remained fond of newspaper paragraphs, compact typographic columns, discrete adver-tising boxes. According to Picasso's usage, the aural potential of press material did not partake in the noisy uttering that the Futurists wanted to cast into an 'onomalanguage'. Rather than the forced move of a commercial injunction or event, Picasso opted for the most attenuated forms and the most ordinary flow of shared language. In the *papiers collés*, as in the automatic poem, the press clipping retains a muffled, consensual, self-derogatory resonance. In both cases, *Le Journal* is precisely this commonplace of a shared language, the aesthetic potential of which was perfectly identified by Tristan Tzara: "this autonomous block of spoken language, taken as a whole and introduced into the written sentence, represents an opposition in the poetic order, where the nature of thought can rise to unsuspected transparencies."[98]

Understood thus, the plasticity inherent in newspaper collage would be discreetly tonal as well as visual. Read or heard, the title *Le Journal* is directly identifiable by everyone as a designation for "newspaper". It is interesting that for a Spanish ear, the word evokes the Castilian or Catalonian *jornal*, which stands for a workday and, by extension, the daily wage (fig. 88). The series of photographs taken at the boulevard Raspail indeed constitute the 'journal' of this phase of the invention of the *papiers collés*, while each one of them encapsulates the *jornal* of the artist, being a visual account of one of the days of this cycle. Moreover, it becomes clear that, in the *papiers collés*, as in the paintings and drawings of the same date, the abbreviations "JOU" and "JOUR" are the most usual (figs. 89, 91, 93). The section following the third letter, "JOU", is found five times in the *papiers collés*,[99] where the syllable is always preceded by the article "LE", whole or cut. The second part of the word, "IRNAL" or "RNAL"

(figs. 86, 92) appears three times,[100] and it is possible to reconstruct at least a pair from the following: "LE JOU" in *Bottle, Cup, Newspaper*[101] comes from the same copy of the newspaper as the "URNAL" in *Bottle, Glass, Newspaper*, "UN COUP DE THÉ".[102] It thus appears that Picasso systematically cut his titles in half in favour of the form "LE JOU". The systematic nature of this 'papery' economy distinguished it from Braque's practice or that of Juan Gris, both of whom, depending on the case, retain the beginning, the middle or the end of the word, seek more elaborated consonances and gladly use other press titles. With Picasso the *journal* is almost always the same, *Le Journal*, and the two halves of the title are alternately used in one collage and then in another. The preponderance of "LE JOU" is probably owing to the fact that the word, cut up like this, remains immediately recognizable. The practice of *papiers collés* applies above all to the use of the object *journal*. Besides that, there are the verbal associations JOIE/JOUER/JOUIR or URNAL/URINAL proposed by Robert Rosenblum[103] and the numerous debates and variations that they have inspired.[104] Jeffrey Weiss thus sees in the reiterated use of "JOU" "something of a logo for these pictures, the *mot d'ordre*".[105] It seems possible to push the interpretation of this syllable further as something of a signal of identity, by highlighting the consonantal correspondence between "LE JOU" and the Castilan *yo* (me/I) or *el yo* (the self), or, all the more so, their Catalonian equivalents: *jo* and *el jo*, or *lo jo* in some dialect variants. It will be recalled that Picasso signed two of his self-portraits of 1901 *Yo* or *Yo Picasso*.[106] Moreover, Daniel-Henry Kahnweiler has underlined this "rather curious fact": from 1908 to 1914, and therefore during the entire period of the *papiers collés*, Braque and Picasso "did not sign their paintings – nor their drawings – on the obverse side but on the back"; he sees here "the tenacious will to get to an impersonal execution, the conviction that the 'hand' of the painter, his 'personal style of writing', must not be discerned in the work".[107] But in 1914, at the very time when he imposed on his work the same rule of anonymity, Juan Gris, in the painting with *papier collé The Breakfast*, "imagined his own name set in headline type, as a kind of alternative signature".[108] So, too, Picasso, by playing on the double meaning *Le Journal/el jo/I myself*, would impose a sign that pointed to himself without having anything to do with the hand of the artist (fig. 90). This choice was a logical extension of his research at the time into the severance of the representative link, a move towards a literal presentation of the thing itself or its facsimile. The *el yo* that would be designated by the "JOU" of the *papiers collés* would thus be less an encrypted signature than an affirmation of the self-referential nature of works deriving their existence and meaning from the totality of formal procedures then 'invented' by the artist. In this sense, the repetition of *jo/yo* in the *papiers collés* resembles a trademark or a scale model. Throughout the sequence, this *jo/yo* signals the link between oral/written/visual cultures, between the signatory and the object, between the singular individual and collective history.

"Aesthetic Meditations"

The singular aesthetic status of the *papier collé* was precociously singled out by Picasso's contemporaries, his friends Guillaume Apollinaire, Louis Aragon, Tristan

Tzara, André Breton and Maurice Raynal. Early on they were able to recognize the plastic innovation of these works as well as their conceptual radicalism. In his text 'Picasso', published in *Montjoie!* on 14 March 1913, Apollinaire inserted into the first draft of the previous autumn a few notes on *papiers collés*, and the terms "wallpaper" and "newspaper" were added to the proofs:

> I am not an art-fearing man and I have no prejudice concerning painters. Mosaicists paint with marble or coloured wood. There is talk of an Italian painter who painted with excrement; during the French Revolution someone painted with blood. One can paint with anything, with pipes, stamps, postcards or playing cards, candelabra, pieces of oilskin, false collars, wallpaper, newspapers. All I need is to see the work – it must be seen – it is through the quantity of work put in by the artist that the value of a work of art is ascertained.[109]

The poet's mention of press cuttings in Picasso's *papiers collés* is justified by a list of elements chosen for their heterogeneous nature and for their common trait: "the art of the painter adds no picturesque element to the truth of these objects".[110] The direct but discreet way these real fragments become pictorial signs constituted for Apollinaire a kind of degree zero of representation in which the gesture of the artist is reduced to the "simple action of the numerator":[111] both "enumeration that becomes individualized"[112] and the numbering of elements and details of a world that would become of itself "its new representation".[113] This approach was, however, not developed in such a way as to allow for a more specific account of newsprint in its dual relation to the world: as material object and as an ensemble of verbal and iconic messages. In 1930, in *La Peinture au défi* (Challenging Painting), Aragon took issue with an even more general fault in the analysis: "No doubt this subject was intrinsically frightening for our minds, because, in the huge corpus of critiques devoted to Cubism, for example, there are but a few words to note the existence of the *papiers collés*."[114] Here is how he recalls Picasso's practice: "And then it would strike his fancy to pin on a piece of old newspaper, to add a few lines in charcoal, and that that be the painting. The extreme and arrogant poverty of the materials always pleased him."[115] Aragon nevertheless opposed two categories of *papiers collés*: "those in which the pasted element has itself form, or more exactly is itself the representation of the object, and those in which the inserted element is material."[116] He adds, "Unquestionably, the latter hardly constitute anything else but simple pictorial works with a colour problem, where the issue is only that of enriching the palette, a jesting".[117] He thus opposes this plastic conception of material with which newsprint has often been confused with a conception in which "what is expressed wins out over the way it is expressed, where the object depicted plays the part of a word".[118]

For Tristan Tzara, in an article published in 1931 by *Cahiers d'art*, 'Le papier collé ou le proverbe en peinture', the dimensions, both linguistic and plastic, of newsprint are not antagonistic:

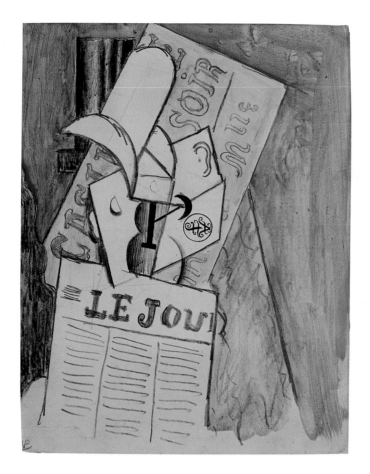
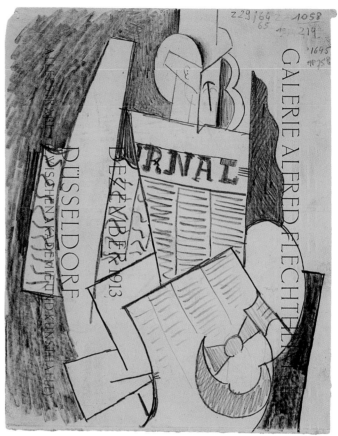

A form cut out of a newspaper and incorporated into a drawing or painting integrates the common-place, a piece of daily common reality, into another reality constructed by the mind. The difference in matter, which the eye can transpose into a tactile sensation, gives a new depth to the painting, where weight is inscribed with mathematical precision in the symbol of volume, and its density, its taste on the tongue, its consistency, places us before a unique reality in a world created by the form of the mind and the dream.[119]

This "taste on the tongue" is triggered by the tension between the discordant modalities of representation: fragment of the real object, facsimile, printed sign or image, drawing. By materially situating on the same plane these modes belonging to distinct semantic families, the *papiers collé* mimes the work of psychic recognition that the subject, in his apprehension of a world itself strewn with heterogeneous signs, must accomplish for himself. The *papier collé* actualizes the effect of this psychic work: hence this "taste on the tongue" that qualifies the pictorial surface, as a sensitive surface, an 'erogenous zone' conducive to the formation of visual and tactile sensations, as well as to a conceptual genetics of ideas. With the title '*Le proverbe en peinture*', Tzara emphasizes the embedding of the *papier collé* in a collective imagination where word and image condense a 'wisdom' foreign to the forms of high culture. In 1935, in his introduction to the catalogue *Papiers collés, 1912–14*, Tzara again took up the question of newsprint:

above, left **Fig. 91**
above, right **Fig. 92**
Pablo Picasso
Man Reading a Newspaper (recto, left)
Man Reading a Newspaper (verso, right)
Avignon, 1914
Gouache and pencil on invitation to Gallery Alfred Flechtheim, Düsseldorf, dated December 1913
16 × 12.7 cm
MP 758 R
MP 758 V
Musée Picasso, Paris

opposite **Fig. 93**
Pablo Picasso
Man Reading a Newspaper
Avignon, 1914
Water-colour and pencil on paper
32.1 × 23.9 cm
MP 759
Musée Picasso, Paris

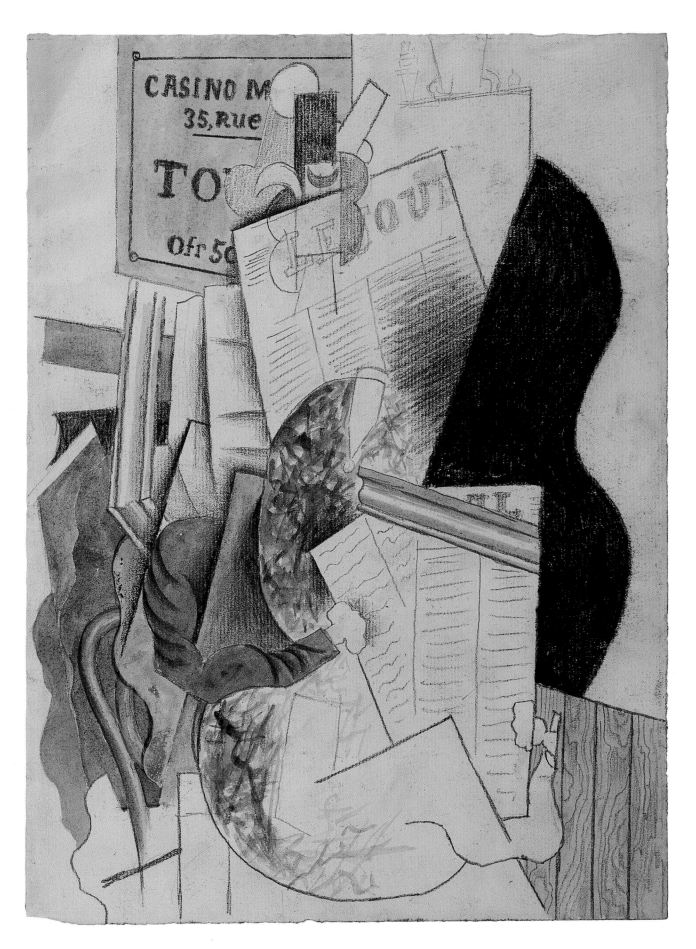

The very problem of reality as consciousness now posing itself as the activity called 'art', is that perishable and sordid matter is able in these circumstances to issue into a system that, while setting down the temporal aspects of a powerful current state, nevertheless transgresses by this very fact the bounds of the unconscious.[120]

The mention of this "perishable matter" directly echoes the article '*Picasso dans son élément*' that André Breton had published two years earlier in the first issue of *Minotaure*. In praise of the new status Picasso had bestowed on "the perishable and the ephemeral", Breton wrote:

Twenty years have passed over them, withering and colouring yellow those very pieces of newspaper in which still-wet ink had added greatly to the impertinence of the magnificent 1913 *papiers collés*. Light has faded the colours, while in some places dampness has stealthily loosened the big blue and pink cut-outs.[121]

But he concluded:

It is as if Picasso had reckoned with this impoverishment, this weakening, this dismemberment to come. As if in that uneven war whose outcome is not in doubt, that war against the elements which man's creations still wage against all odds, he had meant, in anticipation, to comply with, or rather ally himself with, what is ultra-real, hence precious, in the process of their decay.[122]

Tzara, in the wake of Breton, aligned himself with Aragon's *La Peinture au défi:* "The grandeur of Cubism in this era lies here: anything, be it perishable or not, enables these painters to express themselves, and all the better if it's worthless, if it disgusts everyone".[123] But newsprint is not just "anything" at all. For Tzara it was the medium that "sets the temporal characters of a potent current state"; it materializes like a "block of spoken language", the context able to provoke the event of an unconscious.

It was also on the occasion of the exhibition at the Galerie Pierre that Maurice Raynal published his article '*Les Papiers collés de Picasso*' in the April 1935 issue of *Arts et Métiers graphiques*. Comparing newsprint to the "architect's material", he wrote:

And the printer's lines following in the direction of the skimming of the brush, erecting columns of drab grey that light and shadow spin around, the bold letters playing in their graphic meanderings with the drawing of imaginary objects; the whites and blacks orchestrating the measures that are indispensable to the relief of the symphony. Like a piece of chamber music in which the orchestration of several stringed instruments invents a kind of plastic plain chant, or again almost unconscious hummings, like those that joy or suffering bring onto the lips of men'.[124]

Raynal continues:

So there was there an appeal to pure sensitivity, an initiation in feeling an original emotion, in feeling an absolutely disinterested visual shock, removed from the slightest intellectual interference of the

subject, removed from the polytonal resources of colour, removed from all sentimentality.

Like Aragon, Raynal opposes the aural and palpable evocation of newsprint to its purely optical value, a "simple enriching of the palette". For him, of course, the press material provided a superb and unheard-of plastic effect, but this was as an extra: newsprint is not colour, nor is it a still life in which the real object is simply consigned to the place of its representation. It is at one and the same time reality, its sign, its name, its power of affective commotion. "LE JO"/"LE JOUR" refers back as much to the 'I myself' of the signatory as to the infinity of the sensate world. The *papier collé* is a signifying sedimentation, a bifurcation of meaning: the site of an exchange between the author, the work and each spectator. The "unconscious hummings" inspired by the print on the paper speaks of how one of the witnesses to the revolution of the *papiers collés* – Raynal was a member of Picasso's inner circle as of the years 1912–13 – felt about and understood these new 'pictorial objects'. The muted rumination of oral culture expresses itself here by the sound of a hoarse throat. And beyond the sound of the city, it is other places and the legend of each that are remembered. The *papiers collés* thus prompted this daydream of Apollinaire's: "And then there are countries. A grotto in a forest where one does somersaults, a passage on the back of a mule over a precipice and the arrival in a village where everything smells like hot oil and turned wine."[125] One thinks of the summer of 1909 and Picasso's trip to Horta, the voyage to Gosol in 1906, and, moving still further back in time, to the first stay in the mountains of Horta in 1899. For, in Spanish, "LE JO" is also *lejo*, the evocation of the birthplace: 'far from'.The newspaper is indeed a "magic mirror allowing everything happening in the remotest corners of the earth to be seen". It is history, it conserves "the flame of memory", it prompts the resonance of recollection and it is that which "speaks and responds", for you and in your name, of your presence in the world.

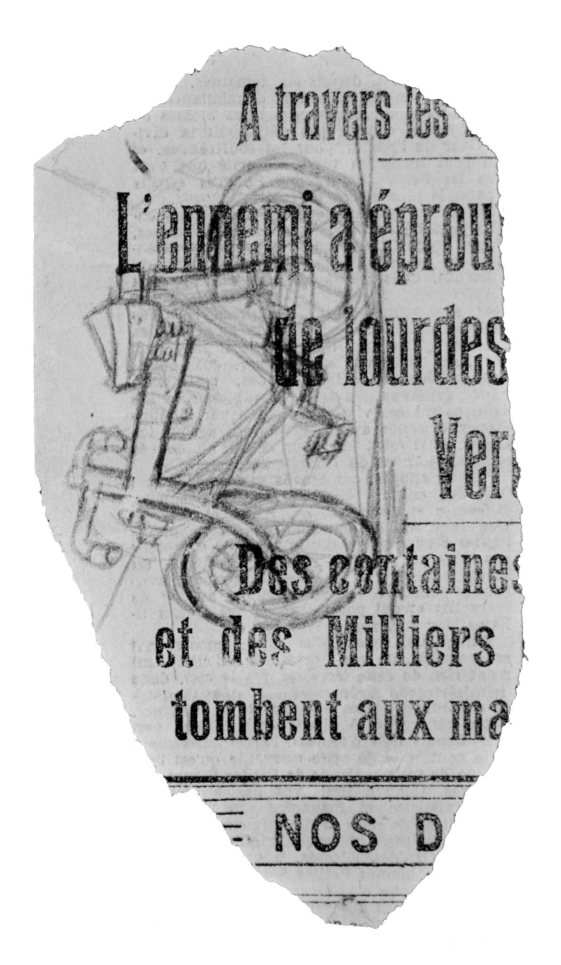

Chapter 3

1914–64: Newsprint as Matrix

The Iconoclast

A torn fragment of a page out of a daily paper, on which Picasso sketched a bicycle that might recall the movement along the Front by the conscripts Braque and Derain, dates from the First World War (fig. 94). The headline speaks of losses inflicted on the enemy at Verdun. In the course of the decade following the armistice, Picasso's use of newspaper as a support was much less systematic than during the period of the *papiers collés*. When Picasso did revert to the use of newspaper it was always in circumstances relating to the immediate consequences of the war, or new military episodes. The first example of this can be found in a collage of 1921, '*De la guerre au Senat*', in which a newspaper cut-out is pasted in the centre of a piece of cardboard and bears the geometric motif of a still life; the dedication to Jean Cocteau and the signature are squeezed into a scroll that extends the frame of the newspaper (fig. 95). As an assessment of the immense loss of human life during the years 1914–18, the article continues Picasso's testimony of wartime current events inaugurated with the *papiers collés* late in 1912. The memory of the carnage was still alive in 1923 when Picasso traced the Neo-classical image of a couple on to two photographs on the front page of the 23 July edition of *Excelsior:* one of the winner of the Tour de France bicycle race, the other of the inauguration by Maréchal Foch of the Bois Belleau memorial (fig. 96). While William Rubin detected in this drawing the evocation of a moment in the artist's love life, specifically his relationship with Sarah Murphy,[1] Kenneth Silver, from a more political vantage-point, wondered "whether Picasso was consciously aware that this beautiful sitter was being given form, literally, on top of the tragic memory of war ..."[2] Whatever the hypothesis, this work is the first in which a drawing is superimposed on a press photograph, which also serves as its source. The observer can thus see, as if through tracing paper, the fundamental difference between symbolization through draughtsmanship and through photography. Ten years later, an illustrated special report in the 15 August 1933 edition of *Paris-Soir* on the war in Morocco gave rise to an ink drawing, but not this time *on* the press photograph, but *after* it – that is, in its style

Fig. 94
Pablo Picasso
Bicycle
1914–18
Pencil on newsprint
14.5 × 8.4 cm
Private collection

(figs. 97, 98). The photographic portrait of the chief of the rebels is faithfully rendered by Picasso's pen, conserving the framing, the low-angle effect and even the line set out for the caption of the article. To be noted also is the article next to this *Paris-Soir* illustration dealing with Roosevelt's decision to send warships to Cuba. Each in their own way, these international events indirectly concern Spanish foreign policy and its colonial history.[3] Here, then, Picasso expressed his always vigilant interest in everything concerning his native country. He would return to the subject in the dramatic circumstances of the years 1936–37.

From 1935, following the coded poem *Maxima au sol*, Picasso's surrealist poems worked up a language of images according to a procedure similar to that whereby, in 1912–13, he pasted together fragments cut out of a newspaper. The textual montage of these writings likewise follows the spiral trajectory of the reader's gaze, but also follows the rules of composition according to which the manuscript graphically fills up the page. Each of these texts is thus destined to be read out loud as well as looked upon as a drawing. The onset of this practice of automatic writing coincided with the exhibition organized in 1935 at the Galerie Pierre, where, for the first time, Picasso's *papiers collés* were presented to the public.[4] Although some of them had been shown in 1930 at the Galerie Goemans in an exhibition of collages,[5] they had not been seen in Paris since the Kahnweiler sale in 1921–23, when the art dealer's stock was dispersed at auction. Between 1926 and 1930, only one *papier collé* was reproduced in *Cahiers d'Art*, to illustrate a piece by Christian Zervos, 'De l'Importance de l'objet dans la peinture d'aujourd'hui II'.[6] Captioned "*La Valse*",[7] it is in fact *Guitar and Musical Score*,[8] perhaps the first of the *papiers collés* from October 1912; it contains no newspaper cuttings. In June 1932, Apollinaire's piece 'Picasso', written in 1912 for *Méditations esthétiques: les peintres Cubistes*, was republished by *Cahiers d'Art* with a new title, '*Picasso et les papiers collés*'. The piece does not contain the corrections and additions Apollinaire made to the proofs in 1913; it appears alongside the *Head of a Man*.[9] Just when Picasso was beginning to be interested in writing, the Galerie Pierre gave him the opportunity to question the workings of his own artistic idiom, which he reconstructed and revealed in *Maxima au sol*. On 18 December of the same year, Georges Hugnet published in *Cahiers d'Art* an article entitled '*L'Iconoclaste*', presenting the first publication of Picasso's poems.[10] For the first time, the link was established between the *papiers collés* and the manuscript poems:

> Picasso lives in the real world. He proposed dazzling charades, he questioned fate and the primitive arts at the same time as immense human obsessions, he manhandled reality out of love. A painter, essentially a painter, he sacrificed painting to reality, the vibrations of which, energized on the canvas, would distort the element borrowed from life and which was suddenly out of place. "*Un coup de dés jamais n'abolira le hasard*", Mallarmé had said. The parts shop of metamorphoses was set on fire by Rimbaud. Picasso overturned images like idols.[11]

But in 1934, the first congress of the Union of Soviet writers offered, with 'socialist realism', the theory of the subjection of artistic practice to propaganda. At the heart of

Fig. 95
Pablo Picasso
***'De la guerre au Sénat'* (Of War in the Senate)**
1921
Ink and newsprint on cardboard
38.7 × 28.6 cm
Signed and dedicated to Jean Cocteau
Private collection

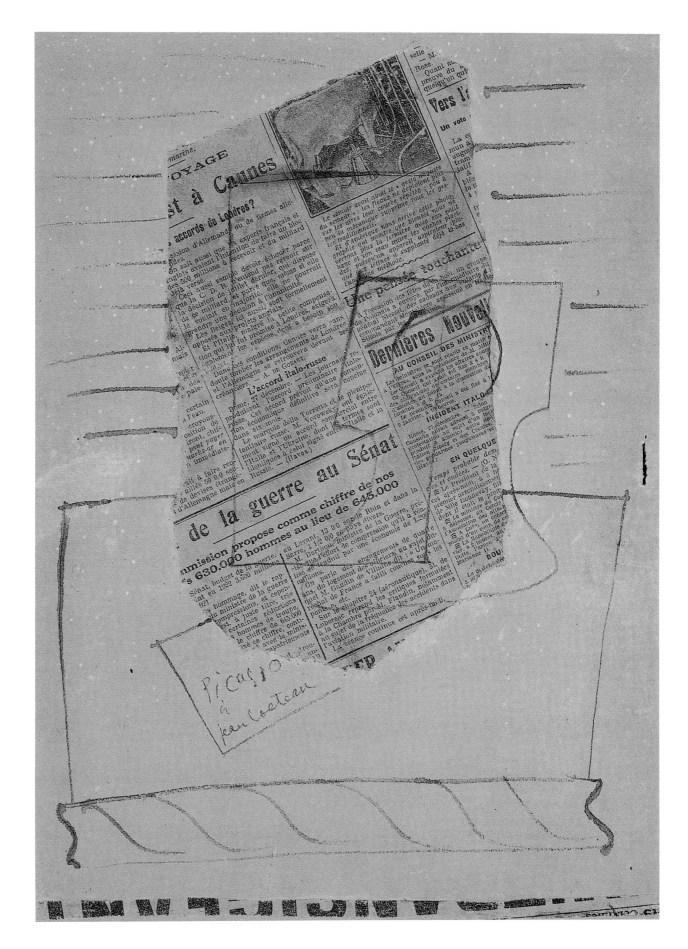

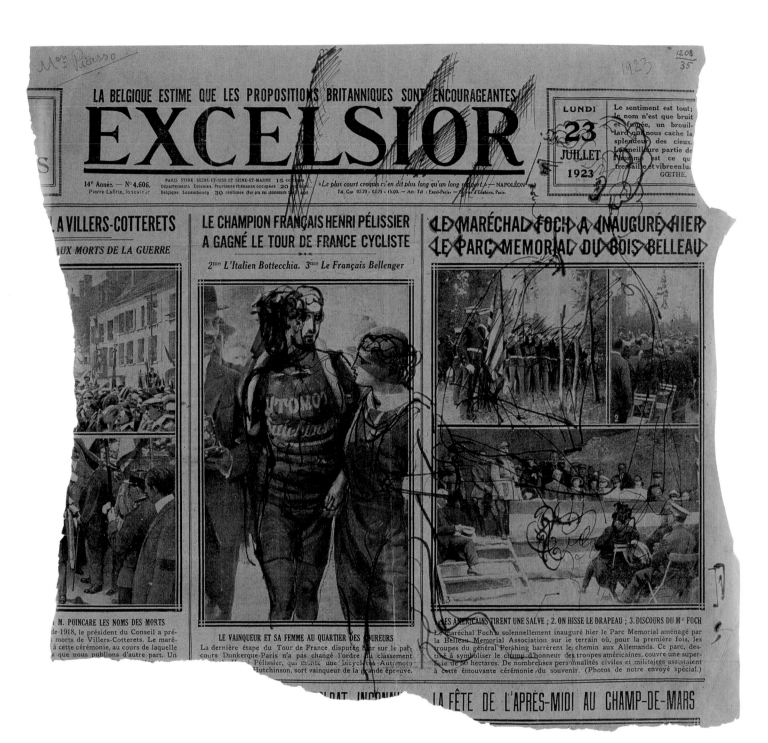

the heated debate among intellectuals and artists brought on by these circumstances, the public presentation of Picasso's *papiers collés* betokened an art informed solely by its own formal requirements without neglecting, for all that, the conscience of its contextualization. Hugnet's further comments suggest as much:

> Picasso offers a great lesson of courage and revolt. He knows and we know we shall be among the first of fascism's victims ... Picasso continues ... his behaviour, the unshakeably aggressive dignity of his work, the *situation* of his contribution in the field of expressive means, makes him, strictly speaking, an authentically revolutionary man. For it is so true that reality cannot be forgotten.[12]

Fig. 96
Pablo Picasso
Profile of Classical Figure
Antibes, summer 1923
Ink on newsprint from *Excelsior*, 23 July 1923
33.9 × 35.5 cm
MP 984
Musée Picasso, Paris

Fig. 97
Paris-Soir
Clipping from *Paris-Soir*, 15 August
1933
MP 1876 A
Musée Picasso, Paris

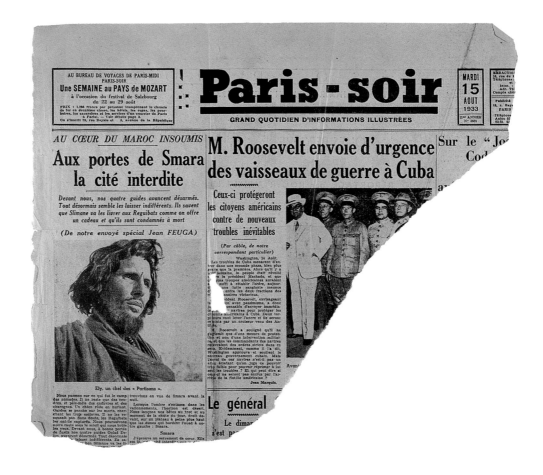

Fig. 98
Pablo Picasso
Portrait of Moroccan Rebel
Cannes, after 15 August 1933
Pen and black ink on sketch-pad
34 × 45 cm
MP 1876
Musée Picasso, Paris

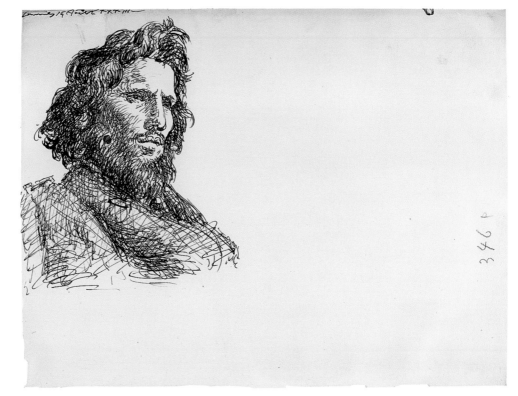

Fig. 99
Pablo Picasso
Three Bull Heads
1923
Indian ink on newsprint
11 × 41 cm
Private collection

At the very time when his practice of poetry seemed to have distanced him from painting and from reality, Picasso returned to the *papiers collés* as to a productive process related to its historical situation and to a renewed practice of reading/cutting newspapers.

Aragon had already underlined the importance of the 1926 work *Guitar* (fig. 100),[13] the collage of a floorcloth, a cord and a press clipping, with nails planted throughout, turned towards the eye of the onlooker. "He made a collage with nails jutting out of the painting. There had been a crisis, two years ago, an actual crisis of collage ... he wanted the true remains of human life, something poor, soiled, disdained."[14] Roland Penrose added: "Picasso told me he wanted to sink razor blades into the corners of the canvas so one's fingers would get cut lifting it up."[15] With this gesture of violent denial of the 'doing' as well as the 'seeing' of painting, Picasso assumed the role of *objector* that Christian Zervos had assigned to him in the editorial 'Fait social et vision cosmique', in the same issue of *Cahiers d'Art* as Hugnet's article.[16] Apollinaire, at the time of the *papiers collés*, described Picasso as a "numerator". This inventory, this numeration of reality, would extend, in a critical development, into the 'objection' of the Surrealist period of 1926–36. The wound caused by *Guitar* would be something like the procedural materialization of the role assigned to the press *clipping* (in French: *coupure*) in this painting, following the *papiers collés* of 1912. Newspaper and floorcloth, far from seeking to transfigure their prosaic reality by stepping into the world of painting, bind their forces so as to desublimate it better. The signal objects – floorcloth, press clipping – and the reading tools – nails, razor blades – comprise what Penrose calls "an evil spell":[17] a machine comparable to the one in the 'Prison Colony' of Kafka's short story, tatooing in its victim's flesh – the lover of painting – its message, the unbearable presence of ordinary reality.

Confirming their ontological tie with press material, several handwritten poems of 1936 were inscribed on newsprint. Thus on 27 January 1936, Piscasso jotted down a few words, using the cut-out margin of a daily newspaper – an oblique angle giving the poem its subject: "News of the thread irrigating the destiny of the sheet's fold ..."[18] (fig. 106.) Similarly, there are, on both sides of a fragment of *Le Journal*, the title of which can be made out, two texts dated respectively Saturday 31 January and Sunday 1 February: "Love is a thistle that must be reaped at every instant if you are to doze in its shadow" (fig. 107); "Another time the tip (of the horn) of the bull opens the horse's barrel of old wine and the tavern lit by blood's oil explodes the parade drum of pain" (fig. 108). On the letterhead of *Ecole et Liberté*, dated 15 December 1936, Picasso noted in Spanish "the virginity of the bull, who is the virgin submitted to/the surrounding , shouting *olés*" (fig. 109).[19] Lastly, on a piece of newspaper margin, the following is written in purple ink: "of horse is the sausage of the soul" (fig. 110). This is the train of Picasso's writing, between aphorism, verbal play and concatenation of poetic associations. The longest texts, most often written at one sitting, were afterwards corrected, transcriptions and translations denoting an infinite patience in the artist and in those of his inner circle. In their shortest form, we have here the initial

Fig. 100
Pablo Picasso
Guitar
Paris, spring 1926
Ropes, newsprint, floor-cloth and nails on painted canvas
96 × 130 cm
MP 87
Musée Picasso, Paris

overleaf, left **Fig. 101**
Pablo Picasso
Handwritten poem, 'Maxima au sol'
Black ink, dated 14.12.1935 on paper
25.5 × 17.5 cm
MP 3663-1
Picasso Archives, Musée Picasso, Paris

overleaf, right **Fig. 102**
Pablo Picasso
Handwritten poem, 'Maxima au sol', second sheet
Black ink dated 14.12.1935 on paper
25.5 × 17.5 cm
MP 3663-2
Picasso Archives, Musée Picasso, Paris

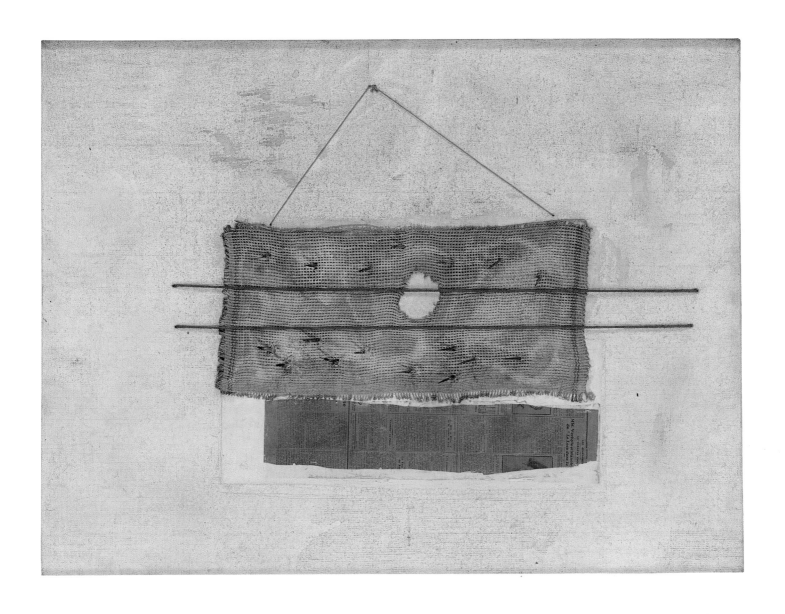

Paris 14-12-35 (Journal pag 2) LE 8-12-35

MAXIMA au sol - sous abri - minima - sous abri -
maxima sous abri -

755 mm. (1.007) maximum +5

Abbeville - ajaccio - alger - angers -
antibes - Belfort - Besançon - Biarritz
Bordeaux - Bréhat - Brest - calais -
chartres - Châteauroux - cherbourg - Dijon
- Le Havre - Le Puy - Lyon - marseille
- Montélimar - Nancy - Orleans - Perpignan
- salon d'automne - grand Palais -
association française pour la défense des
animaux - les precurseurs de Pasteur
- les enfants martyrisés ou enlevés...
... et le message de Noël - A.C les
35 X 285 R. A. L. matiné artistique
14 HS - après l'appel des morts de
la guerre et la minute de silence
- il est souvent indispensable,
pour assurer leur santé et parfois
leur vie la finesse des traits, la force
séductrice et le sex-appeal du ravissant
petit menage - la flamme du
souvenir - oiseaux migrateurs qui
pépient et sautillent avant de plonger leur
essor, ils partirent, laissant derrière eux des
figures de nouveau ravagées, des coeurs tout à
coup refermés, et l'ennui cousin de la douleur.

14 Décembre XXXV.

Ce qu'est ↑S.V.P. s'y prit comme un
enfant on la trouve expirante la tête,
la poitrine engagées sous une armoire
un père de famille tiré dans la porte et
faillit blesser le patron la mort mystérieuse d'une
infirmière et ce n'est pas tout ! il voulait
boire on ne lui ouvrait pas il avait trop bu
et ne pouvait payer un père de famille voulait
jouer les KIDNAPPERS ~~~~~~~~ c'est un
journal qui parle et qui répond car lui seul
l'étreint sans douleurs ôô Fernand — ôô mon collègue
une femme que j'ai refringuée sève ligneur
à la fine champagne Demars St Amand (cher)
Le Journal 8.12.35 page 3

(Page 2)
Tondeuses de lait la séance de rentrée de
la conférence du stage propos carnet mondain
une première au monde des poissons voyages
pour l'arbre de Noël les petits italiens
le jubilé de l'escadron français MÉTÉO
quel entêtement ! les amoureux d'en bas vont
nous quitter fiançailles mariage nécrologie
merveilleuses et muscadins dommage ! ...

— LES FAITS DIVERS = LES TRIBUNAUX —

La mort mystérieuse d'une infirmière

On la trouve expirante la tête, la poitrine engagées sous une armoire

Mme Rallieul, qui assure avec attention la garde de cet immeuble d'aspect modeste qui s'élève 12, rue Eugène-Gibez, était inquiète, bien sûr, hier matin. Elle n'avait point vu depuis trois jours une de ses locataires, une vieille jeune malade, Mme Marie Huanic, âgée de 68 ans, ancienne infirmière.

Mais quand, à la fin de la matinée, Mme Rallieul eut fait ouvrir la porte de l'appartement et qu'elle eut pénétré dans la chambre, elle trouva au locataire étendue et mourante. Le grand désordre qui régnait dans le logis de la vieille femme lui indiquait immédiatement que...

Quand Mme Rallieul entra dans cette chambre, peu poignée, pour tout dire, accompagnée d'un serrurier et d'un voisin, elle aperçut Mme Huanic étendue par le sol. Sa tête, ses épaules et sa poitrine étaient engagées sous une armoire et elle demeurait ainsi inerte.

Son corps ne portait aucune blessure et fut se prêt à douter que Mme Huanic eût été victime d'un bandit.

Ce chômeur, ce garçon de courses...

Henri Poulner a bien été arrêté à Buenos-Ayres

La nouvelle que nous annoncions dès hier en exacte: le confident de Stavisky, le fameux Henri Poulner, en fuite depuis deux mois, vient d'être arrêté à Buenos-Ayres.

La procédure d'extradition est engagée; deux policiers français vont chercher le prisonnier.

FUSILLADES SUR LA RIVE GAUCHE

Il voulait boire on ne lui ouvrait pas

Il tira dans la porte et faillit blesser le patron

Les habitants de la rue Huyghens ont pu croire hier matin que certains hôtes indésirables de Montmartre avaient quitté leur quartier d'élection pour venir régler leurs différends à Montparnasse.

Il était pas tout à fait six heures quand on entendit trois détonations successives; des cris s'élevèrent, puis, de nouveau, des coups de feu crépitèrent. C'était maintenant une véritable fusillade.

Il avait trop bu et ne pouvait payer

C'est avec le revolver qu'il voulut s'acquitter

Un individu certainement peu recommandable, mais sur lequel on ne possède encore que des renseignements imprécis, Marcel Lemoig, 27 ans, a tiré vendredi soir, heureusement sans l'atteindre, un coup de revolver sur le débitant de la rue Violet, il a été ensuite blessé par la femme du cafetier, qu'il a grièvement blessée, puis a retourné son arme contre les agents. Finalement il devait être lui-même blessé et mis hors d'état de nuire après une poursuite mouvementée.

UN PÈRE DE FAMILLE VOULAIT JOUER LES KIDNAPPERS

Il s'y prit comme un enfant... et se fit arrêter

Peut-être si le « kidnapping » avait pénétré, en France, de pratique courante, M. Experi-Besancon, industriel à Aubervilliers, eût-il tremi en recevant, jeudi matin, une certaine lettre signée « Le Tueur ».

AU PALAIS

Le tribunal correctionnel confirme un jugement concernant M. Gaston Vidal

M. Gaston Vidal, dont nous avons relaté il y a quelques jours l'arrestation, sur mandat de la cour d'appel, a été annulé hier après-midi devant la 11e chambre correctionnelle, présidée par M. Milton.

Le collectionneur d'armes est remis en liberté provisoire

EN QUELQUES LIGNES...

— Mme Raffini, tenancière du café du Luxembourg, à Avignon, a grièvement blessé de trois coups de revolver son mari qui l'avait saisie à la gorge.

— Deux des marins blessés dans l'explosion de chaudière du cuirassé *Paris* ont succombé hier: le second-maître chauffeur Prigent Marie et le second chauffeur Le Flem.

DEUX... CHEZ LES GANGSTERS

Le crime de Raymond

Il y avait moins d'un an que Marthe, fille d'Avignon, s'était laissé convaincre de « monter » à Paris, une voie dans les platanes, que un lot de « estranges » n'a l'accent point nettoyé. Un de Marseille, pourtant, à ce qu'il disait.

— Même, affirmait-il, que j'étais officier de la marine marchande. Mais les embarquements sont rares en ce moment. Là-haut, je trouverai bien de quoi m'occuper...

Elle fut un peu surprise quand, au débarqué, il l'emmena prendre l'apéritif à un apéritif de Parisien, mais un tapis, serré au comptoir avec la soucoupe d'olives et d'anchois — dans un bar des boulevards extérieurs, juste la place du Delta, elle fut un peu surprise donc de l'entendre accueillir par une bordée d'exclamations familières:

— Ce! Fernand.
— Oh! Mon collègue...
— Vé! Le Marseillais.

Et plus encore de l'entendre, lui, répondre, on accent qu'elle ne lui connaissait pas, plus chantant et plus mouillé que le sien propre.

SÈVE FOURNIER
LA FINE CHAMPAGNE
FOURNIER — DEMARS
DIAMANT (Cher)

Jean Balensi
et Albert Charles-Mercée

(Dessins de Dignimont)

(A suivre)

Voir le Journal du 7 décembre.

muycercaapocoskilómetrosdelacapitalnadamáscomolotrasmanodelainfrecuentad
arutaparecesinembargoalejarenunaproporcióninverosimillaestanciadelcolora
doantiguapropieddelpresidentesantosdenominábaseprimitivamenterincóndef
alsónaquelextremodeldepartamentodecanelonesfronterizoaldemontevideoencer
radoporelríosantaluciaylosarroyoslasbrujasycoloradoradicabalatoponimiaor
iginalenelapellidodelaviejafamiliaqueemparentóconlosestrázulaselministro
drdonjaimeymonseñorsantiagoeranestrázulasyfalsónelultimoengratitudasupro
tectorelvirtuosovicariojosébenitolamastrocóelapellidomaternoporeldelamas
ahoraperdidacasiladenominaciónvernáculasuelellamárseleavecesrincóndesant
oslaestanciapropieddelexpresidentequeseconocióporestanciadelcoloradoer
aunaposesiónqueentresuslímitesoriginariosabarcabalasuperficiede4.40cuadr
asequivalentesa3250hectáreasdespuésdelamuertedelcapitángeneralocurridaen
buenosairesell0demarzodel889veinticincodíasdespuésdehabercumplido42añosl
aestanciafuéhijueladaentresusherederoslaviudadoñateresamascaróyloshijosm
áximojoaquínlorenzoleónoscarteresamaríacarmenysofíaenlafracciónadjudicad
aadoñateresaseincluyólacasaquedeentoncesalafechahatenidosucesivosdueñosc
reoquelaparticularfisonomíaadustadelpaisajecontribuyaaahondarlasugestión
dequeelcaminoseestiradosvecesunpocoespaciadasprimerobajoelcielocenicient
odeunaventosatardeinvernalyluenenlagloriadeunaradiantetardedeprimaveral
aimpresiónnocambióelgranconjuntodecasaslaespesamanchaverdedelaarboledapi
nceladaocredeltechodeunenormegalpóndesarmonizaconelpaisajeagresteabrusca
squebradas queevocanenciertosmomentospedazosdepaisajeminuanodisimuladapo
rlospronunciadosdesnivelesdelosalrededoreslaestanciaaparecedeimprovisode
spuésdepasarelarroyodelaspiedrasdivisoriodecanelonesyelcoloradoquehaceba
rraenaquelunpocomásabajoambascorrientesdeaguasefranqueanpormpuentes
modernoeldelaspiedrasconstruidoentiendohacemediosigloeldelcoloradosólida
fabricacióndesilleríaaldescubiertounaespeciedetorreonespequeñospuestosen
serieleprestanciertocaráctermilitaracordadoalaépocaenquemandabaelcapitán
generaldentrodelapiedrafundamentaldeestepuenteleíalgunavezeldraugus tonin
presidenteelaño1885delajuntaeconómicoadministrativaquisoquesecolocarajun
toconlaspiezasdeliteraturaoficialyprotocolariaellibroreciénaparecidodeca
rlosroxioestrellasfugaceselpoetamodestoempleadodelregistrocivileradistin
guidoporlaestimadelpersonajepolíticodelahorahombreinteligenteycomprensiv
oporlodemásquepropugnabasegúnpereceporvincularloalasituaciónconstituyeel
cuerpofundamentaldelaspoblaciones unaconstruccióndesuperiormaterialcontr
esfrentescortándoseenángulorectoelcuartoánguidelcuadroloformalaverjadeh
ierroquesearaelpatio

Je me lais endormir dans le murmure du ruisseau dans les mains le bout des doigts

Essaim bruissant de mille abeilles ceci gaillard le dechirer le germe

3663

previous pages, left **Fig. 103**
Le Journal
8 December 1935
Page 2
Documentation Centre, Musée
Picasso, Paris

previous pages, right **Fig. 104**
Le Journal
8 December 1935
Page 3
Documentation Centre, Musée
Picasso, Paris

opposite **Fig. 105**
Pablo Picasso
Type-written poem,
'Muycercaapocoskilometros ...'
Paris, spring 1936
27 × 21 cm
MP 3663-8 SD
Picasso Archives, Musée Picasso,
Paris

above **Fig. 106**
Pablo Picasso
Handwritten poem, 'Mueva al hilo
que vaña ...' (News of the thread
irrigating ...)
27 January 1936
Pencil on newsprint
20.8 × 21.9 cm
MP 3663-3
Picasso Archives, Musée Picasso,
Paris

top **Fig. 107**
Pablo Picasso
Handwritten poem, 'L'amour est une ortie ...' *(Love is a thistle ...)*
31 January 1936
Pencil on newsprint
20.8 × 21.9 cm
MP 3663-3
Picasso Archives, Musée Picasso, Paris

above **Fig. 108**
Pablo Picasso
Handwritten poem, 'Otra vez el pico del toro ...' *(Another time the tip [of the horn] of the bull ...)*
1 February 1936
Pencil on newsprint
3.5 × 21.2 cm
MP 3663-4
Picasso Archives, Musée Picasso, Paris

top **Fig. 109**
Pablo Picasso
Handwritten poem, 'Virginidad del toro ...' (The virginity of the bull ...)
6–25 February 1936
Pencil on newsprint
Ecole et Liberté, 15 December 1935
8 × 24.5 cm
MP 3663-5
Picasso Archives, Musée Picasso, Paris

above **Fig. 110**
Pablo Picasso
Handwritten poem, 'De cheval est ...' (Of horse is ...)
Pink ink on newsprint, undated
2.4 × 11.9 cm
APCS A I, 3
Picasso Archives, Musée Picasso, Paris

flash of scriptural intuitions that Picasso rushed to get on to the page of the newspaper, the raw material of his daily life. It is the rough equivalent of Picasso's gift for conversation that Brassaï described as "full of humour, funny stories, jumps and starts, unexpected images, head-spinning, forceful short-cuts".[20] Sometimes springing directly from a reading of titles or articles, the text-image is as immediately forceful as those "primary visions" of which Picasso spoke in his 1935 conversations with Christian Zervos,[21] and which made up, he said, the point of departure and often the point of arrival of his paintings.

Cadavres exquis

Picasso renewed his habit of making graffiti on newspaper, alongside his poetic experiments, in 1936–37. More than ever, political events in France and abroad were a cause for tension. Picasso's relationship with Dora Maar also contributed to his politicization. A photographer and militant, Dora Maar had just returned from Spain with a searing photographic report on the situation there. She was instrumental in bringing Picasso into the intellectual circle of the French Communist Party, of which Paul Eluard was a member. At the same time, Dora Maar's contacts in the Surrealist movement, whose members had a high opinion of her photomontages, afforded her a good deal of freedom. In games of rhyming, punning and *cadavres exquis* (the game of consequences), she proved to be a fitting partner. In July 1936, Picasso illustrated for her a copy of *Marianne* devoted to the Popular Front (fig. 111). This featured both marks made with a rainbow-lead pencil, unfolding its colours as the line proceeds, and the dove motif. On 16 April 1937 Picasso executed two grotesque caricatures of his lover in the margins of an edition of *Paris-Soir* (figs. 112, 113). On the photographs of the 17 April 1937 edition of this daily, he sketched drawings in the same farcical vein: "The female creator from New York" (fig. 115) becomes a torero, with moustache and sombrero; "The chauffeur Naudin seems out of danger" (fig. 114), but is equipped with an inordinately large nasal appendage; "Four great pilots talking about acrobatics" are disfigured by the slide of their facial components towards their foreheads; and "His Majesty the King of Sweden" (fig. 116) seems stupefied by the frown addressed to his glory by a midget.

Just a few days before the destruction of Guernica by the German army, on Monday 19 April, the intense reaction set off by a *Paris-Soir* headline on the French decision not to intervene in Spain, prompted a graphic commentary in a graver tone: Picasso used this article as the support for a sketch with the same motif as *The Orator* (fig. 117),[22] to which he pinned a raised arm clenching a hammer and sickle. A variation on the subject appears on another sheet, dated the same day, next to an account of a project for the installation of a painting commissioned by the republican government for the Spanish pavilion at the International Exhibition, due to open on 24 May 1937 in Paris (fig. 118). Dismayed by the destruction of Guernica, Picasso decided to centre his composition on the martyred Basque town. The motif of the raised arm was used again in the first stages of the painting, the traces of which are conserved in Dora Maar's

photographs (figs. 120, 121).[23] In the final version of *Guernica*, the hand of the prostrate man still yields the broken sword. The mortal combat between the horse and the bull was, by the end of the 1930s, the dominant metaphor of human violence in Picasso's painting and poetry. The theme was prefigured in 1923 by the drawing *Three Bull Heads* (fig. 99), done on a strip of newspaper spanning six columns. Seen in profile or three-quarters view, the heads are traced in Indian ink, with the unbroken line already observed during the years 1906–07. Three sheets date from this periods,[24] devoted to the same subject and using the technique of the continuous line whereby the pen must not leave the surface from one end of the subject to the other. The skill of the torero is matched by that of the artist. Picasso used the width of the columns to position the three heads into this kinetic sequence: the profile is in the middle of a block of text, while the middle head, drawn in a three-quarters view, straddles a vertical line, and the third, on the right-hand side, takes up three columns. The printed text, turned upside-down, constitutes the ground of the grid. Partitioned by typographic columns, the horizontal structure of the study prefigures that of *Guernica*, as it does the strip-like composition of the two engravings of January 1937 entitled *Dreams and Lies of Franco* (figs. 122, 123). Temma Kaplan has shown how these engravings were directly inspired by the usual form of Catalonian *auques*, a kind of printed popular illustration going back to the seventeenth century: "Engravings printed on large paper, divided into forty-eight boxes in eight lines of six rows, *auques* resembled the features pages of modern newspapers."[25] Originally, *auques* formed a game of chance with divine capabilities and ends, and were banned several times in the seventeenth and eighteenth centuries. Later they would become the supports of fantastic or fanciful images called *El mon al reves* ("the world upside-down", the equivalent of *Azul y Blanco*'s *Todo revuelto*) or of commentaries on current events, such as the Napoleonic occupation (*Baladrers de Franca*), the nineteenth-century Spanish civil wars or the general strike of 1902 in Barcelona. Picasso was not the only one to work in this traditional genre, since the *Auca del noi català, antifeixista i humà* ("The *auca* of our antifascist and human Catalonia") also appeared in 1937. As for *Guernica*, it has been written of Picasso that he was "the first painter to see his work in the light of the mass media".[26] The imagery and monochromy of the great 1937 painting were evidently borrowed from the press illustrations of the town's bombing. It would be their plastic equivalent, extending on the pictorial plane the shock-wave running through the press, in which the visual effects of headline lettering and photographs collided. This is what Stephen Spender saw in *Guernica* as early as 1938:

> a picture of horror reported in the newspapers, of which [one] has read accounts and perhaps seen photographs ... The flickering black, white and grey lights of Picasso's picture suggest a moving picture stretched across an elongated screen, the flatness of the shapes again suggests a photographic image, even the reported words. The centre of this picture is like a painting of a *collage* in which strips of newspaper have been pasted over the canvas.[27]

Fig. 111
Pablo Picasso
Dora My Love
Coloured pencil drawings on the front page of *Marianne*, 8 July 1936
38 × 54.5 cm
Archives de France, Paris

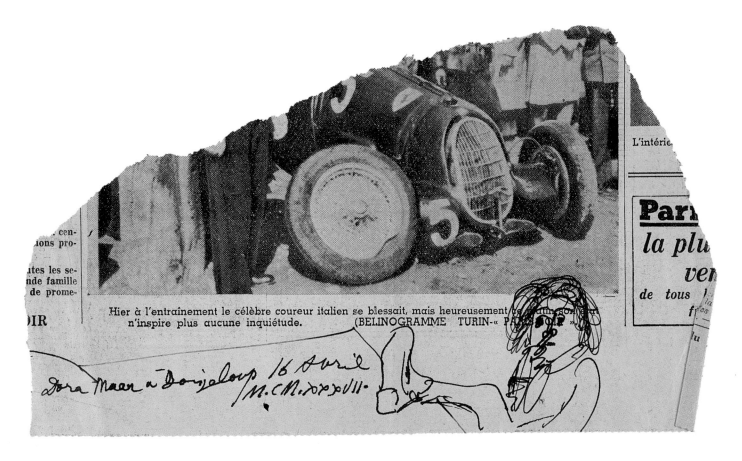

above **Fig. 112**
Pablo Picasso
Caricature of Dora Maar
Boisgeloup, after 16 April 1937
Black ink on newsprint from *Paris-Soir*, 16 April 1937
12.4 × 22.5 cm
MP 1998-85
Musée Picasso, Paris

right **Fig. 113**
Pablo Picasso
Caricature of Dora Maar
Boisgeloup, after 16 April 1937
Black ink and pencil on newsprint from *Paris-Soir*, 16 April 1937
11.8 × 11.6 cm
MP 1998-84
Musée Picasso, Paris

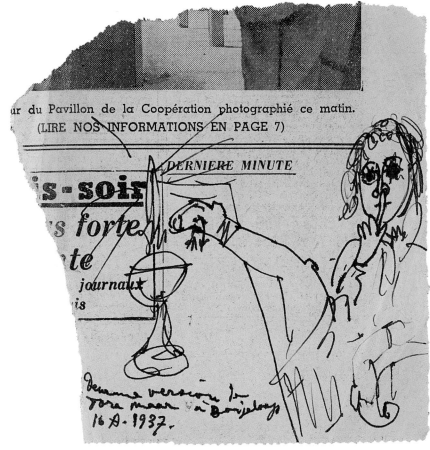

LE CHAUFFEUR NAUDIN PARAIT HORS DE DANGER

Le médecin soignant le chauffeur Naudin et celui qui faillit être son meurtrier, André Theurier, considère les deux hommes comme hors de danger. Tous deux sont soignés à l'hôpital de Vichy. Naudin se souviendra longtemps de la folle randonnée de son taxi sur les routes du bord de la Loire. Voici l'infortuné chauffeur sur son lit d'hôpital, photographié hier à Vichy.

QUATRE GRANDS PILOTES DISCUTENT « ACROBATIE »

Les quatre « as » de l'acrobatie aérienne qui se rencontreront en un match sensationnel le ... Vincennes, étaient réunis hier autour de la même table et, avec une maquette d'avion, p... vrilles, de loopings, de tonneaux et de vols sur le dos. De g... Marcel Doret, Massott... René Paulhan. Ils se quittèrent bientôt pour ... terrain d'entraîner...

Fig. 114
Pablo Picasso
The Chauffeur Naudin and Four Great Pilots
After 17 April 1937
Black ink and pencil on newsprint
from *Paris-Soir*, 17 April 1937
36.9 × 18.9 cm
MP 1998-81
Musée Picasso, Paris

Fig. 115
Pablo Picasso
The Female Creator of New York
After 17 April 1937
Black ink and pencil on newsprint
from *Paris-Soir*, 17 April 1937
16 × 16 cm
MP 1998-83
Musée Picasso, Paris

Fig. 116
Pablo Picasso
His Majesty the King of Sweden
After 17 April 1937
Black ink and pencil on newsprint
from *Paris-Soir*, 17 April 1937
22 × 19 cm
MP 1998-82
Musée Picasso, Paris

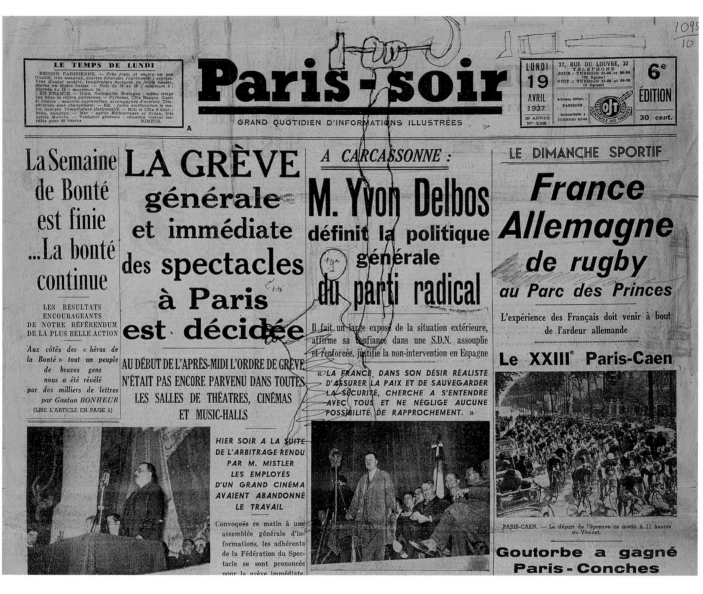

Fig. 117
Pablo Picasso
Character Holding a Hammer and Sickle
Le Tremblay-sur-Mauldre, Paris, April 1937
Ink and pencil on the front page of *Paris-Soir*, 19 April 1937
60 × 43 cm
MP 1177
Musée Picasso, Paris

Fig. 118
Pablo Picasso
The Studio; The Painter and His Model; Arm Holding a Hammer and
Sickle
Le Tremblay-sur-Mauldre, Paris, 19 April 1937
Pen and Indian ink on blue paper
18 × 28 cm
MP 1190
Musée Picasso, Paris

LE PLUS HORRIBLE BOMBARDEMENT
DEPUIS LE DEBUT DE LA GUERRE D'ESPAGNE

Mille bombes incendiaires

lancées par les avions
de Hitler et de Mussolini

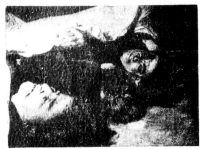

Aucun hasard dans l'atroce extermination, par les fascistes, de la population non-combattante. Marchés fréquentés, églises pleines, quartiers peuplés, voilà les objectifs préférés des meurtriers. Ci-dessus, quelques femmes — des mères sans doute — abattues au cours d'un bombardement

réduisent en cendres la ville de Guernica

LE NOMBRE DES MORTS ET DES BLESSÉS
EST INCALCULABLE

En même temps, à la faveur du contrôle, Valence
est canonnée

JUSQU'A QUAND tolérera-t-on les exploits effroyables du fascisme international ?

Plus que jamais
unité d'action internationale
contre les fauteurs d'agression!

NE le dissimulons pas ; depuis trois jours, la situation sur les fronts espagnols revêt un caractère d'extraordinaire gravité. Bloqués sur le front de Madrid, rebelles et interventionnistes déploient dans le pays basque un effort désespéré. L'intervention active des avions allemands et italiens leur a assuré, avant-hier, la possession de Durango et d'Eibar. Sans doute, la résistance républicaine force-t-elle l'admiration par son courage et son héroïsme. Mais n'oublions pas les conditions dans lesquelles elles se poursuit : les républicains se battent contre l'armée du Duce et contre l'armée du Führer, auxquelles s'ajoutent des Somalis et des Maures.

Hier, eut lieu le bombardement de Guernica par l'aviation allemande. Il s'agit du plus terrible bombardement de la guerre. Guernica est l'ancienne capitale de la Biscaye. Elle a été complètement détruite. 10.000 habitants, hommes et femmes, y vivaient encore. Le nombre de ceux qui périrent dans l'incendie est incalculable de l'aveu même des agences de presse. Les avions allemands et italiens volaient à une faible hauteur. Ils bombardèrent la population pendant plusieurs heures dans la ville et autour. Cette population était exclusivement civile. Guernica n'est pas un centre stratégique : aucun soldat n'y séjournait ! Mais il y avait des hôpitaux et des blessés ont été brûlés vifs. Les fascistes ont battu hier tous leurs records ! Leur record de Badajoz, leur record de Malaga.

Grâces en soient rendues aux démocraties pusillanimes ! La politique de la non-intervention telle que l'ont pratiquée la France et la Grande-Bretagne, voilà la grande coupable des horreurs de Guernica.

Gabriel PERI.
(SUITE EN 8ᵉ PAGE, 1ʳᵉ COLONNE)

Fig. 119
L'Humanité
28 April 1937
'*Mille bombes incendiaires* ...' (A Thousand Fire Bombs ...)
Front page of *L'Humanité*, 28 April 1937
Documentation Centre, Musée Picasso, Paris

opposite, top **Fig. 120**
Dora Maar
Guernica *in Progress*: State III
Paris 1937
Gelatin silver print
20.5 × 29.4 cm
APPH 1373
Picasso Archives, Musée Picasso, Paris

opposite, below **Fig. 121**
Dora Maar
Guernica *in Progress*: State VI
Paris 1937
Gelatin silver print
24 × 30.7 cm
APPH 1372
Picasso Archives, Musée Picasso, Paris

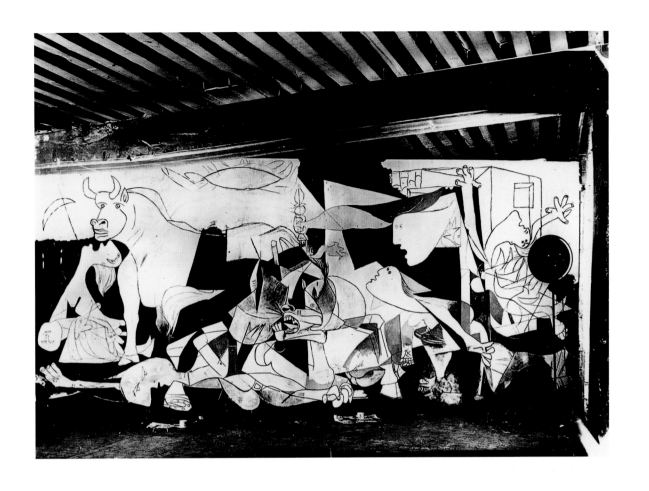

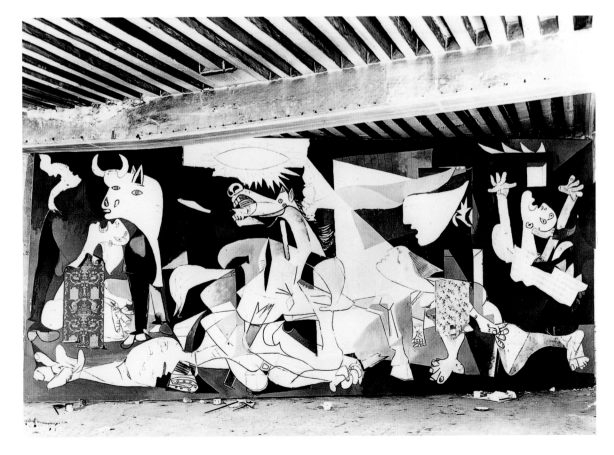

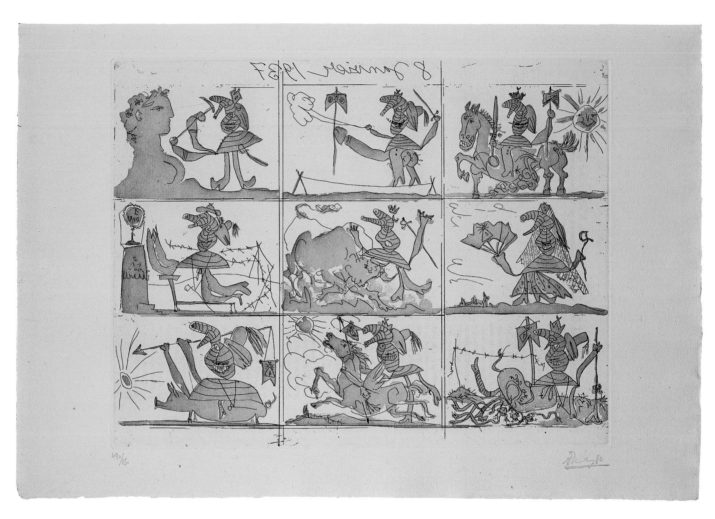

Fig. 122
Pablo Picasso
Dreams and Lies of Franco, Plate I
8 January 1937, Paris
Etching, aquatint and engraving on copper: state V
17 × 42.2 cm
Baer 615 II BC
Private collection

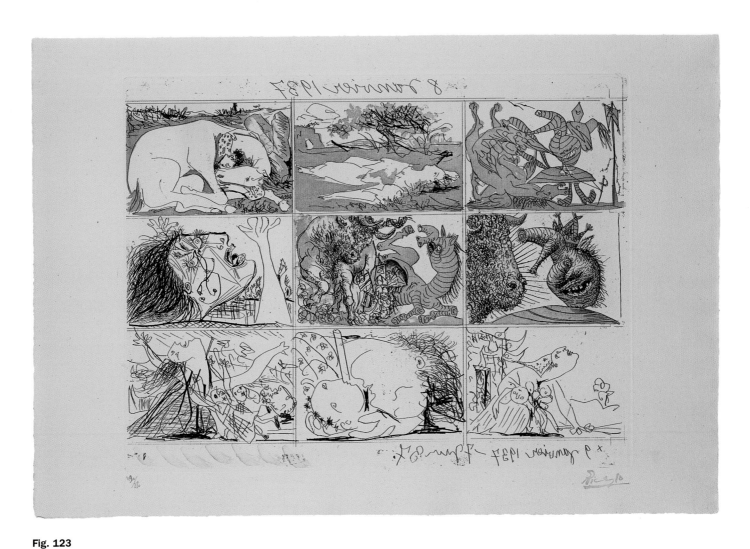

Fig. 123
Pablo Picasso
Dreams and Lies of Franco, Plate II
8 and 9 January 1937; 7 June 1937, Paris
Etching, aquatint and engraving on copper: state V
318 × 42.2 cm
Baer 616 V BC
Private collection

Paris - soir

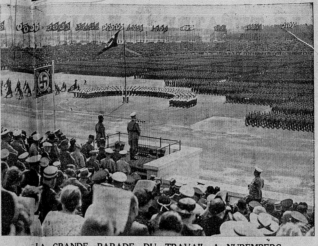

LA GRANDE PARADE DU TRAVAIL A NUREMBERG

La journée d'hier à Nuremberg a été consacrée au Service du Travail. Entre 10 et 13 heures sous un soleil ardent l'appel s'est déroulé sur le « Zeppelin feld ». Dans un ordre militaire, 38.000 hommes, bêche sur l'épaule ont défilé devant Hitler et les dirigeants du Parti national-socialiste. Voici, avant la marche, le Führer haranguant les travailleurs en présence de centaines de milliers de spectateurs.

TRAVERSÉE DE LA MANCHE EN PARACHUTE

Le parachutiste Etienne Denois a fait hier un essai de traversée de la Manche en parachute, en vue de la tentative qu'il doit effectuer prochainement. Ayant sauté d'un avion à 20 kilomètres des côtes françaises il a atteint une plage près du cap Gris-Nez. En haut : Denois sort de l'eau, aidé par un baigneur. En bas : un groupe de jeunes gens entoure le parachutiste après son atterrissage.

GRANDES MANŒUVRES EN ANGLETERRE

Dans l'Est de l'Angleterre les grandes manœuvres ont commencé, mettant à l'épreuve les nouveaux engins de combat. Le chef d'état-major de l'armée française, le général Gamelin, y assiste. Voici (de gauche à droite) le général Norton, le général Sir J. Francis Cathorne-Hardy, directeur des manœuvres, et le général Gamelin.

IL Y A VINGT ANS, GUYNEMER TOMBAIT

Le vingtième anniversaire de la mort de Guynemer sera célébré dans deux jours avec un éclat tout particulier. Du terrain d'aviation de Malo-les-Bains, d'où le 11 septembre 1917 le héros légendaire prit son dernier envol, un avion partira et ira jeter des fleurs au monument de Poelcappelle en Belgique, élevé à la mémoire de Guynemer, près de la forêt d'Houthulst où il fut abattu. Voici le monument de Poelcappelle.

LE FILM, HISTORIEN SINCÈRE

En haut : une photo extraite des archives du musée Bartholdi, montrant le sculpteur exécutant le premier moulage de la main de la statue de la « Liberté ». En bas : la scène correspondante du film. Le rapprochement de ces deux curieux documents exprime le scrupule de vérité historique des réalisateurs du film...

L'ANNIVERSAIRE DE MISTRAL

Le 107e anniversaire de la naissance du grand poète provençal a été célébré dans la petite ville de Maillane, où le souvenir de l'auteur de « Mireille » n'est pas près de s'éteindre. Voici la veuve du poète présidant cette cérémonie de commémoration.

INSENSIBLE A LA MUSIQUE...

Ce marin japonais casqué d'acier en faction dans une rue de Hong Kéou, faubourg chinois de Shanghaï, garde son impassibilité orientale malgré la mélodie que joue auprès de lui sur son harmonica un jeune Chinois. La guerre et la discipline interdisent toute distraction et c'est ce qu'exprime le masque du Japonais

RÉSURRECTION D'AI BROWN

Ce cycliste champêtre n'est autre que l'ancien champion du monde Al Brown, en cours d'entraînement pour le match qui doit l'opposer ce soir à la Salle Wagram à l'ex-champion de France André Régis. Après être resté deux ans loin du ring, Al Brown fait sa rentrée...

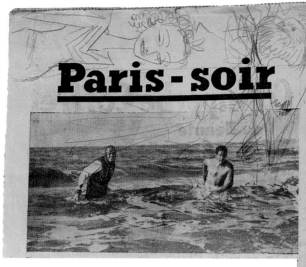

La journée d'hier à Nuremberg a été consacrée au Service du Travail. Entre 10 et 13 heures sous un soleil ardent l'appel s'est déroulé sur le « Zeppelin feld », Dans un ordre militaire, 38,000 hommes, bêche sur l'épaule ont défilé devant Hitler et les dirigeants du Parti national-socialiste. Voici, avant la marche, le Führer haranguant les travailleurs en présence de centaines de milliers de spectateurs.

LA GRANDE PARADE DU TRAVAIL A NUREMBERG

opposite **Fig. 124**
Pablo Picasso
Drawings
Mougins, after 10 September 1937
Ink and pencil on the last page of
Paris-Soir, 10 September 1937
43 × 60 cm
Archives de France, Paris

above **Fig. 125**
Pablo Picasso
Nush Eluard and a Pigeon
Mougins, after 10 September 1937
Detail from fig. 124

right **Fig. 126**
Pablo Picasso
Satirical Portraits of Men
Mougins, after 10 September 1937
Detail from fig. 124

IL Y A VINGT ANS, GUYNEMER TOMBAIT

Le vingtième anniversaire de la mort de Guynemer sera célébré dans deux jours avec un éclat tout particulier. Du terrain d'aviation de Malo-les-Bains, près de Dunkerque, d'où le 11 septembre 1917 le héros légendaire prit son dernier envol, un avion partira et ira jeter des fleurs au monument de Poelcappelle en Belgique, élevé à la mémoire de Guynemer, près de la forêt d'Houthulst où il fut abattu. Voici le monument de Poelcappelle.

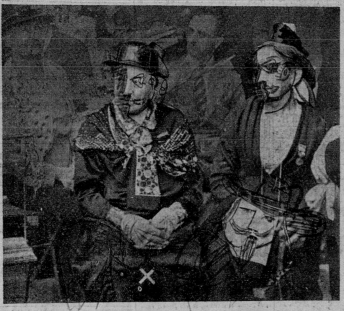

GRANDES MANŒUVRES EN ANGLETERRE

Dans l'Est de l'Angleterre les grandes manœuvres ont commencé, mettant à l'épreuve les nouveaux engins de combat. Le chef d'état-major de l'armée française, le général Gamelin, y assiste. Voici (de gauche à droite) le général Norton, le général Sir J. Francis Cathorne-Hardy, directeur des manœuvres, et le général Gamelin.

Le vingtième
dans deux jour
de Malo-les-Ba
le héros légen
jeter des fleurs
la mémoire de
aba

L'ANNIVERSAIRE DE MISTRAL

Le 107ᵉ anniversaire de la naissance du grand poète provençal a été célébré dans la petite ville de Maillane, où le souvenir de l'auteur de « Mireille » n'est pas près de s'éteindre. Voici la veuve du poète présidant cette cérémonie de commémoration.

INSENSI

Ce marin japonais casqué d'acier e
garde son impassibilité orientale m
Chinois. La guerre et la discipline int

INSENSIBLE A LA MUSIQUE...

Ce marin japonais casqué d'acier en faction dans une rue de Hong Kéou, faubourg chinois de Shanghaï.

On the last page of the 10 September 1937 edition of *Paris-Soir* – a mosaic of photographs depicting international current events – Picasso went back to his little game of image diversion (figs 124–28). The upper margin displays two studies of pigeons and a caricature of Nusch Eluard. The photograph of the anniversary of the death of the pilot Guynemer is completed by two grotesque heads: the faces of a Japanese sailor and an infant are metamorphosed, while the widow of the poet Mistral is disguised as an *Arlésienne*. During the summer of 1937, Picasso was at Mougins, at the Hôtel Vastes-Horizons. Dora Maar, Nusch and Paul Eluard, Lee Miller and Roland Penrose were also staying at the hotel. Although most of the drawings on this sheet seem to be Picasso's, the page may have been the object of a group game in the Surrealist spirit, a game in which transformation and image superimposition would have been substituted for construction by addition, as in the game of *cadavres exquis* (consequences). The figures of Mistral's widow and her neighbour should be compared with the series *Portrait of Lee Miller as Arlésienne* and *Portrait of Paul Eluard as Arlésienne*, dated precisely from this period, the end of the summer of 1937.[28] Lastly, in a more complex elaboration, the vignette of a special offer depicting a doctor holding a baby in his arms is worked over in such a way that the doctor seems to be devouring the infant (fig. 129). A piece of newspaper supplies a caption for the image, itself taken from an advertisement: "What a lesson for every mother ... for every woman!" The cutting composes a new text: "*maman/aigner votre/bébé/si pur*", in which, in accordance with the image, the 'b' of *baigner* (to bathe) suggests the 's' of *saigner* (to bleed). Picasso's interest in these visual and verbal games has already been mentioned, especially on the occasion of the discovery of a 1950 issue of *Vogue* with numerous erotic and burlesque graffiti on its pages.[29] The same methods of graphic alteration are at work: a face recomposed on the clear surface of the forehead, a nose transformed into a mouth, a face masked by shadow or a beard *etc*. In certain more elaborate cases, such as *Women at Work* (figs. 130, 131), executed in June 1941 during the Occupation, the drawing embraces the shading and previous characteristics of the photograph in a composition of frightening strangeness. Deformation becomes a bite, an unfinished healing, reminiscent of the First World War's *gueules cassées* [broken faces], randomly sewn back together. Ranging from playful diversion to the simulacrum of a monstrous reality, the drawings on press photographs constitute, during these tragic years, a laboratory for the reinvention of the portrait. These were the times in which a eugenicist ideology brought violently to the fore questions of identity and dissemblance. As Christian Zervos said, Picasso was indeed the objector who, in his own way, knew how to refuse the 'evidence' of the collaborationist press and its imagery. At the centre of the mosaic page of the September 1937 edition of *Paris-Soir*, a long article had already been devoted to the workers' parade in Nuremberg. This was the same *Paris-Soir*, in the Parisian edition taken over by the Gestapo, that Picasso would use in *Women at Work*.[30] With his ferocious science of signs, Picasso transformed into grotesque figures the subjects of the propaganda photography praising the benefit of forced work in Germany.[31] It must be recalled that,

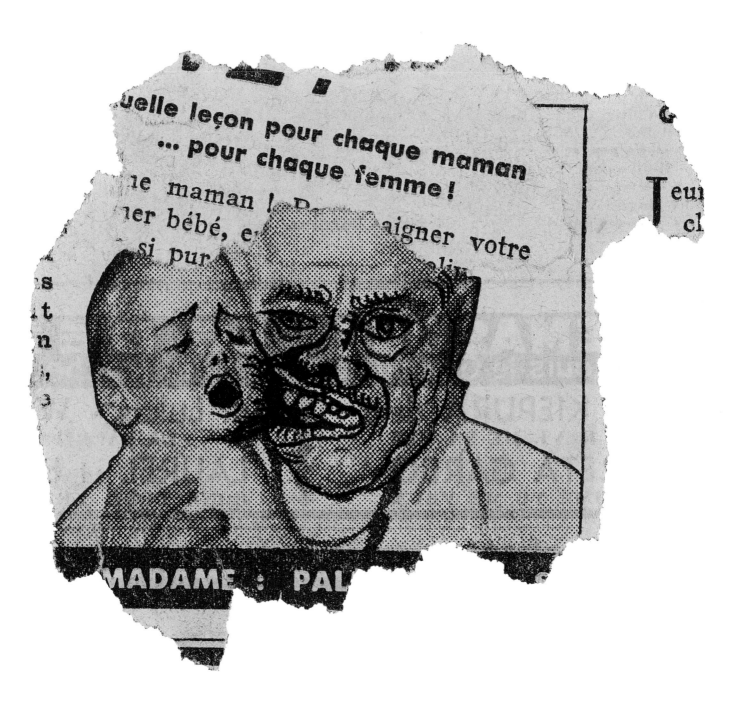

Fig. 129
Pablo Picasso
The Embrace
1943
Newsprint torn, pasted and touched up with ink
7.9 × 8.9 cm
MP 1998-31
Musée Picasso, Paris

146 Picasso working on paper

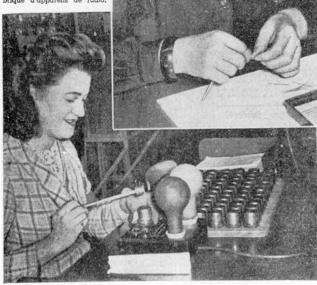

Fig. 130
Paris-Soir
8 June 1941
'Près de 7000 ouvrières françaises travaillent en Allemagne' (Nearly 7000 French Female Workers Labour in Germany)
Documentation Centre, Musée Picasso, Paris

Fig. 131
Pablo Picasso
Women at Work
Paris, after June 1941
Pencil on newsprint from *Paris-Soir*, 8 June 1941
24.5 × 18 cm
MP 1226
Musée Picasso, Paris

with a few exceptions,[32] the French press was, before the war, complicit with the Reich and, during the Occupation, fell into the most vile collaboration. As Christian Zervos said after the war, Picasso never participated in the resistance movement, but "his work itself is the greatest form of resistance".[33] Indeed, in these circumstances, his scrutiny of newspapers proved more openly critical. Instead of direct insertion in the *papiers collés* of press cuttings as so many indexed signs of the world's reality, there was now a 'summons' of the press whereby, by visual techniques all his own, the trial of the true and the false, the human and the inhuman, could begin.

Palettes

In the chapter of his book *Conversations with Picasso* devoted to the year 1939, Brassaï recalls the confiscation by the French military censors of one of his photograph

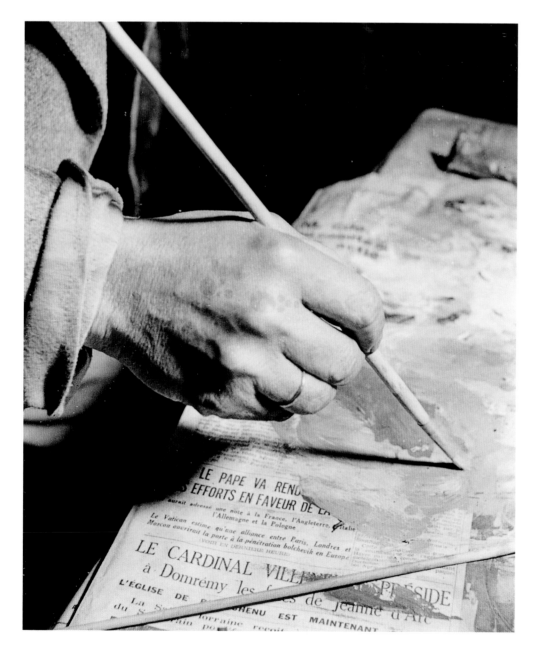

Fig. 132
Brassaï (Gyula Halász)
Picasso Painting on a Newspaper,
rue des Grands-Augustins
Paris, 18 August 1939
Gelatin silver print
32.6 × 27.3 cm
MP1996-268
Paris, Musée Picasso

opposite **Fig. 133**
Brassaï (Gyula Halász)
Folding Table and Newspapers, rue
des Grands-Augustins
Paris, 1945
Gelatin silver print
29.9 × 22 cm
MP 1996-308
Musée Picasso, Paris

in which Picasso's hand is seen mixing colours on a palette of newsprint (fig. 132):

> Has showing Picasso's hand holding a brush become the betrayal of a state secret, a violation of
> military security? I kept racking my brain to no avail ... Then I examined the 'palette' also visible on
> this photo ... I discovered that on this page from *Paris-Soir*, drenched in colour, there was an article
> on the Pope and another on a cardinal ... Headings and texts were half-covered over with paint, but
> one could still make out: "LE PAPE VA RENOU ... SES EFFORTS/EN FAVEUR DE LA .../He is said to
> have addressed a message to France, England, Italy, Germany and Poland. The Vatican estimates
> that an alliance between Paris, London and Moscow would open the door to a Bolshevik take-over of
> Europe. (See also the Late News column.)" The second article contained this: "LE CARDINAL VILL ...
> / PRESIDE A DOMREMY/LES FETES DE JEANNE D'ARC/The church of ... is now a basilica ..." What
> alerted the eye of the censor? Did they see in Picasso's gesture of smearing Jeanne d'Arc, Cardinal
> Vill ... and the Sovereign Pontiff with paint a deliberately sacrilegious act? Did they wish to avoid a
> diplomatic incident with the Vatican? Or did they suspect a practical joke, which, in this time of
> turmoil, they judged inappropriate?[34]

This is a fascinating passage in more ways than one. The military expert asks fewer
questions than the art historian; the former's attitude highlights the fact that a
newspaper, even one smeared with paint, is always there to be *read*. Its presence is of
the order of the *already there*. It is an essential element of a historical, social, and
political environment and can be neither ignored nor overestimated. The decoding of the
lacunary text by Brassaï anticipates the subtle readings of the *papiers collés* by art
historians and Picasso scholars. In this particular case, his interpretation in all
likelihood is correct: the artist's gesture, of covering with paint this image of papal
diplomacy towards the Reich that irritated the censors. Picasso, iconoclast to the core,
even in the way he mixed his colours, would continue to say "No!"

Brassaï's narrative is of value to us for what it reveals of the artist's techniques
(fig. 133):

> Picasso, who seldom held a palette in his hand, also managed to put one on a chair, a stool or even
> on the floor ... Most often, he doesn't even use one. At the studio on the rue des Grands-Augustins
> he mixed his colours on a folding table covered with a thick layer of newspaper. This cover, once
> saturated with colours, linen oil and turpentine, was thrown away.[35]

It is plain, in studying his relations with the guitar motif, that Picasso indeed used the
palette more as an emblem than a tool. Up to the end of his life as a painter he would
use this type of chair-palette, one of which exists in the Musée Picasso collection. It is
a thick layer of newspaper with coagulated paint all over it. This practice goes back to
Picasso's first years as a painter. For, as Brassaï says in another article, he "never
used an easel or palette, he left those to artist-painters".[36] The photographs Picasso
himself took of his studio between 1910/11 and 1915 reveal the presence of piles of
newspapers in the course of being read, scattered all over the floor, cut out, torn,
crumpled or flattened out and covered with paint. The same sheets, ripped apart from
wet paint, can also be seen in the studio photos taken by Brassaï or by Bernès and
Marouteau in the rue La Boétie, while Dora Maar, in 1937, in her wide-angle photograph

Fig. 134
Brassaï (Gyula Halász)
Imprint of Crumpled Paper
1943
Gelatin silver print
22.5 × 27.5 cm
MP 1996-207
Musée Picasso, Paris

Fig. 135
Brassaï (Gyula Halász)
Imprint of Crumpled Paper
1943
Gelatin silver print
29 × 23 cm
MP 1996-206
Musée Picasso, Paris

of the early stages of *Guernica*, shows the floor of the Grands-Augustins studio strewn with newspapers, either used as palettes or documentary sources, or purely and simply discarded. With those newspapers-cum-palettes, where the text was little by little engulfed in colour, Picasso experienced the gradual take-over of the real by painting. This is the solitary game where in typography will inescapably be obliterated: a kind of game of chance that preludes painting and attends its genesis – and another way for Picasso to keep a 'journal' of his work and thus to leave behind some of its traces.

An analysis of the still-legible articles confirms that it was between mid-1941 and 1943 that the artist painted a series of large heads on sheets from *Paris-Soir* (figs. 138–47). On the scale of a full page, these faces are drawn in black oil paint, with white, Prussian blue or red touch-ups. These likenesses use the sheet three times in the direction of reading, and six times in the opposite direction. In two cases, the motif is framed in a quadrangular scroll intersecting with the typographic layout (figs. 141, 142). In another case, the lower margin is covered with paint to form a bust (fig. 143). The composition of these geometric studies for the large portraits of Dora Maar[37] comes up against the page's blank margins, using every element of the typographic grid to anchor its motif. The rhythm of the columns is respected in the placement of the eyes or mouth. The scrolls, boxes, print-free areas and subtitles all go to highlight some feature or other of the face. Advertisements for stomach-ache cures appear repeatedly on these sheets. In the case of a head dated 7 July 1943, a dialogue seems to take place between two suffering beings, a woman painted by Picasso and a typical patient

above, left **Fig. 136**
Pablo Picasso
Portrait of Dora Maar
Paris, 1936–37
Gelatin silver print
24 × 18.2 cm
APPH 13880
Picasso Archives, Musée Picasso, Paris

above, right **Fig. 137**
Pablo Picasso
Portrait of Dora Maar Reading a Newpaper
26 June 1941
Oil on canvas
100 × 81 cm
Z XI, 334
Private collection

with a bilious look about him (fig. 144). The text of the pharmaceutical advertisement seems to match the appearance of each of the portraits, being descriptions of symptoms to make each reader realize how sick he or she is with precisely this malady: "headaches that wrinkle the brow/yellow sclerotics/listless look/baggy eyes/pimples/bitter mouth/bad breath ..." The female head, with its twisted mouth and distorted nose, personifies this dark diagnosis, combined with an expression of exhausted and painful stupefaction. The period between June and October 1941 was marked by the implementation of a new 'Status of Jews', along with round-ups unprecedented in scope: 30,000 Jews would be put in occupied-zone camps in less than a year.[38] In September of that year an exhibition entitled *The Jew and France* opened at the Palais Berlitz. Picasso proceeded here as if he were projecting on to the image of the woman he loved the fantasized ugliness of racist hatred. A painting of disfigurement restores to Nazi barbarity its own denial of humanity. As Leo Steinberg has pointed out, it can indeed be observed that, as of 1939, there is a new physiognomy of ugliness in Picasso's work.[39] One of Dora Maar's photographs, taken in the Grands-Augustins studio, displays a hanging of recent portraits: the figure maintains a mimetic quality and the model is both stylistically analyzed and idealized by the painting. Afterwards, Picasso would mount a violent campaign against the wholeness of the female figure as if, in these terrible times, he wanted his painting to be publicly declared 'degenerate'. In a typically Picassian reversal, the painting of June 1941 with Dora Maar reading a newspaper (fig. 137) foreshadows the series of large heads on newsprint. What is more, the work refers to a photograph of Dora Maar taken by Picasso in 1936 (fig. 136) in which she can be seen engrossed in a daily paper.

Although Picasso's preference in these large drawings of 1941–43 was for cultural commentary, entertainment or women's columns, there nevertheless are items about the political situation. This relatively discreet presence should be compared to the way in which, in 1912–13, the Balkan War was at once mentioned and reduced by a cut to an allusive or ambiguous presence. Here the page, used in its entirety, conveys, in its arrangement, a more brutal form of interaction between painting and the newspaper as object-sign. The most terrifying of these portraits are surely the twin effigies painted on a double page in October 1941 (fig. 141). Framed in black and rising out of a dark ground, each one of these geometrical heads recalls, with their empty orbits, the bronze *Death's Head*. It is to be noted that such a use of a full sheet of a newspaper is unprecedented in the previous work of Picasso, save for the large portrait of a male done by the artist on a page of *Excelsior* in 1913 just after the death of his father (fig. 83). In October 1941, the representatives of French painting – André Derain, Kees van Dongen and Maurice de Vlaminck – were in Germany sealing an informal pact of collaboration between a particular intellectual and artistic milieu and the Nazi occupants.[40] In these circumstances, one might use the most beautiful of the commentaries inspired by *Guernica*, that of Michel Leiris, on the funereal effigies of the autumn of 1941:

In a black and white rectangle, in the way ancient Greek tragedy appears to us, Picasso sends his letter of mourning: everything we love is dying, and that is why it was so extremely necessary that everything we love be resumed, like the effusion of final leavetakings, in something unforgettably moving.[41]

Between July and September 1941, at the same time as the execution of these heads, Picasso used the same technique of painting in black oil paint on newspaper for a series of studies of hands (figs. 150–54). Usually he used the page headed Late News; international current events were overshadowed by the tension between Japan and the United States, preceding the attack on Pearl Harbor the following December. The newspaper is folded in half and the drawings completely cover each half-page, except in the case of the drawing of 25 September, which fills an entire page (figs. 148, 150). These studies, generally thought to depict joined hands, instead represent a hand holding a stick, the thumb folded on the side. They precede, in fact, the large painting *Woman with Artichoke* (fig. 149),[42] in which the woman holds out the vegetable like a sceptre. In 1943, Picasso would use the same technique for *Study of a Foot* (fig. 156): drawn on the sports page of *Paris-Soir* at the end of May, it is a study related to the painting *First Step* (fig. 155).[43] As if to close this series, which extended over a period of three years with a high degree of plastic coherence, Picasso left, folded in four sections in his archives, a large sheet from the 24 September 1943 edition of *Paris-Soir* (fig. 147). A line in black, covered over in grey, leaves room for the structure of a head. This painted hieroglyph leaves entirely legible the column of an editorial entitled 'Propaganda': a violently anti-Semitic text by P.A. Cousteau denouncing the influence of the "warriors of Israel". Lastly, three months before the liberation of Paris in May 1944, Picasso, with a double newspaper page drenched in colour, participated in the exhibition *The Work and the Palette from 1830 to Today*, organized by the Galerie Renée Breteau. The newspaper palette, this locus of everything possible, at once both limbo and shroud of reality, is thus shown in its material reality and in all its symbolic force. The pair of the large crossed-out head dating from the autumn of 1943, it condenses a complex arrangement of signs that, as shown in the first chapter, were proposed by the paintings of 1938, with the motif of a painter's palette placed on a book or newspaper.

In the mid-1930s, while the Boisgeloup studio was filling up with the huge plaster creatures immortalized by Brassaï, Picasso practised the technique of taking impressions – of just about anything. Cardboard, fencing, plates and discarded objects were thus duplicated in a kind of three-dimensional photography. Through contact, the positive object exchanges its density for a negative made of recesses and reliefs. Picasso next rearranged these 'doubles' in ambiguous assemblages or left them in their new forms. Probably one of the earliest of these experiments, one of these imprints used sheets of newspaper. Thanks to Brassaï's 1943 photographs, we know these *Imprints of Crumpled Paper* (figs. 134, 135) – a ball and a crumple of plaster marvellously and delicately compact – had been made using paper. But Brassaï added:

Fig. 138
Pablo Picasso
Head of a Woman
1941
Oil on a full page from *Paris-Soir*,
4 November 1941
60 × 43 cm
MP 1990-72
Musée Picasso, Paris

overleaf, left **Fig. 139**
Pablo Picasso
Head of a Woman
1941
Oil on a full page from *Paris-Soir*, 17 July 1941
60 × 43 cm
Private collection

overleaf, right **Fig. 140**
Pablo Picasso
Head of a Woman
1941
Oil on a full page from *Paris-Soir*, 1 November 1941
60 × 43 cm
Marina Picasso Collection (inv. 4304), courtesy of Galerie Jan Krugier, Diteisheim & Cie, Geneva

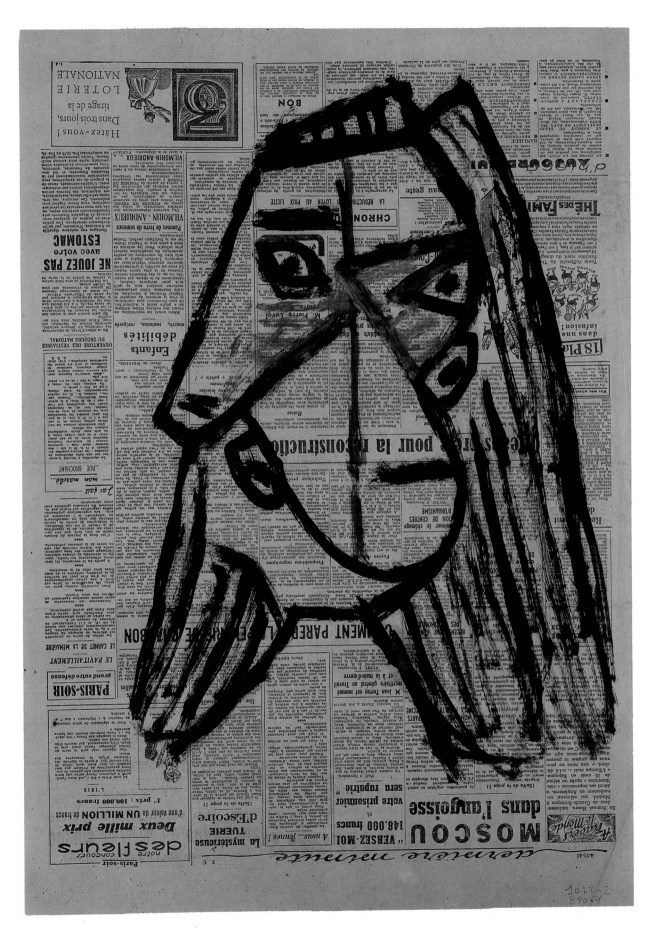

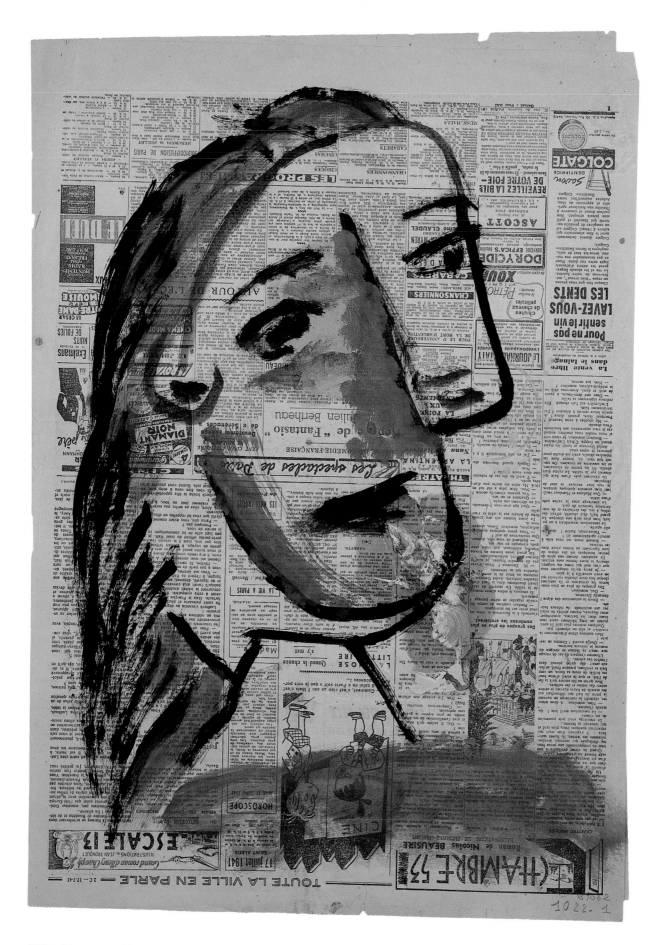

156 Picasso working on paper

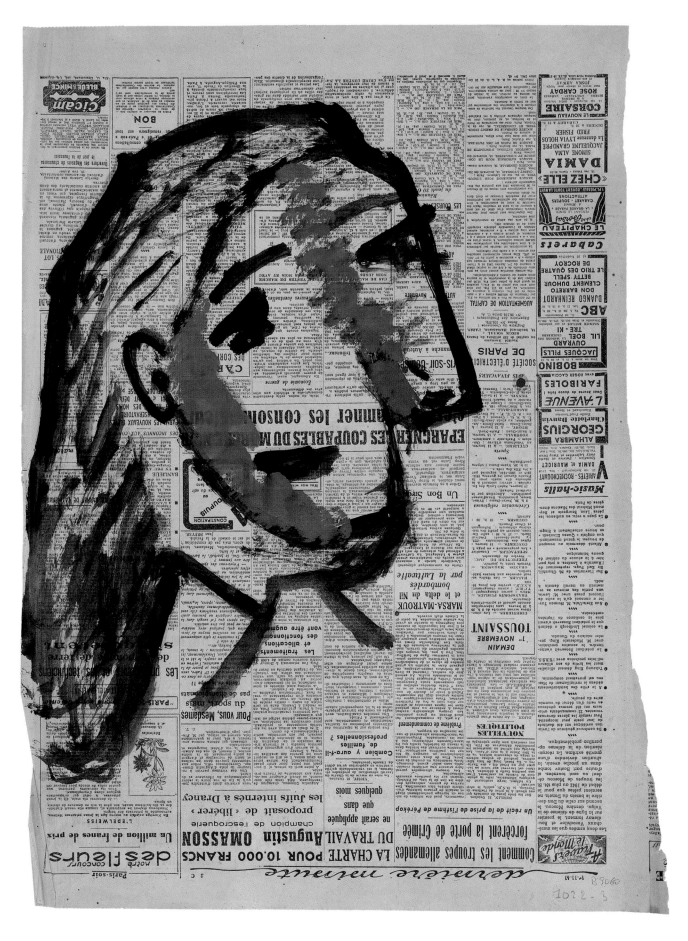

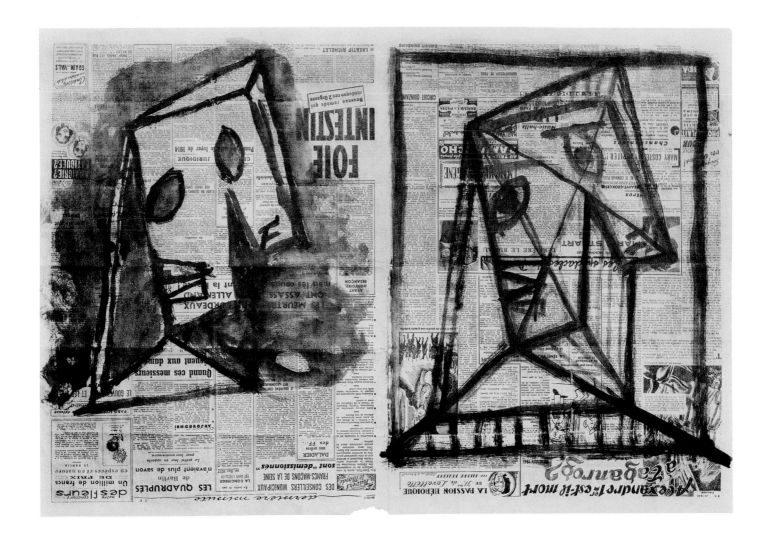

above **Fig. 141**
Pablo Picasso
Heads of Women
1941
Oil on a full page from *Paris-Soir*, 28 October 1941
60 × 80.5 cm
Z 11, 284
Private collection

opposite **Fig. 142**
Pablo Picasso
Face
1941
Charcoal on a full page from *Paris-Soir*, 11 September 1941
60 × 43.5 cm
Z XI, 2900
Marina Picasso Collection (inv. 4305), courtesy of Galerie Jan Krugier,
Ditesheim & Cie, Geneva

overleaf, left **Fig. 143**
Pablo Picasso
Head of a Woman
1943
Oil on a full page from *Paris-Soir*, 19 June 1943
60 × 43 cm
Z XII, 38
Private collection

overleaf, right **Fig. 144**
Pablo Picasso
Head of a Woman
1943
Oil on a full page from *Paris-Soir*, 7 July 1943
60 × 43 cm
Private collection

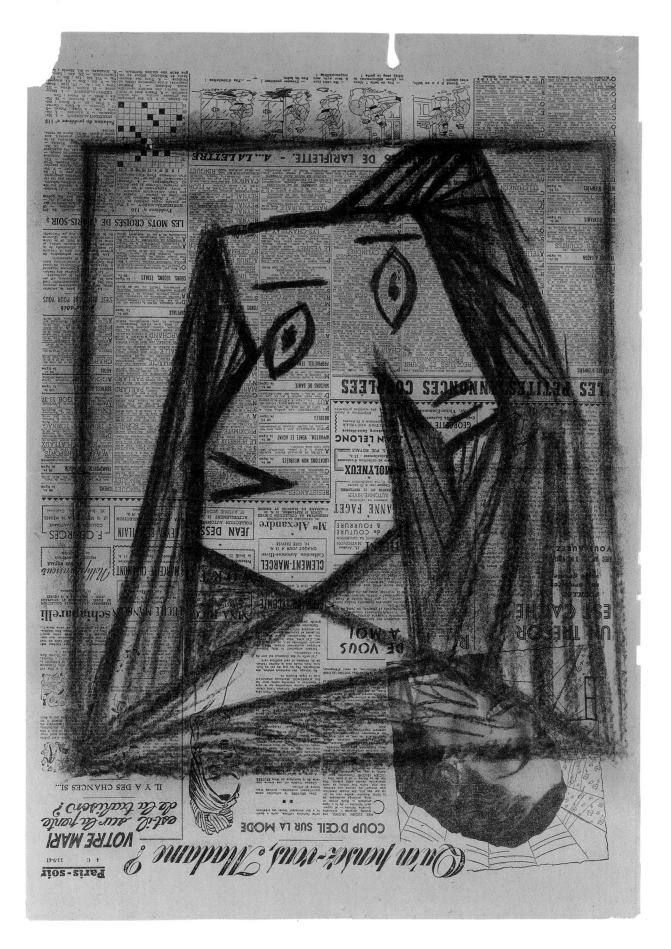

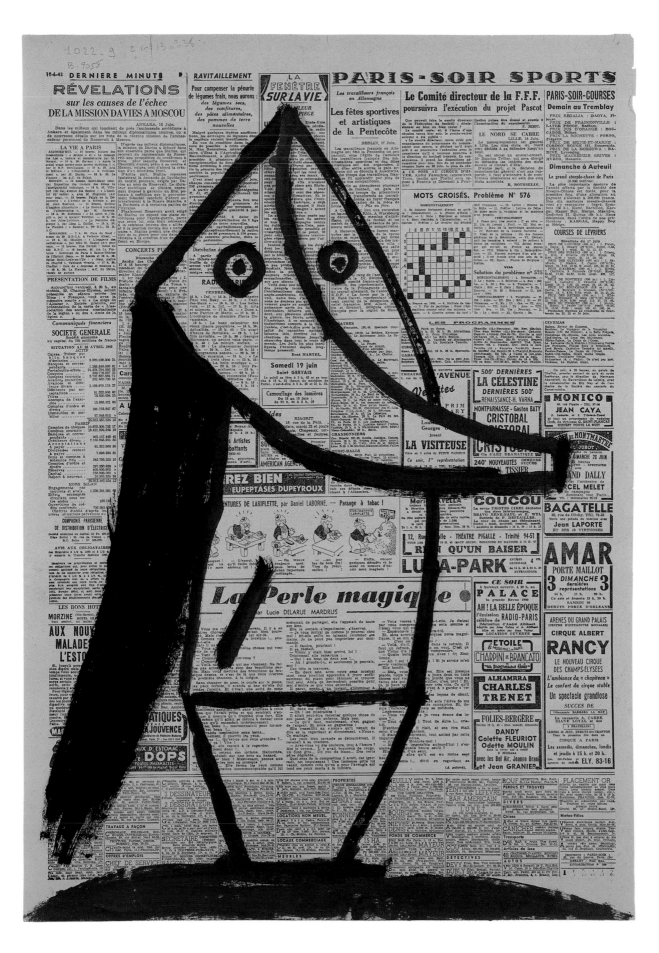

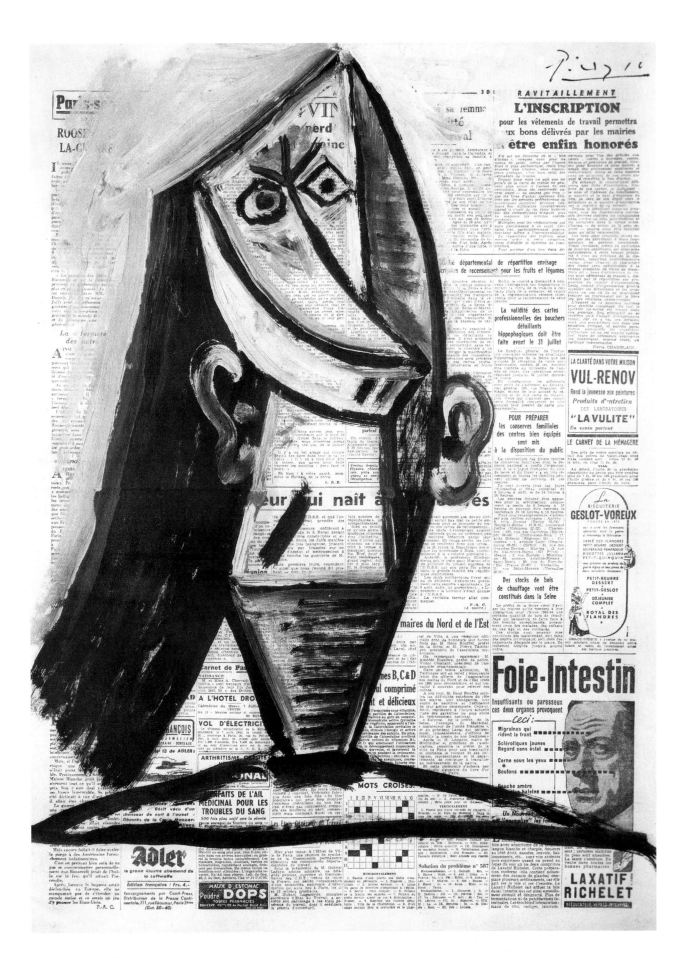

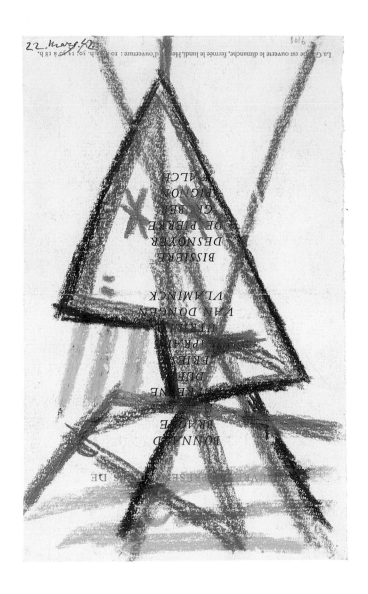

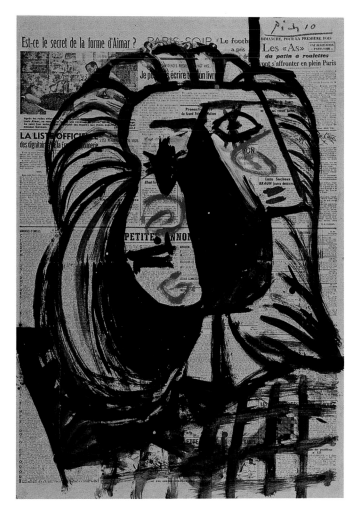

Fig. 145
Pablo Picasso
Head
22 March 1942
Coloured pencils and Indian ink on invitation card
21 × 13.5 cm
Z XII, 22
Private collection

Fig. 146
Pablo Picasso
Portrait of Dora Maar
1941
Oil on a full page from *Paris-Soir*, 19 September 1941
59 × 41 cm
Private collection

opposite **Fig. 147**
Pablo Picasso
Face
1943
Black and grey oil on a full page from *Paris-Soir*, 24 September 1943
60 × 55.5 cm
APCS A II, 5
Picasso Archives, Musée Picasso, Paris

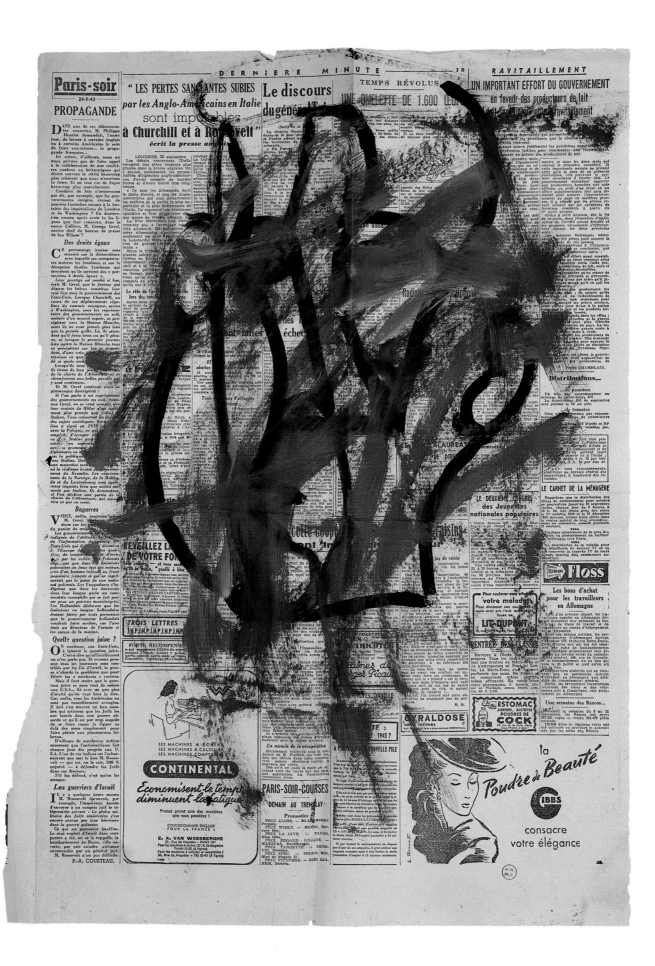

Fig. 148
Paris-Soir
25 September 1941
Private collection

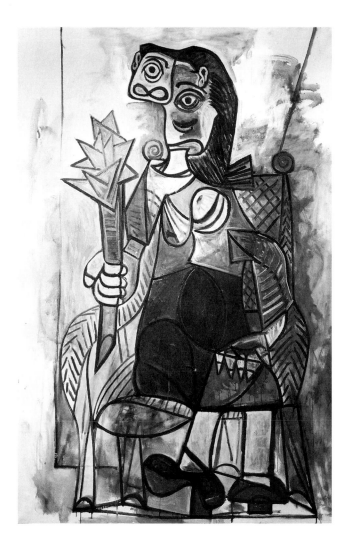

Fig. 149
Pablo Picasso
Woman with Artichoke
1942
Oil on canvas
195 × 130 cm
Z II, 36
Museen der Stadt, Cologne

Fig. 150
Pablo Picasso
Hand
Oil on a full page from *Paris-Soir*, 25
September 1941
60 × 42.5 cm
Private collection

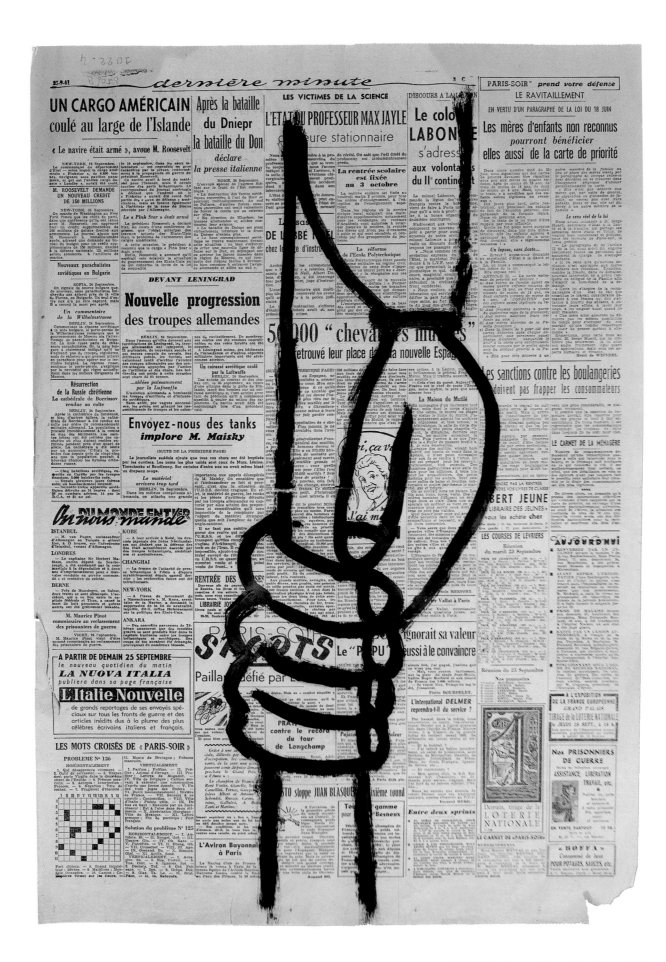

Fig. 151
Pablo Picasso
Joined Hands
1941
Oil on newsprint from *Paris-Soir*, 31 July 1941
30 × 43 cm
Private collection

Fig. 152
Pablo Picasso
Hand
1941
Oil on newsprint from *Paris-Soir*, 1 August 1941
30 × 43 cm
Private collection

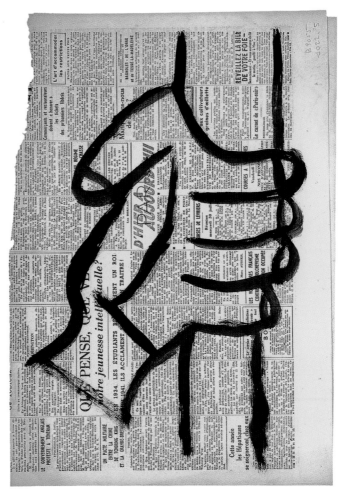

Fig. 153
Pablo Picasso
Joined Hands
1941
Oil on newsprint from *Paris-Soir*, 31 July 1941
30 × 43 cm
Private collection

Fig. 154
Pablo Picasso
Joined Hands
1941
Oil on newsprint from *Paris-Soir*, 1 August 1941
30 × 43 cm
Private collection

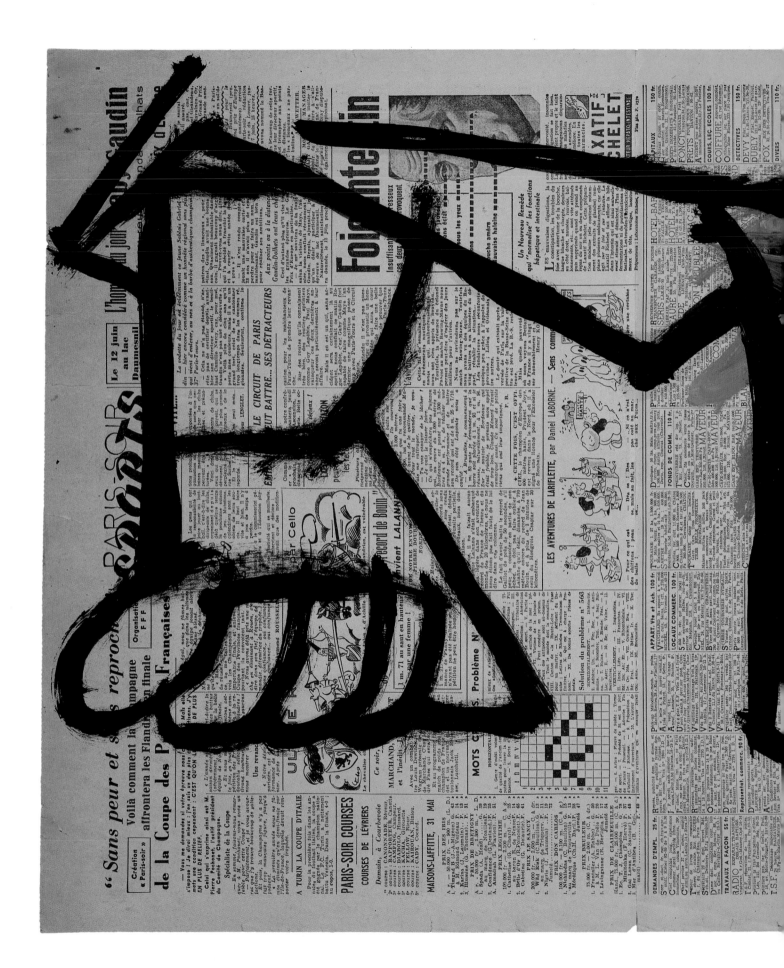

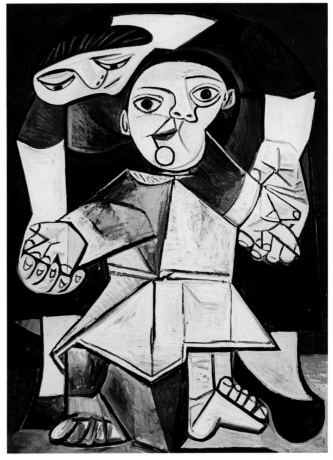

above **Fig. 155**
Pablo Picasso
First Step
21 May 1943 (?)
Oil on canvas
130 × 97 cm
Z XIII, 36
Yale University Art Gallery, New Haven, CT, United States

left **Fig. 156**
Pablo Picasso
Study of a Foot
1943
Oil on a full page from *Paris-Soir*, 2 June 1943
Z XIII, 35
Private collection

Troisième année. — N° 111

MERCIER
FRÈRES
ANCIEN - MODERN
AMEUBLEME
DÉCORA

Vendredi 14 décem

above **Fig. 157**
Pablo Picasso
Study
3 September 1943
Pencil on newsprint from *Comoedia*,
14 August 1943
6.4 × 17.5 cm
APCS A II, 4
Picasso Archives, Musée Picasso,
Paris

left **Fig. 158**
Pablo Picasso
Papier collé
14 December 1945
Newsprint from *L'Humanité* (?), 14
December 1945, cut out and pasted
on to a sheet of ruled sketch-book
paper, touched up in ink
21.5 × 17 cm
APCS A II, 2
Picasso Archives, Musée Picasso,
Paris

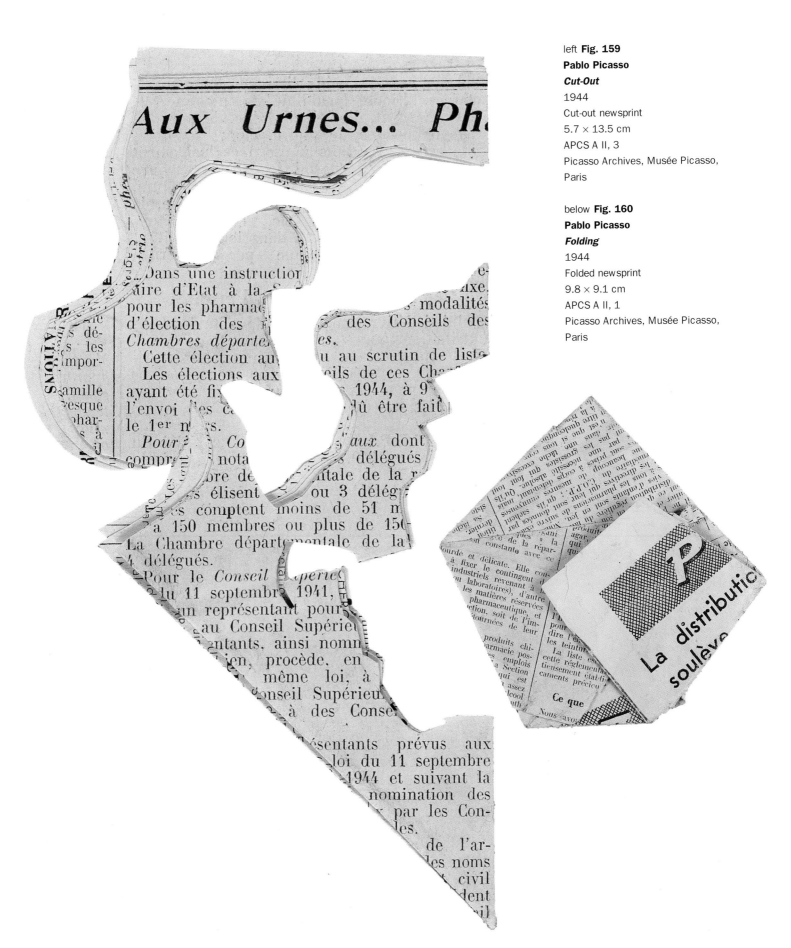

left **Fig. 159**
Pablo Picasso
Cut-Out
1944
Cut-out newsprint
5.7 × 13.5 cm
APCS A II, 3
Picasso Archives, Musée Picasso,
Paris

below **Fig. 160**
Pablo Picasso
Folding
1944
Folded newsprint
9.8 × 9.1 cm
APCS A II, 1
Picasso Archives, Musée Picasso,
Paris

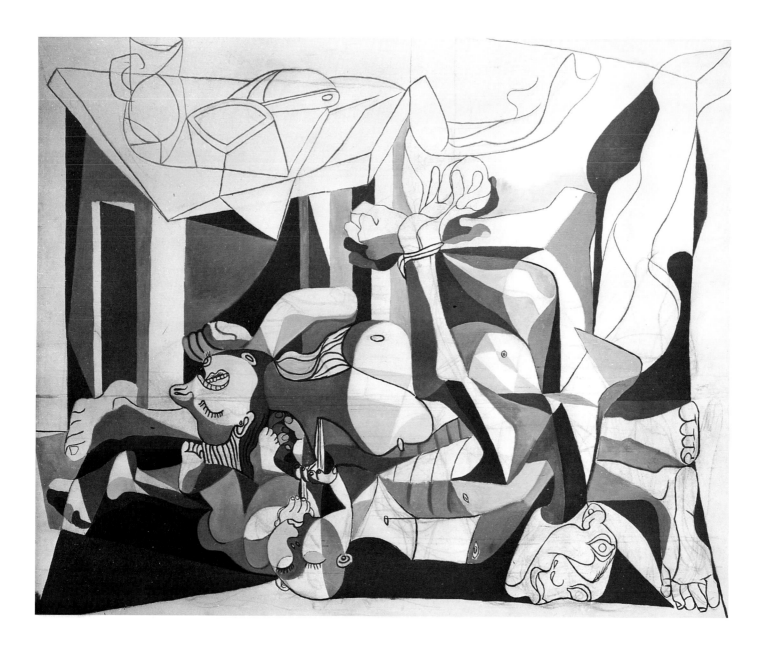

"By taking on a new material, plaster, Picasso's mind discovered unexpected possibilities: the imprint of crumpled newspaper looked like a rugged rock and the moulding of folded cardboard started to look like the Great Wall of China."[44] The discovery of a fragment of newspaper, a heading in Spanish too small to be precisely identified, still adhering to the plaster of the imprint preserved at the Musée Picasso, goes to show that these were indeed full pages of the newspapers that had served their purpose. Picasso would have spread the page out, placing in its centre the fresh plaster, wrapping the sheet over the ball as one would a towel around kneaded bread dough, to create this rounded, fissured form, wrinkled and folded back inside itself. The same technique would have been used for another imprint in which crumpled paper gives its substance and its volume to the new object. More than simply making a sculpture, the artist sought to fix the gestures of a hand: in the first piece the hand caresses and covers, in the other it contracts and destroys. At this time Picasso would

Fig. 161
Pablo Picasso
The Charnel House
Paris, 1945
Oil on canvas
199.8 × 250 cm
The Museum of Modern Art, New York, NY, United States

Fig. 162
L'Humanité
13 December 1944
'Bodies of Soviet Victims'
Documentation Centre, Musée
Picasso, Paris

De Gaulle rapporte le texte du traité

D'après l'agence *France-presse*, le général de Gaulle rapporte lui-même le texte de l'alliance conclue à Moscou et le présentera au conseil des ministres qu'il convoquera dès son arrivée à Paris. Ce n'est qu'à l'issue de ce conseil des ministres qu'on devra s'attendre à la publication du traité, qui aura lieu, selon les habitudes diplomatiques, simultanément à Paris et à Moscou.

Le pacte d'alliance et d'assistance mutuelle marque bien la large communauté de points de vue existant entre les deux plus grandes puissances du continent, voisines de l'Allemagne. La nécessité, reconnue des deux côtés, de résoudre, une fois pour toutes, le problème allemand en réduisant à l'impuissance l'Allemagne agressive, constitue l'intérêt fondamental du pacte unissant les deux nations et déterminant essentiellement leur politique, signé le 10 décembre 1944.

Une entente sur les principaux points essentiels, de la compréhension sur ceux restant à éclaircir, tel est le résultat du fécond séjour de neuf jours qu'a fait, à Moscou, le général de Gaulle.

Gaston MON et Ambrois

délégué de

Hier après-midi, la Consultative a commencé l'examen du projet instituant des comités d'entreprise dans les établissements industriels et commerciaux. M. *Parodi*, ministre du Travail, expose le projet gouvernemental.

Gazier, rapporteur de la commission du Travail, souligne que la commission a amélioré le texte gouvernemental. Il précise que les comités seront composés du chef d'établissement et de délégués élus par le personnel sur des listes présentées par les organisations syndicales les plus représentatives. Ces comités seront créés dans les établissements de plus de cinquante ouvriers.

La commission souhaiterait voir étendre la création de ces comités aux exploitations agricoles les plus importantes ainsi qu'aux services publics.

(SUITE EN 2e PAGE, 6e COLONNE)

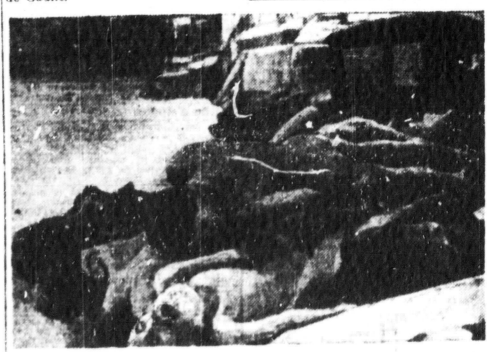

Encore un document recueilli sur un soldat allemand qui le conservait pieusement en témoignage sans doute de la « civilisation » nazie : des cadavres horriblement mutilés de victimes soviétiques entassées pêle-mêle

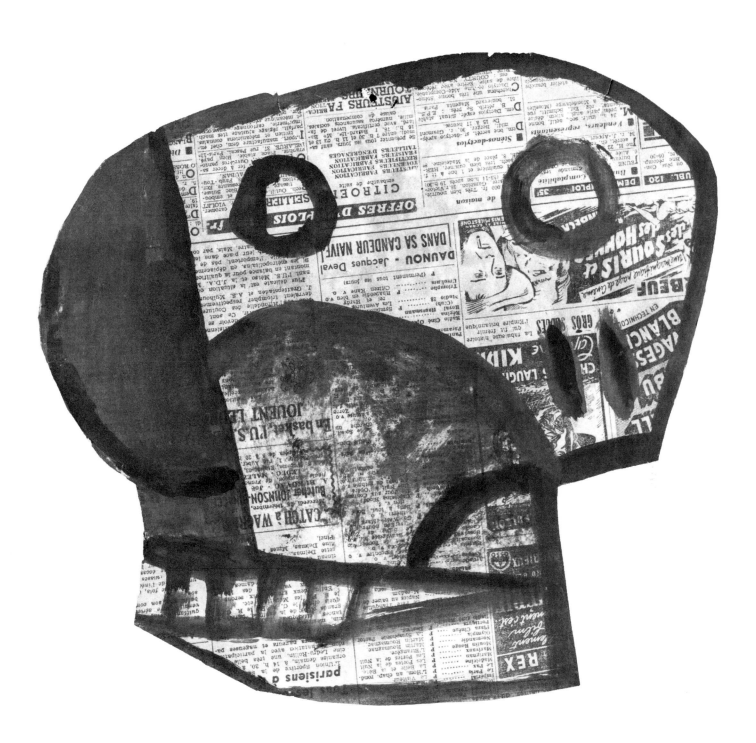

left **Fig. 166**
Pablo Picasso
Cut-Out (The Plate)
Paris, 1948
Oil on newsprint cut-out from
Ce Soir, 12 November 1948
29 × 33 cm
Private collection

below **Fig. 167**
Pablo Picasso
Cut-Out (The Fish)
Paris, 1948
Oil on newsprint cut-out from
Ce Soir, 12 November 1948
9 × 27.5 cm
Private collection

left **Fig. 168**
Pablo Picasso
Cut-Out (The Cage)
Paris, 1948
Oil on newsprint cut-out from
Ce Soir, 12 November 1948
24 × 28 cm
Private collection

Fig. 169
Pablo Picasso
The Kitchen
9 February 1948
Oil on canvas
175 × 250 cm
MP 200
Musée Picasso, Paris

also take moulds of his own open hand or fist. The plaster version embodies an invisible choreography, that of the ordinary mobility at the heart of the creation and destruction of things: unfolding a newspaper, crumpling it up, letting it uncrumple slowly, freeing the kinetic energy pent up inside, in a muted crackle.

Either painter's palette or paper for moulding, newsprint lends itself to primary gestures just as photography could once capture the 'primary visions' of the painter. Picasso had fun trying out the simplest cut-out. Thus, in 1944, he cut out of the sheets of a professional journal for chemists an ornamental motif after having folded the sheet four times (fig. 159). He did the same with two tiny fragments of a newspaper dated 14 December 1945, denouncing the collaborationists of the occupying period – probably an edition of *L'Humanité* – which suffice for a little collage, the curves of which match the calligraphy of an imaginary monogram (fig. 158). Repeating the technique several times from 1946, it is in the use of newspaper for scale models that Picasso uncovered the matricial potential of such material.

Scale Models

Cut out of a December 1946 edition of *Ce Soir*, a death's head touched up with Indian ink appears the exact replica of the one appearing in the still lifes of the year before.[45] On the plywood painting of 27 February 1946, *Still Life with Death's Head*,[46] the chin of the skull rests on a sheet of newspaper rather than on the canonical book of the *Vanities:* the image suggests a gesture similar to one of chewing paper, a gesture begun by the head's teeth on the left-hand side (fig. 165). On a variant of this cut-out, with no touch-ups, incised simultaneously in the double thickness of the sheet, an article of December 1946 on the funeral of Paul Langevin can be read (fig. 164). A third cut-out, slightly different in form, reveals a commentary on the rapid economic recovery of the post-war period (fig. 163). It is to be noted that these cut-outs are not studies for pictures: they come after and, at least with regard to their most elaborate forms, they can claim to be works in their own right. The work, in its brutal simplicity, brings to a close the funereal sequence linking the large 1941 female heads, the bronze *Death's Head* (1943), the still lifes of 1945–46 and the paper masks and death's heads photographed by Brassaï in 1946.

In November 1948, three newspaper scale models touched up in oil formed a plate (fig. 166), a fish (fig. 167) and a cage (fig. 168), which would be the motifs of the painting *The Kitchen* (fig. 169).[47] Here again it would appear to be the 12 November 1948 edition of *Ce Soir* that served as Picasso's material point of departure. The three cut-outs were taken from the same page of various news items, notepads and comic strips. The names of Jean Cocteau and Marie Laurencin appear in a piece on the arts and are underlined in red. In an adjoining column are references to a "communist putsch" and the trial of La Cagoule. Françoise Gilot[48] says that a second version of *The Kitchen*,[49] now in the Musée Picasso, was prepared with her help and that of Jaime Vilato with the aid of a pattern. But the paper models described here were used to make

top **Fig. 170**
Pablo Picasso
Handwritten Poem, 'Est-ce la réalité …' (Is it reality …)
Blue pencil on newsprint from *L'Humanité* (?), undated
2.2 × 34.2 cm
APCS A I, 2
Picasso Archives, Musée Picasso, Paris

above **Fig. 171**
Pablo Picasso
Handwritten Poem, 'Il faut vraiment avoir la trouille …' (You have to be really afraid …)
Blue pencil on newsprint from *Le Patriote*, 1950
7.9 × 31.7 cm
APCS A I, 4
Picasso Archives, Musée Picasso, Paris

above, left **Fig. 172**
Staline par l'image
Cover illustration
Editions Sociales, Paris
FP 913
Picasso Archives, Musée Picasso,
Paris

above, right **Fig. 173**
Pablo Picasso
Portrait of Stalin
Front page of *Les Lettres
Françaises*, no. 456, 12–19 March
1953
AP Pr 28
Picasso Archives, Musée Picasso,
Paris

the original version. If the plate motif is conserved as such, the fish is reduced to nothing more than an intertwining network of lines recognizable in the centre-left of the painting. As for the cage, the motif of which is frequently used to various ends during this period, it is placed in the square, in the middle of the canvas.

The next decade ushered in Picasso's collaboration with the communist press (figs. 173, 174–76, 179). The ambiguities of this association came to the fore in the 1953 storm over Stalin's portrait (fig. 173). The contested drawing was perhaps less an improvization than previously believed, for the Picasso archives preserve a copy of the book *Staline par l'image* published by Editions Sociales, a book that Picasso had acquired to enable him to approach his model (fig. 172). Pierre Daix, at the time editor of *Les Lettres Françaises*, confirms, moreover, that Picasso had requested photographs of Stalin, and chose to start from one depicting him as a younger man, bringing to it "this simplification (in which he was interested at the time) of photographic depth in several powerful, contrasted traits".[50] There is an indication of the critical relations between Picasso and the press, even when the latter was close to his political allegiances, in a fact also recorded by Daix: the first to react adversely to the portrait were the journalists and workers of the printer of both *L'Humanité* and *Les Lettres Françaises*, who considered it "tantamount to an attack" against the standard hagiographic codes of Stalinian imagery.

The last newspaper to be used in the construction of a scale model, the 3 May

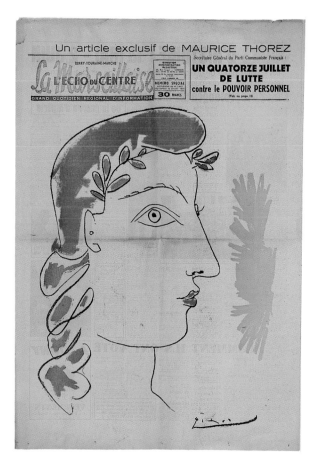

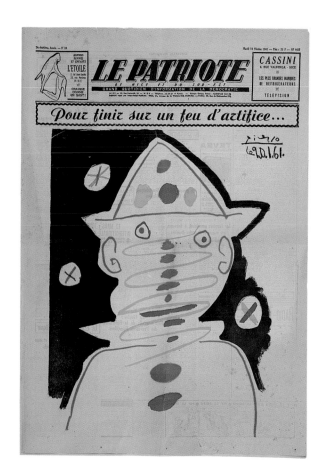

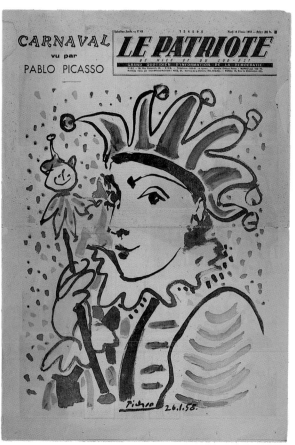

above, left **Fig. 174**
Pablo Picasso
Marianne
Front page of supplement to *La Marseillaise*, 12 July 1958
AP Pr 38
Picasso Archives, Musée Picasso, Paris

above right **Fig. 175**
Pablo Picasso
'Pour finir sur un feu d'artifice'
20 January 1961
Front page of *Le Patriote*, no. 38, 14 February 1961
AP Pr 42
Picaso Archives, Musée Picasso, Paris

left **Fig. 176**
Pablo Picasso
'The Carnival as seen by Picasso'
21 January 1958
Front page of *Le Patriote*, no. 49, 18 February 1958
AP Pr 41
Picaso Archives, Musée Picasso, Paris

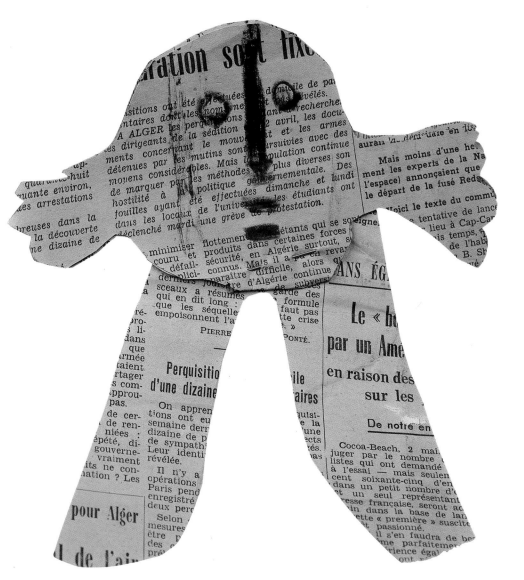

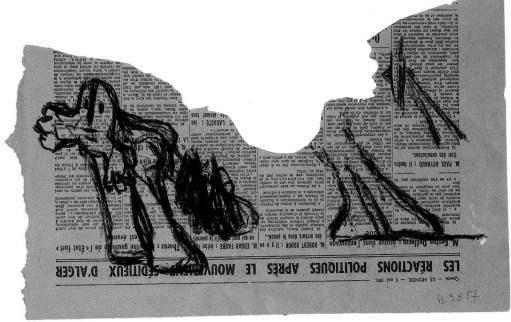

1961 edition of *Le Monde* relating the repercussions of the putsch in Algiers, formed the basis both for a project in sculpture, *Study for a Bronze Sculpture* (fig. 178),[51] and for a scale model, *Standing Figure* (fig. 177), touched up with charcoal.[52] From this Picasso obtained the sculpture *Infant*.[53] This page from *Le Monde*, containing both the charcoal drawing of the sculpture and the cut-out of the model, is precious material for an investigation into Piccaso's procedure. The sculpture is shown in the drawing from a three-quarter view and in profile in three successive studies working exclusively on the feet of the figure. Picasso was evidently looking for an unstable equilibrium whereby the head and shoulders of the figure juts forward with arms wide open, leaving both legs behind. In terms of static analysis, the sculpture is a physical impossibility proven, in the study in profile, by the erasures of one of the legs. The model solved this problem analytically. Separating the head and shoulders from the legs creates a logical break between these two parts of the body, giving distance back to them. The figure is, in the final analysis, engendered by the precariousness and the very instability of his posture: a little broken puppet who, against the backdrop of a major political crisis reported in this edition of *Le Monde*, was Picasso's version of a modern-day *Man Walking* by Rodin.[54]

In late 1963, Picasso printed a series of drawings straight on to the plate of an issue of *Le Patriote:* a profile, crossing the entire page, a bullfighter, a faun's head and a centaur (fig. 180). These last three motifs were inserted in a pre-existing layout of newspaper as ordinary illustrations, in place of the special offers in this page of advertisements. The artist made prints of this flong, before and after his intervention, as if to mark out its emergence. The profile dividing the page in two distantly echoes the large heads of *Paris-Soir* in 1941. But this bemused profile is a substitute for the accusatory effigies of the dishonest joy of living under the Occupation. Picasso returned here to the shaded profile that had appeared recurrently in his painting between 1927 and 1930.[55] This image forms an ambiguous self-portrait of the artist as both voyeur and protagonist of his painting.[56] It is as if, at the boundary between the two worlds, he was actually painting the material contour of his body's shadow, projected on to the painting by the artificial light of his long nights of work. Here the profile stares at the three image-emblems facing him: the bullfighter, the masked figure of the faun and amorous pursuit, which embody once again the legend of Picasso. They illustrate the artist's 'journal' on this page of advertisements and local entertainment where the old man – *le vieil homme* – must have found provincial charm. Cut into the ductile thickness of a printer's flong, these 'primary visions' seek to embody the permanence of a universe of images in which Picasso depicts himself *in* and *through* the journal/newspaper/log book of the world, of his life and of his work.

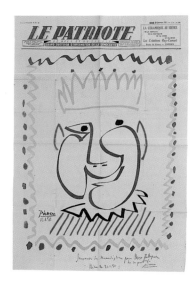

Fig. 179
Pablo Picasso
Souvenir of the Nice Carnival
31 January 1951
Front page of *Le Patriote*, 30
January 1951, inscribed to Max
Pellequer
62 × 43.3 cm
MP 1981-3 (1951)
Picasso Archives, Musée Picasso,
Paris

opposite **Fig. 180**
Pablo Picasso
Profile, Bullfighter, Faun and
Centaur Chasing a Bather
Late 1963
Engraving on flong of the advertise-
ments page of *Le Patriote*,
December 1963
60.8 × 43.6 cm
Baer TV, no. 1367
Private collection

Picasso and the Press: A Journey Through the Century

1 Letter illustrating Monod-Fontaine 1982, p. 40: "*Mon cher ami Braque. Je emploie tes derniers procedes paperistiques et pusiéreux ...*"

2 Fry 1982, p. 28.

3 For a synthetic presentation of the debates on the *papiers-collés*, see Daix 1995, pp. 662–66, and Cottington 1988, pp. 350–51. See also the quite extensive discussions in *Picasso and Braque: A Symposium*, 1992.

4 Monod-Fontaine 1982, p. 39.

5 Baldassari 1995, pp. 87–171.

6 The listed works or manuscripts are mostly part of the Picasso archive, or belong to the collection of drawings of the Musée Picasso in Paris (inventoried MP), or else to the Picasso estate (inventoried 'Est.').

7 Green 1993, p. 121, underscores the more systematic way in which Picasso, from the years 1929–30, set down the date the work was completed and sometimes the order in which, on any single day, his paintings or drawings were worked on, and connects this attitude to the beginning of regular publication of Picasso's work in the *Cahiers d'Art*, then to his collaboration with Brassaï.

8 Brassaï 1997, pp. 150–51.

9 *Idem*.

10 Sabartès 1946, p. 118.

11 Verdet 1978, p. 198.

12 Palau i Fabre 1990, p. 38.

13 Sabartès 1946, p. 36.

14 Published in Barcelona from 15 February 1900 to 31 December 1906.

15 Published in Barcelona from June 1898 to December 1903.

16 Published in Barcelona from 14 June 1900 to 6 November 1902.

17 A veritable media group, the *Sociedad Editorial de España* published editions of *El Liberal* in Bilbao, Seville and Murcia.

18 Edition dated 10 August 1910, pp. 502–03.

19 In an article of 1958, which has retained its importance in subsequent debate, Greenberg underscored the extent of the break with pictorial illusionism accomplished by the *papiers collés* in "signifiying the very real flatness of the picture plane so that everything else shown on it would be pushed into illusioned space by force of contrast. The surface was now *explicitly* instead of implicitly indicated as a tangible but transparent plane". Greenberg 1958, p. 45.

20 Especially the paintings of 1912, *Violin, Score and Newspaper*, DR 514, Z II**, 369, *Violin*, DR 517, Z II**, 774 1913, *Student with Newspaper*, DR 621, Z II**, 443, *Bottle, Newspaper, and Musical Instruments*, DR 622, Z II**, 505, *Bottle, Clarinet, Violin, Newspaper, Glass*, DR 623, Z II**, 496, *Bottle of Bass, Clarinet, Guitar, Violin, Newspaper, Ace of Clubs*, DR 624, Z II**, 487, and 1914, *Glass, Pipe and Newspaper*, DR 654, *Ham, Glass, Bottle of Vieux Marc, Newspaper*, DR 705, Z II**, 508, *Bottle of Bass, Ace of Clubs, Newspaper*, DR 706, Z II*318.

21 Rosenblum 1973, pp. 34–35.

22 Rioux 1990.

23 Rosenblum 1971 and 1973.

24 Daix 1973.

25 Leighten 1985 argues that "Anarchist ideas played a crucial role in Picasso's use of newsprint in his cubist collages of 1912–1913, not only influencing his choice and placement of news items but also inspiring the original act of introducing into his art, in the most literal way, the issues and events of the current Balkan Wars" (p. 653). This 'propagandist' conception of Picasso's work has been severely criticized by American formalist critiques (for example Chalmers Johnson 1986), respectful of the line set down by Rosalind Krauss for whom, especially in the case of the *papiers collés*, such "manoeuvres of finding an exact (historical) referent for every pictorial sign" are simply "grotesque" (Krauss 1985, p. 39). A more dialectical appreciation of the facts has since been set out by David Cottington, who calls for a more detailed historical study of the relations between hegemonic nationalism and the artistic vanguards in France at the beginning of this century, and concludes with the following remark: "if our understanding of Cubism is to get beyond the subjectivism not only of the formalist readings but also of idealist contextualizing we must uncover its material determinants, its ideological discourses" (1998, p. 358).

26 Weiss 1994, pp. 1–47. The author clearly specifies the correspondences in dates, political subjects and procedures existing between the *papiers collés* campaign and the revues being staged in Paris at the time.

27 *Picasso and Braque: A Symposium*, 1992, p. 76.

28 Paulhan 1971, p. 11.

29 *Guitar*, DR 608, Z II*, 348.

30 DR 701, Z II**, 461.

31 DR 702.

32 DR 529, Z XXVIII, 300.

33 Rosenblum 1971, pp. 604–06.

34 *Idem*, p. 605.

35 Frontisi 1997, p. 77.

36 Baldassari 1997, pp. 17–35.

37 DR 610, Z II**, 406.

38 A reproduction can be seen in Baldassari and Flammarion 1997, fig. 105, p. 90. In 1911 a friend of Picasso's, the poet André Salmon, wrote a musical revue in which one of the songs was devoted to *Excelsior* (Salmon 1911, p. 105, and commentary by Weiss 1994, pp. 37–38).

39 Varnedoe 1990, p. 32.

40 *Bottle and Newspaper*, DR 610, Z II**, 406.

41 Sabartès 1946, p. 114.

42 MP 1876. See the commentary in Baldassari 1995, pp. 104–05.

43 Ferrier 1985, p. 47–49 analyses the painting as a visual echo of the front page of the 30 April edition of *Ce Soir*, not only of the image of the Basque city in flames or the photograph of a wounded victim but also of the image of a violent automobile collision or of a reproduction of a painting by Jean Fouquet, *Mother with Infant*. Ferrier pp. 49–50 links several motifs from *Guernica* to the 1 May edition of *Paris-Soir*, which featured a special report on the bombing but also an illustrated article on the death of the 'bird-man' Clem-Sohn.

44 MP 1998–31 and MP 1998–81 to 1998–85.

45 Two other closely related studies are dated 3 September 1943, Z XIII, 110 and 111.

46 Z XIII, 89.

47 This edition also features an article by A. Tabarant,'Perspectives on 60 years of Painting', with a portrait of the critic Félix Fénéon by Signac.

48 Edition dated 6 June 1942.

49 Edition dated 20 June 1942.

50 See Baldassari 1997, fig. 240 and p. 256, n. 575, where we compared the body situated on the left-hand side of *Guernica* with a photograph published in the 28 April edition of *L'Humanité* showing several women victims of the bombing.

51 Published for the first time in Baldassari 1997, fig. 244 and p. 214.

52 MP 326, Spies 219, II.

53 A flong is a paper or cardboard cast on which is stamped the imprint of the form in stereoscopic plating.

54 Spies 559 A.

55 Wescher 1953, p. 33.

56 Rosenblum 1973.

57 Idem p. 34.

58 Freud 1905, p. 105.

59 Idem p. 87.

60 Leighten 1985, p. 665.

61 Picasso and Braque: A Symposium, 1992, p. 88.

62 Krauss 1980, p. 94.

63 "My impression is that there is no single rule his collage cuttings follow. In some instances, Picasso very obviously cared about the content of the newsprint cut-out. In other cases, I think, it didn't matter what the text said, he wanted it for its pointillist value, as 'shading'", Picasso and Braque: A Symposium, 1992, p. 79.

64 Picasso and Braque: A Symposium, 1992, p. 77.

Chapter 1

1 Azul y Blanco no. 1, 8 October 1893, MPB 110.863 R and MPG 110.863; Azul y Blanco, special Christmas issue 1993, Est. 1053 1 R; Azul y Blanco no. 2, 28 October 1894, MP 403 R and V, Z XXI, 13 and 12; La Coruña, 16 September 1894, MP 402 R and V, Z XXI, 10 and 11.

2 The issue entitled La Coruña is thus dedicated to Salvador Ruiz-Blasco, Picasso's well-to-do uncle, who would play for quite some time the role of financial benefactor.

3 MP 403 V.

4 MP 403 R.

5 Sabartès 1954, p. 26. This is the context in which the Malaga school came to be, along with the museum whose first director was José Blasco. One of his closest friends, Juan Carreño, reached a high position of power in Spanish politics.

6 Catalonian politician, president of the first Spanish Republic.

7 Sabartès 1946, p. 39.

8 Idem, p. 37.

9 No. 48, 3 April 1892, p. 213.

10 "¡Que telegramas! ¡Que noticias!! ¡Que sueltos se ven estos dias!"

11 Blanco y Negro, no. 68, Madrid, 21 August 1892.

12 DB -D. I, 7; Z VI, 219.

13 In Richardson 1991, p. 217.

14 Blanco y Negro, no. 62, 10 July 1892.

15 For example, the plate published in no. 60, 26 June 1892, p. 407.

16 See McCully 1995.

17 No. 61, 3 July 1892, p. 240.

18 1905, DB XII, 18, Z XXII, 159.

19 1905, DB XII, 19, Z I, 290.

20 Massine 1968, p. 106.

21 Kaplan 1992, pp. 61–74.

22 Idem, p. 75.

23 No. 59, 19 June 1892.

24 See especially La Soupe, DB VII, 11, Z I, 131, Mother and Child in Profile, DB VII, 20, Z; VI, 478, Woman and Child on the Seaside, DB VII, 21, Z I, 381, Mother and Child, DB VII, 18, Z XXI, 367, and also The Two Sisters, DB VII, 22, Z I, 163.

25 Apollinaire, 'Calligrammes: Poèmes de la paix et de la guerre (1913–1918)' ['Calligrammes: Poems of Peace and War'] 1981, pp. 163–314.

26 These two sketches can be respectively compared to the portrait in pencil (Barcelona, 1899–1900, Robert and Lisa Sainsbury, University of East Anglia) in which the model is clean-shaven, and the portrait done in Paris in 1901–02 (DB VI, 33, Z I, 86) in which the model is wearing a beard.

27 See especially the studies MPB 110.807 and 110.834.

28 Paris 1901, MPB 110.833 and Z VI, 312, MP 430 R.

29 An ink caricature of a bust in profile (the Reina Sofia art centre in Madrid) is quite similar to these two sketches, see Ocaña 1996, p. 97. A profile of Riera is also a part of a 1905 drawing, Spanish Friends of the Artist, Z XXII, 299.

30 "Es muy divertido que estos pobres gentes sin haber estado nunca en presidio no habieran sido nunca inocentes – y que carga terrible todo el resto sus vidas."

31 DB XII, 5, Z I, 307.

32 Portrait of Fernande, Z XXII, 333.

33 MP 446, Z XXI, 413.

34 Z XXII, 182.

35 DB XIII, 7, Z XXII, 180.

36 For example, Z XXII, 178, 179, 181 and 183.

37 "Madame s'acheta un chapeau, des gants, un bouquet" ("Madame purchased a hat, gloves, a bouquet").

38 DB XV, 43, Z I, 253.

39 DB XII, 35, Z I, 285.

40 Z XXII, 347.

41 For example, Standing Nude, April–May 1907, MP 535.

42 Self-Portrait and Studies of a Nude, Z I, 364.

43 DB XVI, 28, Z I, 375.

44 Doñate 1995.

45 Daix 1988, p. 145.

46 Est. 1067 R and V.

47 Z XXVI, 259.

48 See Leja 1985.

49 Est. 1070.

50 DR 131, Z II*, 108.

51 Z XXVI. 179.

52 Gopnik 1990, p. 131.

53 Idem.

54 Rubin 1996, pp. 28–31, note 36.

55 DR, 23, Z XXVI, 18, MP 17.

56 MP 3543.

57 MP 1990–59.

58 MP 3163.

59 MP 3167.

60 Z XXVI, 267.

61 Z II*, 50.

62 An identical formal likeness between personage and object appears in the drawings

of a man with pitcher (especially a 1905 draw-
ing *The Dance*, Z XXII, 205), studies for *The
Family of Saltimbanques*. It shows up again in
1930 in the *Large Still Life with Pedestal Table*
(MP 134), an encrypted portrait of Marie-
Thérèse.

63 Kahnweiler 1961, p. 27.

64 Written mention in Spanish and English on
an envelope in the Picasso archive in Paris.

65 Z II**, 47. The painting was purchased by
the Steins with several of its preparatory stud-
ies.

66 Baldassari 1997, figs. 16–18 and p. 22.

67 Stein 1938, p. 13.

68 As for the *Demoiselles d'Avignon*, this
'magician' can also conjure up that dangerous
sexuality of prostitutes that had already
inspired Picasso's 1905 etching on the castra-
tion theme, *Salome's Dance*. Such sexual
anguish may have occured again in the course
of this summer of 1907, the period of the
final stage of the *Demoiselles*, and which
preceded *Nude with Drapery*; there were in
fact at this time private discussions causing
Fernande and Picasso to separate before
getting back together in November.

69 18 April 1935, in Spanish. Reproduced in
Picasso 1989, pp. 1–13.

70 Apollinaire 1980, p. 60.

71 *Idem*, p. 79.

72 Z VI, 1148.

73 *Girl with Mandolin*, Z II*, 235.

74 Seckel 1994, pp. 79–83.

75 Z VI, 1019.

76 Z VI, 1134.

77 We owe this reference to an indication by
Mrs Bleton at the Arsenal Library, Paris.

78 DR 239, Z II*, 111.

79 Z II, 150, DR 241.

80 *Seated Nude*, MP 628, 629 and 630.

81 After his trip to Horta, Picasso moved to
this address in September 1909.

82 DB V, 2, Z XXI 192.

83 See Baldassari 1997, fig. 153. Two
palettes also appear on the wall of the studio
in the 1915 photograph *Self-Portrait with
'Musical Instruments on a Pedestal Table'*,
idem, fig. 152.

84 *Guitar*, DR 596, Z II** 415 and DR 598, Z
XXVIII, 301.

85 Spies, 27.

86 MP 403 R, translated from the Spanish,
Azul y Blanco, no. 20, Sunday, 28 October
1894.

87 MP 1045, 1047, 1048, 1049, 1050
(1930); MP 1139 and 1140 (1935).

88 *Palette, Candlestick and Minotaur Head*
1938, Z IX, 235; *Candle, Palette, Bull's Head*
1938, Z IX, 240; *Still Life with Red Bull's
Head*, Z IX, 239.

89 See Baldassari 1997, figs. 122–24.

90 DR 412, Z II*, 264.

91 Daix 1973, unpaginated.

92 *Ibidem*.

93 *Ibidem*.

94 DR 451, Z II*, 293.

95 DR 466, Z II*, 294, MP 36.

96 Daix 1973, unpaginated.

Chapter 2

1 Z II*, 66, also entitled *The Dream*.

2 Daix 1982, pp. 14–15.

3 Rubin 1989, p. 59, note 72.

4 'Discussion' in *Picasso and Braque: A
Symposium*, 1992, p. 209.

5 In an article of 1982, p. 14, Pierre Daix
considered this rectangle of paper to be a
ticket for entrance into the Musée du Louvre.

6 Daix 1995, p. 80.

7 Frontisi 1997, p. 67.

8 Daix 1982, p. 15.

9 Letter reproduced in Monod-Fontaine 1982,
fig. 5, p. 40.

10 Rubin 1989, pp. 30–32.

11 DR 506, Z II**, 372.

12 DR 633.

13 DR 513, Z II**, 423.

14 DR 513 to 522.

15 Baldassari 1994, pp. 213–21. On the
analysis of this photographic sequence with
regard to the genesis of the *papiers collés*,
see Karmel 1993, pp. 185–240.

16 DR 553, Z II**, 756.

17 DR 549, Z XXVIII, 209.

18 DR 543, Z II**, 424.

19 DR 545, Z II**, 397.

20 DR 508, not in Zervos.

21 DR 555, Z II**, 770, Spies no. 30 and DR
556, Z II**, 779; Spies no. 29.

22 Zervos 1950.

23 Z II**, 390.

24 DR 525, Z II**, 409. The clippings used
would be dated after 9 December 1912.

25 Z XVIII, 304. Pierre Daix mistook it for
Musical Score and Guitar, DR 520, Z II**,
416.

26 DR 547, Z II**, 429.

27 DR 542, Z II**, 755.

28 DR 537, Z II**, 391.

29 This *papier collé* is reproduced in Rubin
1989, p. 266.

30 The half page of the 18 November 1912
edition of *Le Journal* has been reproduced in
Cottington 1998, fig. 36, p. 141.

31 DR 544, Z XXVIII, 203.

32 DR 550, Z VI, 1149.

33 Z VI, 1105.

34 *Violin*, Z XXVIII 192.

35 DR 552, Z XXVIII, 204.

36 DR 538, not in Zervos.

37 DR 548, Z II**, 428.

38 *Head with Moustache*, Z XXVIII, 85. This
head belongs to a series that was dated from
the summer of 1912 in Sorgues. Its presence

in the photographs of the *papiers collés* hangings should move the date to the end of 1912, in Paris, and place them at the moment of the genesis of the *papiers collés*, with which it shares the same format and graphic technique.

39 DR 546, not in Zervos.

40 DR 554, Z II*, 331.

41 Kirk Varnedoe, 'Discussion' in *Picasso and Braque: A Symposium*, 1992, p. 119, in reference to an article of 1987 by Antoinette King.

42 In the ratio of one clipping in photo no. 1 (5 *papiers collés*), 1 in photo no. 2 (5 *papiers collés*) and 3 in photo no. 3 (7 *papiers collés*).

43 Leighten 1985, p. 667.

44 Cottington 1988, p. 356.

45 Weiss 1994, pp. 1–47. The author points out that the revues used to use characters standing for the various newspapers and wearing costumes with typographic motifs printed on them: see especially a costume referring to *Le Journal*, fig. 20, p. 19. He also analyses the use of plays on words, *doubles entendres* and abrupt changes of subject as characteric of revues, comparing them to the collage technique and *papiers collés*.

46 Z XXVIII, 307, Est. 1534.

47 DR 523, Z II**, 422.

48 DR 530, Z II**, 385.

49 DR 551, Z II**, 782, MP 369.

50 DR 552, Z XXVIII, 204.

51 See in Guéry 1997 three examples of the front page of *L'Homme libre (Free Man)* by Georges Clémenceau, the title of which, in protest against censorship, was changed to *L'Homme Enchaîné (Enchained Man)*.

52 Picasso 1926.

53 DR 471, Z II**, 773, Spies no. 27.

54 Salmon 1919, pp. 102–03.

55 Baldassari 1997, p. 116.

56 The five acts of the play are published in full in two successive issues of *L'Illustration théâtrale*, nos. 170 and 171, 21 and 28 January 1911.

57 "No sooner had we entered the studio than we glimpsed, posed on easels or hung on the wall, 20, 30, sometimes 50 sketches, none of which has been touched by a paintbrush since the first outline of the sketch. But as soon as an idea catches his fancy, or an art dealer enters, the artist will choose one of these sketches and in two hours' time will finish off a work from the forgotten study. Well now, the writing quarters of a man of letters looks like the studio of a painter". Georges de Porto-Riche, interviewed by Léo Marchès, as quoted in *L'Illustration théâtrale*, no. 170, on the inside cover.

58 *Idem*, p. 2.

59 *Idem*, p. 3.

60 *Idem*, p. 7.

61 Penrose 1958, pp. 24–25.

62 Between December 1912 and May 1913, Picasso, who had not returned home since 1910, went twice to Barcelona to visit his sick father, then a third time for his funeral. This mourning weighed him down. In a letter to Kahnweiler from Barcelona, Picasso wrote: "You can easily imagine the state I am in!" During his March trip, Picasso had taken along the 31 March edition of the newspaper *El Diluvio*, which would be the basis of the *papier collé Guitar* (DR 608, Z II*, 348). The *papier collé Bottle and Newspaper* (DR 610, Z II**, 406), which includes a fragment of a headline (ELSIOR) dated 6 May 1913, has also been connected to the death of don Blasco. See note 88.

63 Sabartès 1954, pp. 38–39.

64 Penrose 1996, p. 25.

65 Palau i Fabre 1990, p. 329.

66 Quoted in *L'Illustration théâtrale*, inside back cover.

67 *Idem*, Charles Méré.

68 *Idem*, Francis Chevassu.

69 *Idem*, M. Nozière.

70 Issues dated 19 January and 9 February 1911. This anti-Semitic campaign would well up again after the War: see Charasson 1925.

71 *L'Œuvre*, 9 February 1911, p. 23.

72 *Idem*.

73 Boghen 1923, p. 83.

74 *L'Illustration théâtrale*, no. 170, p.3.

75 Lasserre 1911.

76 *L'Illustration théâtrale*, no. 170, p. 29.

77 *L'Illustration théâtrale*, no. 170, p. 29.

78 Wescher 1960, unpaginated.

79 DR 557, Z II**, 378.

80 See especially 'Discussion' in *Picasso and Braque: A Symposium*, 1992, pp. 79–90, around the interpretation of this lettering as a sexually connoted pun in Rosenblum 1973, p. 36.

81 DR 890, Z II**, 551.

82 Est. 1427.

83 Z XXVIII, 135.

84 MP 705, 1.

85 Léal 1996, p. 227ff.

86 Est. 1353.

87 DR 610; Z II**, 406.

88 Sutherland Boggs 1992, p. 128. The author interprets the fragment "ELSIOR" as designating *el señor Ruiz*.

89 Pierre Cabane 1975, re-edited 1992, vol. 1, p. 40.

90 Picasso 1989, pp. 63 and 390–91.

91 This strip shows Nimbus struggling with a pipe holder strangely evocative of the one hanging from the boulevard Clichy studio (see Baldassari 1994, figs. 92–95, pp. 121–25).

92 Picasso underlined the whole passage taken from the weather forecast. When numerals are suppressed the fact is indicated by dashes.

93 1939, MP 136.

94 Sabartès 1946, p. 121.

95 *Idem*, pp. 125–26.

96 MP 3663.

97 Especially, *Guitar, Sheet Music, Glass, "La Bataille s'est engagé"*, DR 513, Z II**, 423, *Violin, Score and Newspaper*, DR 514, Z II**, 369, and finally *Bottle, Newspaper, and Musical Instrument*, DR 622, Z II**, 505.

98 Tzara 1931, p. 62.

99 DR 513, 526, 527, 545, 600.

100 DR 554, 530, 542.

101 DR 545.

102 DR 542. Likewise, the "IRNAL" complementary to "LE JOU" is visible on the floor of the studio in one of the photographs at the boulevard Raspail, of *Guitar, Sheet Music and Glass, "La Bataille s'est engagé"* (DR 513). This "IRNAL" could not have been used in the collages of *Bottle and Glass on a Table* (DR 542) or *Fruit Dish with Fruit, Violin and Glass*, for the cup of the "U" is different. On the other hand, "LE JOU" of *Newspaper and Violin* (DR 526) or of *Glass, Violin and Newspaper* (DR 527) could perhaps correspond to it. One would thus obtain three possible pairs of "LE JOU"/"RNAL" and two isolated "LE JOU"s. There is also the exceptional case of "JOURNAL" without an article, in *Siphon, Glass, Newspaper, Violin* (DR 528).

103 Rosenblum 1973, pp. 34–35.

104 Especially Varnedoe 1990, pp. 36–37, and Weiss 1994, pp. 1–21.

105 Weiss 1994, p. 11.

106 DB V, I, Z 1, 113 and DB V, 2, Z XXI 192.

107 Kahnweiler 1944, p. 180.

108 Varnedoe 1990, p. 45.

109 Apollinaire 1980, p. 80.

110 *Idem*, p. 76.

111 *Idem*, 1980, p. 79.

112 *Idem*, p. 80.

113 *Idem*, p. 79.

114 Aragon 1980, p. 45.

115 *Idem*, footnote, p. 47.

116 *Idem*, p. 47.
117 *Idem*, pp. 47–48.
118 *Idem*, p. 48.
119 Tzara 1931, p. 62.
120 Tzara 1935, unpaginated
121 Breton 1932, p. 14.
122 *Idem*.
123 *Aragon* 1980, p. 47, footnote.
124 Raynal 1935, p. 31.
125 Apollinaire 1980, p. 79.

Chapter 3

1 Rubin 1994.
2 Silver 1989, p. 291.
3 Spain had lost its Cuban colony in 1898, simultaneous to the loss of Puerto Rico, Guam, and the Philippine Islands. The creation of a Spanish Morocco at the Algéciras conference and the political problems of the occupation are behind the events of the 'bloody week' in Barcelona in 1909. In 1933, the 'pacification' of the French protectorate of Morocco had been going on for seven years, following the war in the Rif, where the uprising of Abd-el-Krim was put down by a joint force of French and Spanish troops under the command of Maréchal Pétain.
4 Exhibition *Papiers collés 1912–1914 de Picasso*, 20 February – 20 March 1935.
5 Louis Aragon's *La Peinture au défi* was published in the catalogue of this exhibition.
6 *Cahiers d'Art*, V, 1930, pp. 225–28.
7 *Idem*, p. 232.
8 DR 506, Z II**, 372.
9 *Cahiers d'Art*, V, 1932, p. 117, DR 534, Z II**, 398.
10 Hugnet 1935.
11 *Idem*, p. 82.
12 *Idem*.
13 Aragon 1930, p. 70.
14 *Idem*, 1930, p. 70.
15 Penrose 1996, p. 299.
16 Zervos 1935.
17 Penrose 1996, p. 229.
18 Picasso 1989, p. 99.
19 "*virginidad del toro que es la virgen puesta debajo de la copa que/rodean les abejas haciendo oles*". The text exists in Spanish and in French, in one handwritten copy and two typed copies.
20 Brassaï 1982, p. 173.
21 Zervos 1935, pp. 173–178.
22 Spies 181.
23 *Cahiers d'Art*, IV, V, 1937, unpaginated portfolio.
24 Z; VI, 931, 932, 939 and 940.
25 Kaplan 1992, p. 174.
26 Ferrier 1985, p. 47. The author points out, p. 46, that "A newspaper is something with headings and photos of all sorts shaking the page, editorials punctuating it, boxes splitting it up, articles extending to other pages and losing themselves in the no man's land of full-page advertisements. ... The press photo and its caption, in particular, substitute for linear rational demonstration along several large avenues, a whole gamut of global images working by instantaneous assemblage to the extent that they are simply scanned by the gaze of the reader".
27 'Guernica', *New Statesman*, 15 October 1938, quoted in Kaplan 1992, p. 184.
28 The painting MP 1990–18 is dated 20 September 1937.
29 Baldassari 1997, figs. 261–63, pp. 232–35.
30 *Women at Work*, MP 1226. On *Paris-Soir* and the collaboration policy, see Cotta 1964, Lazareff 1942 and Quéval 1945.
31 The 8 June 1941 edition of *Paris-Soir*; the photograph before touch-up was identified and published by Baldassari 1995, fig. 86, p. 110.
32 See Cotta 1964.
33 Christian Zervos, letter to Alfred H. Barr Jr, 28 March 1945, quoted in Michael FitzGerald, 'Reports from the Home Front: Some Skirmishes over Picasso's Reputation', in Nash and Rosenblum 1999, p. 119.
34 Brassaï 1997, pp. 73–74.
35 *Idem*, p. 73.
36 Brassaï 1982, p. 170.
37 In particular *Woman in an Armchair*, versions of 4 October 1941, Z XI, 319, and of 12 October, Z XI, 340 or *Female Bust*, 15 October 1941, Z XI, 338.
38 'Chronology', Nash and Rosenblum 1998, p. 214.
39 Steinberg 1976.
40 'Chronology', Nash and Rosenblum 1999, p. 217.
41 Leiris 1937, p. 128.
42 1941, Z XII, 1, Musée Ludwig, Sammlung Ludwig, Cologne.
43 Z XIII, 36.
44 Brassaï 1982, p. 158.
45 Z XIV, 87–88, 93–100.
46 Est. 13081.
47 Z XV, 106.
48 Gilot and Lake 1991, p. 210.
49 Z XV, 107, MP 200.
50 Daix 1995, p. 744.
51 Est. 6596.
52 Est. 6595.
53 Cannes 1961, Spies no. 559A.
54 *Man Running* (Spies no. 558) and *Infant* (Spies no. 559), both in bronze, refer to Rodin's bronze statue.
55 Especially MP 111 and Z VII, 125, 126, 129 (MP 103).
56 On the previously unpublished photographic source of this cycle of paintings, see Baldassari 1994, figs. 57–87, and Baldassari 1997, figs. 220–21, pp. 189–91.

Selected Bibliography

Compiled by Jeanne-Yvette Sudour

Chargée d'études documentaires at the Musée Picasso

Catalogue References

Baer Baer, Brigitte, *Picasso peintre-graveur*, 7 vols. and adden-
 dum, Berne, Editions Kornfeld, 1990–96.

DB Daix, Pierre, and Boudaille, Georges, *Picasso 1900–1906,
 catalogue raisonné de l'œuvre peint*, Neuchâtel, Ides et
 Calendes, 1966.

DR Daix, Pierre, and Rosselet, Joan, *Le Cubisme de Picasso,
 catalogue raisonné de l'œuvre peint 1907–1916*, Neuchâtel
 (Ides et Calendes) 1979.

Duncan Duncan, David Douglas, *Les Picasso de Picasso*, Paris,
 Bibliothèque des Arts, 1961.

MP Bozo, Dominique; Bernadac, Marie-Laure; and Seckel,
 Hélène, *Musée Picasso, catalogue sommaire des collec-
 tions, peintures, papiers collés, tableaux-reliefs, sculptures,
 céramiques*, Paris, Réunion des musées nationaux, 1985.
 Richet, Michèle, *Musée Picasso, catalogue sommaire des
 collections, dessins, aquarelles, gouaches, pastels*, Paris,
 Réunion des musées nationaux, 1987.
 Léal, Brigitte, *Musée Picasso, Carnets*, I and II, Paris,
 Réunion des musées nationaux, 1996.
 Régnier, Gérard; Bernadac, Marie-Laure; Léal, Brigitte; and
 Seckel, Hélène, *Picasso, une nouvelle dation*, Paris, Réunion
 des musées nationaux, 1990.

PiF Palau i Fabre, Josep, *Picasso vivant (1881–1907)*, Paris,
 Albin Michel, 1981; new edition 1990.
 Palau i Fabre, Josep, *Picasso Cubisme (1907–1917)*, Paris,
 Albin Michel, 1990.

Spies Spies, Werner, *Picasso, das plastische Werk*, Stuttgart,
 Verlag Gerd Hatje, 1983.

Z Zervos, Christian, *Pablo Picasso*, Paris, Editions Cahiers
 d'Art, I, 1932, to XXXIII, 1978.

Books and Articles

Adhémar, Jean, 'Les Journaux amusants et les peintres cubistes', *L'Œil*,
 IV, 15 April 1955, pp. 40–42.

Apgar, Garry; Higgins, Shaun O'L.; and Striegel, Colleen, *The Newspapers
 in Art*, Washington, New Media Ventures, 1996.

Apollinaire, Guillaume, *Les Peintres cubistes*, Paris, Eugène Figuière et
 Cie, 1913.

Apollinaire, Guillaume, 'Picasso et les papiers collés', *Montjoie!*, Paris,
 14 March 1913, republished in *Cahiers d'Art*, VII, no. 315, 1932,
 p. 117.

Apollinaire, Guillaume, *Les Peintres Cubistes*, Paris, Hermann, Collection
 Savoir, 1980.

Apollinaire, Guillaume, *Œuvres poétiques*, Paris, Editions Gallimard,
 Pléiade, 1981.

Apollinaire, Guillaume, 'Méditations esthétiques: les peintres Cubistes',
 in *Œuvres en prose complètes II*, Paris, Editions Gallimard,
 Pléiade, 1991, pp. 3–51.

Aragon, Louis, *Les Collages*, Paris, Hermann, 1980.

Baldassari, Anne, *Picasso photographe, 1901–1916*, Paris, Réunion des
 musées nationaux, 1994.

Baldassari, Anne, *Picasso et la photographie: «A plus grande vitesse que
 les images»*, Paris, Réunion des musées nationaux, 1995.

Baldassari, Anne, *Le Miroir noir: Picasso, sources photographiques
 1900–1928*, Paris, Réunion des musées nationaux, 1997.

Baldassari, Anne, *Picasso and Photography: The Dark Mirror*, Paris,
 Flammarion, Houston, The Museum of Fine Arts, 1997.

Baro, Roser, *Picasso Cubista 1907–1920, Colecció/Coleccion Marina
 Picasso*, Barcelona, Fundacio Caixa, 1987.

Bellanger, Claude; Godechot, Jacques; Pierre, Guiral, and Terrou,
 Fernand, *Histoire générale de la presse française*, Paris, Presses
 universitaires de France, III, 'De 1871 à 1940', 1972, IV, 'De
 1940 à 1958', 1975.

Bernadac, Marie-Laure, and Sutherland Boggs, Jean, *Picasso et les
 choses, les natures mortes*, Paris, Réunion des musées
 nationaux, 1992.

Blunt, Anthony, and Pool, Phœbe, *Picasso: The Formative Years: A Study
 of his Sources*, Greenwich, Connecticut, New York Graphic Society,
 1962.

Boghen, André, *Le Théâtre de Porto-Riche*, Paris, La Table Ronde, 1923.

Bois, Yve-Alain, 'The Semiology of Cubism', in *Picasso and Braque: A
 Symposium*, ed. William Rubin, New York, The Museum of Modern
 Art/Harry N. Abrams, 1992, pp. 169–209.

Brassaï, *Conversations avec Picasso*, Paris, Editions Gallimard, 1964;
 new edition 1997.

Brassaï, *Les Artistes de ma vie*, Paris, Denoël, 1982.

Breton, André, 'Picasso dans son élément', *Minotaure*, no. 1, 1933,
 pp. 8–14.

Butor, Michel, *Les Mots dans la peinture*, Paris, Flammarion, 1980.

Cabanne, Pierre, *Le Siècle de Picasso*, Paris, Denoël, 1975; new edition
 1992.

Caizergues, Pierre, and Seckel, Hélène, *Picasso – Apollinaire: correspon-
 dance*, Paris, Editions Gallimard/Réunion des musées nationaux,
 1992.

Camón Aznar, José, *Picasso y el cubismo*, Madrid, Espasa-Calpe, 1956.

Carmean, Jr, E.A., 'Braque, le collage et le cubisme tardif', in *Georges
 Braque: les papiers collés*, Paris, Centre Georges Pompidou,
 1982, pp. 57–63.

Chalmers Johnson, Diane, 'Picasso's 1912, *Papiers Collés*: La Bataille
 s'est Engagée', in *World Art: Themes of Unity in Diversity: Acts of
 the XXVIth International Congress of the History of Art*, Washington
 1986; ed. Irving Lavin, Pennsylvania State University Press, 1989,
 pp. 379–83.

Charasson, Henriette, *M. de Porto-Riche ou le «Racine juif»*, Paris,
 Editions du Siècle, 1925.

Cooper, Douglas, *The Cubist Epoch*, London, Phaidon in association with
 the Los Angeles County Museum of Art and the Metropolitan
 Museum of Art, 1970.

Cooper, Douglas, and Tinterow, Gary, *The Essential Cubism, 1907–1920*,
 London, The Tate Gallery, 1983.

Cotta, Michèle, *La Collaboration 1940–44*, Paris, Armand Colin,
 Collection Kiosque, 1964.

Cottington, David, 'What the Papers Say: Politics and Ideology in
 Picasso's Collages of 1912', *Art Journal*, XXXXVII, no. 4, winter
 1988, pp. 350–59.

Cottington, David, 'Cubism, Aestheticism, Modernism', in *Picasso and Braque: A Symposium*, ed. William Rubin, New York, The Museum of Modern Art/Harry N. Abrams, 1992, pp. 58–72.

Cottington, David, *Cubism in the Shadow of War: The Avant Garde and Politics in Paris 1905–1914*, New Haven and London, Yale University Press, 1998.

Cowling, Elizabeth, 'The Fine Art of Cutting: Picasso's Papiers Collés and Constructions in 1912–1914', *Apollo*, CXLII, no. 405, November 1995, pp. 10–18.

Daix, Pierre, and Rosselet, Joan, 'Pablo Picasso, la révolution des papiers collés', *L'Œil*, no. 284, March 1979, pp. 52–57.

Daix, Pierre, 'Des bouleversements chronologiques dans la révolution des papiers collés (1912–1914)', *Gazette des Beaux-Arts*, October 1973, pp. 217–27.

Daix, Pierre, 'Les Trois séjours «cubistes» de Picasso à Céret (1911–1912–1913)', in *Picasso et la Paix*, Céret, Musée d'art moderne, 1973.

Daix, Pierre, 'Braque et Picasso au temps des papiers collés', in *Georges Braque: les papiers collés*, Paris, Centre Georges Pompidou, 1982, pp. 12–25.

Daix, Pierre, 'Trois périodes de travail de Picasso sur «Les Trois Femmes», (automne 1907–automne 1908), les rapports avec Braque et les débuts du cubisme', *Gazette des Beaux-Arts*, no. 111, January–February 1988, pp. 141–54.

Daix, Pierre, 'Le Cubisme de Picasso, Braque, Gris et la publicité', *Art et Publicité*, Paris, Centre Georges Pompidou, 1990, pp. 136–51.

Daix, Pierre, *Dictionnaire Picasso*, Paris, Robert Laffont, 1995.

Diehl, Gaston, *Picasso*, Paris, Flammarion, 1960.

Doñate, Mercè, 'Las Actividades Artísticas de Els Quatre Gats', in *Picasso y els 4 Gats*, ed. Maria Teresa Ocaña, Barcelona, Lunwerg Editores, 1995, pp. 223–36.

Elbaz, Irène, 'Les Premiers collages, les premiers papiers collés', *Collages, collections des musées de province*, Colmar, Musée d'Unterlinden, 1990, pp. 21–25.

Ferrier, Jean-Louis, *De Picasso à Guernica, généalogie d'un tableau*, Paris, Denoël/L'Infini, 1985.

Freud, Sigmund, *Le Mot d'esprit et sa relation à l'inconscient*, 1905, trans. into French, Paris, NRF/Editions Gallimard, collection Connaissance de l'Inconscient, 1988.

Frontisi, Claude, *Cubisme et Cubistes*, Paris, CNDP, 1989.

Frontisi, Claude, 'Picasso et Cie: collages en tous genres', in *Picasso: dessins et papiers collés, Céret 1911–1913*, Céret, Musée d'art moderne, 1997, pp. 56–79.

Fry, Edward, *Cubism*, London, Thames and Hudson, 1966.

Fry, Edward, 'Braque, le cubisme et la tradition française' in *Georges Braque: les papiers collés*, Paris, Centre Georges Pompidou, 1982, pp. 26–36.

Gilot, Françoise, and Lake, Carlton, *Vivre avec Picasso*, Paris, Calmann-Lévy, 1991.

Golding, John, *Le Cubisme*, Paris, Julliard, 1962.

Gopnik, Adam, 'High and Low: Caricature, Primitivism, and the Cubist Portrait', *Art Journal*, XLIII, no. 4, winter 1983, pp. 371–76.

Gopnik, Adam, and Varnedoe, Kirk (eds.), *High and Low: Modern Art and Popular Culture*, New York, The Museum of Modern Art/Harry N. Abrams, 1990.

Green, Christopher, *Art Critics since 1900*, Manchester, New York, Manchester University Press, 1993.

Greenberg, Clement, 'The Pasted-Paper Revolution', *Art News*, LVII, no. 5, September 1958, pp. 46–49, 60; trans. into French in *Art et Culture*, Paris, Macula, 1988, pp. 81–95.

Guéry, Louis, *Visages de la presse, la présentation des journaux des origines à nos jours*, Paris, Editions du centre de formation et de perfectionnement des journalistes, 1997.

Hoffman, Katherine, *Collage: Critical Views*, Ann Arbor, Michigan, UMI, 1989.

Hugnet, Georges, 'L'Iconoclaste', *Cahiers d'Art*, V, no. 7, pp. 82–83.

Jacob, Max, 'Souvenirs sur Picasso', *Cahiers d'Art*, II, no. 6, 1927, p. 199.

Jouffroy, Jean-Pierre, and Ruiz, Edouard, *Picasso de l'image à la lettre*, Paris, Messidor-Temps actuels, 1981.

Kachur, Lewis C., *Themes in Picasso's Cubism, 1907–1918*, PhD thesis, Colombia University 1988, Ann Arbor, Michigan, UMI, 1990.

Kahnweiler, Daniel-Henry, 'Art conceptuel et papiers collés', *Cahiers d'Art*, XVI–XIX, Paris, 1940–44, pp. 179–85.

Kahnweiler, Daniel-Henry, 'Naissance et développement du cubisme', in *Les Maîtres de la peinture française contemporaine*, ed. Maurice Jardot and Kurt Martin, Baden-Baden, Woldemar Klein, 1949, pp. 9–22.

Kahnweiler, Daniel-Henry, *Les Années héroïques du Cubisme*, Paris, Braun, 1950.

Kahnweiler, Daniel-Henry, *Mes Galeries et mes peintres: entretiens avec François Crémieux*, Paris, Editions Gallimard, 1961.

Kahnweiler, Daniel-Henry, *Confessions esthétiques*, Paris, Gallimard, 1963.

Kahnweiler, Daniel-Henry, *Huit Entretiens avec Picasso*, Caen, L'Echoppe, 1988.

Kaplan, Temma, *Red City, Blue Period: Social Movements in Picasso's Barcelona*, Berkeley, Los Angeles, Oxford, University of California Press, 1992.

Karmel, Pepe, *Picasso's Laboratory: The Role of his Drawings in the Development of Cubism, 1910–1914*, PhD thesis, Institute of Fine Arts, New York University, New York, 1993.

King, Antoinette, 'The Conservation Treatment of a Collage: *Man with a Hat*, by Pablo Picasso', in *Conservation of Library and Archive Materials and the Graphic Arts*, ed. Guy Petherbridge, London, Butterworths, 1987.

Krauss, Rosalind, 'Re-Presenting Picasso', *Art in America*, no. 10, December 1980, pp. 90–96.

Krauss, Rosalind, 'The Motivation of the Sign', *Picasso and Braque: A Symposium*, (ed. William Rubin) New York, The Museum of Modern Art/Harry N. Abrams, 1992, pp. 261–86.

Krauss, Rosalind, 'In the Name of Picasso', *October*, no. 16, spring 1981; trans. into French in *L'originalité de l'avant-garde et autres mythes modernistes*, Paris, Macula, 1993, pp. 179–99.

Lascault, Gilbert, 'Lettres figurées, alphabet fou', *Critique*, no. 285, February 1971.

Lasserre, Pierre, *Le Théâtre de M. de Porto-Riche*, off-print, 1911.

Laude, Jean, 'Le Cubisme', in Jean Cassou, *Pablo Picasso*, Paris, Somogy 1975, pp. 85–122.

Lazareff, Pierre, *Dernière édition*, New York, Brentano's, 1942.

Léal, Brigitte, *Picasso: papiers collés*, Paris, Réunion des musées nationaux, 1998.

Leighten, Patricia, 'Picasso's Collages and the Threat of War, 1912–1913', *The Art Bulletin*, XVII, no. 4, December 1985, pp. 653–72.

Leighten, Patricia, *Re-Ordering the Universe: Picasso and Anarchism, 1897–1914*, Princeton, New Jersey, Princeton University Press, 1989.

Leiris, Michel, 'Faire-part', *Cahiers d'Art*, XII, no. 415, 1937, p. 128.

Leja, Michael, 'Le Vieux Marcheur and "Les deux risques": Picasso, Prostitution, Veneral Disease and Maternity, 1890–1907', *Art History*, VIII, March 1985, pp. 66–81.

Manevy, Raymond, *Histoire de la presse, 1914–1939*, Paris, Correa, 1945.

Massine, Leonide, *My Life in Ballet*, London, Macmillan/St Martin Press, 1968.

McCully, Marilyn, *Els Quatre Gats and Modernista Painting in Catalonia in the 1890s*, New Haven and London, Yale University Press, 1975.

McCully, Marilyn, *Els Quatre Gats: Art in Barcelona around 1900*, Princeton, The Art Museum/Princeton University Press, 1978.

McCully, Marilyn, 'Picasso retrata a sus amigos barceloneses', in *Picasso y els 4 Gats*, ed. Maria Teresa Ocaña, Barcelona, Lunwerg Editores, 1995, pp. 175–86.

Melot, Michel, 'Le Modèle impossible ou comment le jeune Pablo Ruiz abolit la caricature', in *Picasso jeunesse et genèse: dessins 1893–1905*, Paris, Réunion des musées nationaux, 1991, pp. 68–87.

Miller, Michael Barry, *The Bon Marché: Bourgeois Culture and the Department Store, 1869–1920*, Princeton, New Jersey, Princeton University Press, 1981.

Monod-Fontaine, Isabelle, 'Braque, la lenteur de la peinture', in *Georges Braque: les papiers collés*, Paris, Centre Georges Pompidou, 1982, pp. 37–55.

Monod-Fontaine, Isabelle; Angliviel de la Baumelle, Agnès; and Laugier, Claude, *Donation Louise et Michel Leiris: Collection Kahnweiler-Leiris*, Paris, Centre Georges Pompidou, 1984.

Murray, J. Charlat, *Picasso's Use of Newspaper Clippings in his Early Collages*, New York, Master's thesis, Columbia University, 1967.

Nash, Stephen, and Rosenblum, Robert, (eds.) *Picasso and the War Years, 1937–45*, London, New York, Thames and Hudson/Fine Arts Museums of San Francisco, 1998.

Nochlin, Linda, 'Picasso's Color: Schemes and Gambits', *Art in America*, December 1980, pp. 108–23.

Ocaña, María Teresa (ed.), *Picasso and els 4 Gats: The Early Years in Turn of the Century Barcelona*, Boston, New York, Toronto, London, Bulfinch Press Book/Little, Brown and Company, 1996.

Olivier, Fernande, *Picasso et ses amis*, Paris, Stock, 1933.

Olivier, Fernande, *Souvenir intimes*, Paris, Calman Lévy, 1988.

Palau i Fabre, Josep, *Picasso en Catalogne*, Paris, Société Française du Livre, 1979.

Palau i Fabre, Josep, *Picasso vivant (1881–1907)*, Paris, Albin Michel, 1981; new edition 1990.

Palau i Fabre, Josep, *Picasso cubisme (1907–1917)*, Paris, Albin Michel, 1990.

Paulhan, Jean, 'L'espace cubiste ou le papier collé', *L'Arc*, no. 10, special edition, Aix-en-Provence, spring 1960, pp. 9–12.

Penrose, Roland, *Picasso: His Life and Work*, London, Victor Gollancz, 1958.

Penrose, Roland, *Picasso*, Paris, Flammarion, collection Champs, 1996.

Picasso, Pablo, 'Cinq natures mortes', *Les Soirées de Paris*, no. 18, 15 November 1913, pp. 1, 13, 27, 39, 45.

Picasso, Pablo, 'Lettre sur l'art', *Ogoniok*, no. 20, Moscow, 16 May 1926; trans. from the Russian by C. Motchoulsky, *Formes*, no. 2, Paris, February 1930.

Picasso, Pablo, *Écrits*, ed. Marie-Laure Bernadac and Christine Piot, Paris, Gallimard/Réunion des musées nationaux, 1989.

Poggi, Christine, 'Mallarmé, Picasso and the News Paper as Commodity', *The Yale Journal of Criticism*, I, no. 1, 1987, pp. 133–51.

Poggi, Christine, 'Braque's Early Papiers Collés: The Certainties of Faux Bois', in *Picasso and Braque: A Symposium*, ed. William Rubin, New York, The Museum of Modern Art/Harry N. Abrams, 1992, pp. 129–50.

Poggi, Christine, *In Defiance of Painting: Cubism, Futurism, and the Invention of Collage*, New Haven and London, Yale University Press, 1992.

Porto-Riche, Georges de, 'Le Vieil Homme', *L'Illustration théâtrale*, nos. 170–71, 21 and 28 January 1911.

Quéval, Jean, *Première page, cinquième colonne*, Paris, Arthème Fayard, 1945.

Raynal, Maurice, 'Les papiers collés de Picasso', *Arts et métiers graphiques*, no. 46, Paris, 15 April 1935, pp. 28–33.

Read, Peter, *Picasso et Apollinaire: les métamorphoses de la mémoire, 1905–1973*, Paris, Jean-Michel Place, 1995.

Reff, Theodore, *Cubism and 'Trompe l'œil'*, Lecture at the Picasso symposium, Fogg Art Museum, Harvard University, 21 February 1981.

Richardson, John, *A Life of Picasso, 1881–1906*, New York, Random House, 1991.

Richardson, John, *A Life of Picasso, 1907–1917: The Painter of Modern Life*, New York, Random House, 1996.

Rioux, Jean-Pierre, 'Le Canard à un sou', *Le Monde*, 25 July 1990.

Roche-Pezard, Fanette, 'Espèces d'espaces: les collages encore', in *L'art, effacement et surgissement des figures: hommage à Marc Le Bot*, Paris, Publications de la Sorbonne, 1992, pp. 63–69.

Rodari, Florian, *Le Collage, papiers collés, papiers déchirés, papiers découpés*, Lausanne, Skira, 1988.

Rosenblum, Robert, *Cubism and Twentieth Century Art*, New York, Harry N. Abrams, 1960.

Rosenblum, Robert, 'Picasso and the Coronation of Alexander III: A Note on the Dating of Some *Papiers Collés*', *Burlington Magazine*, no. 113, London, October 1971, pp. 604–06.

Rosenblum, Robert, 'Picasso and the Typography of Cubism', in *Picasso in Retrospect*, ed. Roland Penrose and John Golding, New York, Harper and Row, 1973; Icon edition, 1980, pp. 33–45.

Rosenblum, Robert, 'Still Life with Chair Caning', in *Picasso from the Musée Picasso*, Minneapolis, Walker Art Center, 1980, pp. 41–42.

Rosenblum, Robert, 'Cubism as Pop Art', in *Modern Art and Popular Culture: Readings in High and Low*, ed. Kirk Varnedoe and Adam Gopnik, New York, The Museum of Modern Art/Harry N. Abrams, 1990, pp. 116–32.

Rubin, William (ed.), *'Primitivism' in 20th Century Art*, New York, The Museum of Modern Art, 1984.

Rubin, William, 'La Genèse des *Demoiselles d'Avignon*', in *Les Demoiselles d'Avignon*, Paris, Réunion des musées nationaux, 1988, pp. 367–487.

Rubin, William, *Picasso and Braque: Pioneering Cubism*, New York, The Museum of Modern Art, 1989.

Rubin, William (ed.), *Picasso and Braque: A Symposium*, New York, Museum of Modern Art/Harry N. Abrams, 1992.

Rubin, William, The Pipes of Pan: Picasso's Aborted Love Song to Sara Murphy', *Artnews*, LXXXXIII, no. 5, May 1994.

Rubin, William, 'Reflections on Picasso and Portraiture', in *Picasso and Portraiture, Representation and Transformation*, New York, The Museum of Modern Art, 1996, pp. 12–109.

Sabartés, Jaime, *Picasso, portraits et souvenirs*, Paris, Louis Carré et Maximilien Vox, 1946.

Sabartés, Jaime, *Picasso, documents iconographiques*, Geneva, P. Cailler, 1954.

Salmon, André, 'Garçon! ... de quoi écrire!', *Le Printemps des Lettres*, July–August 1911, pp. 93–127.

Salmon, André, *La Jeune Sculpture Française*, Paris, Albert Messein, 1919.

Seckel, Hélène, *Max Jacob et Picasso*, Paris, Réunion des musées nationaux, 1994.

Seckel-Klein, Hélène, *Picasso collectionneur*, Paris, Réunion des musées nationaux, 1998.

Seitz, William, *The Art of Assemblage*, New York, The Museum of Modern Art, 1961.

Silver, Kenneth, *Esprit de Corps: The Art of the Parisian Avant-Garde, and the First World War, 1914–1925*, Princeton, New Jersey, Princeton University Press, 1989.

Spender, Stephen, 'Guernica' (*New Statesman*, 15 October 1938), in *And I Remember Spain: A Spanish Civil War Anthology*, ed. Murray A. Sperber, New York, London, Macmillan, 1974, pp. 151–52.

Staller, Natasha, 'Méliès Fantastic Cinema and the Origins of Cubism', *Art History*, XII, no. 2, June 1989, pp. 202–32.

Stein, Gertrude, *The Autobiography of Alice B. Toklas*, New York, 1933.

Stein, Gertrude, *Picasso*, London, B.T. Batsford, 1938.

Steinberg, Léo, 'Who Knows the Meaning of Ugliness?', in *Picasso in Perspective*, ed. Gert Schiff, New Jersey, Prentice Hall, Inc., Englewood Cliffs, 1976, pp. 137–39.

Sutherland Boggs, Jean, and Bernadac, Marie-Laure, *Picasso et les choses*, Paris, Réunion des musées nationaux, 1992.

Tudesq, André, 'La Guerre des Balkans', *Les Soirées de Paris*, no. 11, 1912; Geneva, Slatkine Reprints, 1971, pp. 338–41.

Tuffelli, Nicole, 'Le Collage: une esthétique du discontinu', *Artstudio*, no. 23, winter 1991, pp. 6–21.

Tzara, Tristan, 'Le papier collé ou le proverbe en peinture', *Cahiers d'Art*, VI, no. 2, 1931, pp. 61–73.

Tzara, Tristan, 'Picasso, papiers collés, 1912–1914', introduction to the exhibition at the Pierre Gallery, Paris, 20 February – 20 March 1935.

Ullmann, Ludwig, *Picasso und der Krieg*, Bielefeld, Karl Kerber Verlag, 1993.

Varnedoe, Kirk, 'Words', in *High and Low: Modern Art and Popular Culture*, New York, The Museum of Modern Art/Harry N. Abrams, 1990.

Varnedoe, Kirk, and Gopnik, Adam (eds.), *Modern Art and Popular Culture: Readings in High and Low*, New York, The Museum of Modern Art/Harry N. Abrams, 1990.

Verdet, André, *Entretiens, notes et écrits sur la peinture*, Paris, Editions Galilée, 1978.

Weiss, Jeffrey S., 'Picasso, Collage, and the Music Hall', in *Modern Art and Popular Culture: Readings in High and Low*, ed. Kirk Varnedoe and Adam Gopnik, New York, The Museum of Modern Art/Harry N. Abrams, 1990, pp. 82–115.

Weiss, Jeffrey S., *The Popular Culture of Modern Art: Picasso, Duchamp and Avant-Gardism*, New Haven and London, Yale University Press, 1994.

Wescher, Herta, *Picasso: papiers collés*, Paris, Fernand Hazan, 1960.

Wescher, Herta, 'Les Collages cubistes', *Art d'aujourd'hui*, no. 4, May–June 1953, pp. 33–43.

Wescher, Herta, 'Collages cubistes', *Art d'aujourd'hui*, special edition, March–April 1954, p. 4.

Will-Levaillant, Françoise, 'La Lettre dans la peinture cubiste', *Le Cubisme*, Saint-Etienne, Université de Saint-Etienne, Travaux IV, 1973, pp. 45–61.

Zervos, Christian, 'Picasso', *Cahiers d'Art*, VII, no. 315, Paris, June 1932, pp. 85–88.

Zervos, Christian, 'Conversation avec Picasso', *Cahiers d'Art*, X, nos. 7–10, 1935, pp. 173–78.

Zervos, Christian, 'Fait social et vision cosmique', *Cahiers d'Art*, X, nos. 7–10, pp. 145–50.

Zervos, Christian, 'Œuvres et images inédites de la jeunesse de Picasso', *Cahiers d'Art*, XXV, no. 2, 1950, pp. 277–333.